T0419756

AMOS
BADERTSCHER

AMOS BADERTSCHER

IMAGES AND STORIES

EDITED BY
Hunter O'Hanian
Jonathan D. Katz
Beth Saunders

WITH TEXTS BY
Rafael Alvarez
Theo Gordon
Joseph Plaster
James Smalls

ALPHAWOOD
FOUNDATION CHICAGO

MSAC
DEPARTMENT OF COMMERCE
maryland state arts council

UMBC

PREFACE Beth Saunders

In his groundbreaking 1963 novel *City of Night*—which follows the exploits of its hustling protagonist through the seedy and seductive backdrop of mid-century Times Square in New York—John Rechy's autobiographical alter ego reflects, "That world, being a world of fleeting contacts, has a great attachment to photographs, as if to lend some permanence to what is usually all too impermanent." This observation aptly characterizes Amos Badertscher's body of work, itself a memorial to chance encounters, fleeting youth, and lives lost amidst the social margins of Baltimore from the 1960s to the early 2000s.

It was my pleasure to organize the first retrospective of the artist's career held in the United States. It opened at the Albin O. Kuhn Gallery at the University of Maryland, Baltimore County in the autumn of 2024, a mere month after his passing. I couldn't have anticipated what a gift working on this exhibition would be. Foremost, I feel privileged to have known Amos and to have consulted with him to plan the show, but also it introduced me to Bill Badertscher, Hunter O'Hanian, and Jonathan Katz as trusted collaborators committed to the importance and vibrancy of Amos's photographic vision and cultural legacy. I am grateful to them for sharing their knowledge, scholarship, and memories of Amos, much of which is captured in this publication.

Amos Badertscher first had a retrospective in Berlin (curated by Katz and O'Hanian for the Schwules Museum in 2020) before he did in his hometown of Baltimore. I initially encountered his work within the book collection at the home of another local photographer and found it instantly compelling. I flipped through pages of photographs proffering smooth skin, dark eyes, and scantily leather-clad bodies, all framed with exuberant handwritten anecdotes about hustlers on Baltimore's streets and nightlife in downtown clubs. Amos's work transported me to a side of the city hidden from view, a Baltimore that no longer exists. I assumed that such a talent was a hometown hero—this was the city of John Waters after all—and certainly there is a through line from Amos's waifs to Waters's characters, as both are so rooted in the specificity of Baltimore. Yet, as I soon discovered, Amos and his photographs were simultaneously widely known and rarely seen among the local crowd. How had this huge body of work been hiding in plain sight here in Baltimore?

Although he had bachelor degrees in English literature and history, as a photographer Amos was an autodidact, proud of never having attended art school. His home was filled with monographs, photobooks, literary masterpieces, and shelves overflowing with DVDs of foreign films. Looking at his work from the 1970s, when he began to pursue photography with a single-minded artistic rigor, I catch glimpses of a hungry talent experimenting with compositions and techniques he was learning through his self-guided studies: *Frank G.* (p. 274) recalls Diane Arbus's *A young man in curlers at home on West 20th Street, N.Y.C.* (1966). The handwriting that frames his images immediately conjures the narrative quality of Duane Michals. A later mirror portrait riffs on Robert Mapplethorpe's *Man in a Polyester Suit* (1980, p. 323).[1] These allusions to his contemporaries were both a means of learning from work he admired and tongue-in-cheek references to the New York–centered art scene from which he consciously distanced himself. Here was a man working, for the majority of his career, almost entirely outside the institutions of the art world and its market. Although he made trips to New York to visit galleries and go out to clubs, he pursued his vision along the social margins of Baltimore, and for decades, in private. Less an outsider artist than a committed contrarian, Amos made his distaste for the mainstream and his preference for the periphery of polite society clear in the musings that annotate his work.

To me, Amos's attitude recalls the late-nineteenth-century bohemian concept of *épater le bourgeois*—a slap-in-the-face rejection of the middle-class world into which he was born. Indeed, his compositions sometimes reveal a partiality for the dreamy evocations of youthful beauty to be found in that century's photographs: *Joseph, The White Portraits* (1974, p. 101) evokes the heavy-lidded maidens of Julia Margaret Cameron; *A Hippie #3* (1972, p. 178) does the Uranian Eden of F. Holland Day's sylvan frolics. *Kevi and the Baron* (1982, p. 57) explicitly references the sun-drenched classical fantasy land of Baron Wilhelm von Gloeden, populated by Taormina's "young peasant gigolos"[2] in the guise of toga-clad (and unclad) ephebes.

Roland Barthes, whose writings on the medium scrutinize the ways in which desire, memory, and loss are embedded in and adhere to the photographic image, noted of the baron's work, "von Gloeden's photography is 'artistic' in its staging (poses and settings) but never in its technique: few dissolves, little studied lighting. The body is simply there, uniting nakedness and truth, phenomenon and essence...."[3] This candid quality of bodies present is a defining feature of Amos's style. He cultivated this through often stark lighting and spare surroundings that accentuate the particularities of each subject's physicality, laying bare their distinct vitality and vulnerability—but while von Gloeden's eroticism tipped into kitsch, Amos's is laced with pathos.

Amos's affinities with the bohemian spirit of another time abound, whether in the appropriated portrait of Rimbaud that served as emblem and artist's statement, the nods to Greek poet C. P. Cavafy, or in his preference for a salon-style arrangement of photographs in his home. (Amos liked to move his pictures around, to cycle favorites in and out.) The faces stared down on his antique bed with its old driving blanket for a coverlet—objects from another era.

I often pictured Amos like Marcel Proust in his final years in bed working on his opus *In Search of Lost Time*. Amos was not bedridden, but he was in search of lost time and lost souls. Returning to the same images repeatedly, he told and retold their stories, etching their names in eternity by writing, editing, and revising histories as he learned about the frequently tragic fates of his young subjects. His body of work functions much like a cherished album, lovingly inscribed, dates recorded, important events noted, each print touched—as the smeared ink reminds us—and revered. The handwriting on the prints makes visible the haptic and iterative qualities of his work. To spend time with his photographs is an act of devotion.

Although Amos often seemed to me to be drawn to the past, his work speaks so specifically to his own time. The faces that stare out from his photographs are framed by the subtle indicators of shifting fashion trends, as the long hair and feathered shag cuts of the mid-1970s give way to punk and new wave looks in the '80s, and later to baggy jeans and Timberland boots of hip-hop and rave culture. The details of leather and lace, feathers and fishnets, metal studs, tattoos, eyeliner, lipstick, and piercings are markers for time and for self-fashioning. And of course, framing the works both literally in Amos's texts and figuratively through our knowledge of this volatile period in queer history is evidence of the social and political transformations that shaped the lives of his subjects, from Stonewall and gay liberation to the AIDS crisis and the inundation of drugs into Baltimore's post-industrial urban landscape.

"Breaking all the rules of documentary," as Amos put it, he never aimed for objectivity, but arrived rather at autoethnography. Even when he is not visibly present, the images are transactional and relational—the writing never lets

INSTALLATION VIEW, <u>LOST BOYS: AMOS BADERTSCHER'S BALTIMORE</u>, ALBIN O. KUHN LIBRARY GALLERY, UNIVERSITY OF MARYLAND, BALTIMORE COUNTY, AUGUST 30–DECEMBER 15, 2023

you forget his voice. Yet his role as author is most apparent in the mirror portraits, in which Amos captures his desiring self, reflected. Those images are among his most visually and conceptually complex. They also elide genre categorization and resist easy interpretation. They are both group portraits and artist's self-portraits in his studio, even as they nod to tropes of DIY pornography. These photographs succinctly reveal the artist's negotiation of the complex power dynamics that is the real subject of his work: Here is an older, wealthier man who desires younger men of a lower socio-economic status. Wielding the camera, he is at once director, participant, client, and voyeur appearing naked before the lens for the thrill of picturing himself with these youths that hold so much power over him. Rather than flee from the ethical questions that make his work both compelling and challenging, the mirror images contend with and hold all of these contradictions together within the frame.

Amos's work is an important record of a certain moment in queer life in a certain place and time that nonetheless resonates with experiences of queer people in many other cities across the United States in the late twentieth century. As mainstream culture progressively accepts and even appropriates queer culture, Amos's work stands as a memorial to the closed clubs, the safe spaces, and the diverse ways of living and loving that came before. While preparing for the presentation of Amos's work at UMBC, I consulted with a professor in the gender and women's studies department to hear her perspective on how students might react to the exhibition. She stated simply, "I think they will see their queer ancestors."[4] We at the AOK Gallery are humbled and honored to have played a role in preserving and promoting Amos's legacy in the exhibition in Baltimore, and now to a wider audience through this publication.

1. It is worth noting here that Mapplethorpe did not start making the sexually charged portraits that would make him famous until 1975. Michals started writing on his photographs in 1970, while Amos first began inscribing his prints in 1975; see also Theo Gordon's essay in this book.

2. Roland Barthes, *The Responsibility of Forms*, trans. by Richard Howard (Berkeley: University of California Press, 1991), 196.

3. Ibid.

4. My thanks to Dr. Kate Drabinski for her support of the exhibition and its public programming.

INTRODUCTION Hunter O'Hanian

For more than forty years, Amos Badertscher (1936–2023) documented the grittier side of a unique American city: Baltimore, known for its parallel cultures of working-class and wide-ranging gay hustler scenes.

Sourcing and shooting his portrait subjects in bars and back alleys, by cruising corners, passing under highway overpasses and abandoned buildings, as well as shooting photographs in his own home and studio, Amos sought to capture, in an inescapable style, what he couldn't avoid. Looking back after he retired from photography he once said, "It seemed like almost the whole damned city was a meat rack."

Amos asserted he never saw nudity, especially male nudity, as lurid. "Although it seems today that people no longer find nudity shocking, as nearly the entire country is drowning in porn, to photograph the naked body is, for me, the ultimate dimension in photographing the person," he wrote in 2018.

He recounts that his first sexual encounter with a man—a street hustler—was in 1960 when he was twenty-four, shortly after graduating from Union College. He mustered the courage only during an encounter with a friend and a hustler where, once together in a room, his friend encouraged Amos to "lay a little bread" on the hustler's stomach. He later said before that first encounter, he had no idea what to do with another man's penis. In fact, up until that point, he just assumed that he would marry a woman and have a family.

The next year, he wrote the following poem placing his experience with hustler in a greater historical context:

Lament

I am a whore with a heart of gold.
The soul is gone; the flesh is sold.
I've fingered love, and now it's cold.
I am a whore with a heart of gold
My story's old.

Soon after, Amos discovered the power of the camera, black-and-white photography, and its relation to his own sexual interest. He began to take his first photographs in the mid-to-late 1960s—small Polaroids of hitchhikers he picked up and invited home (pp. 30–31).[1] He was then living in the "maid's room" of his mother's house and teaching math and English at a nearby junior high school.

Things changed for Amos in the late 1960s, when he went to a local "hippie festival" and took a photograph of an attendee. After seeing the print, he discovered what he really wanted to do was make images of male figures that sexually attracted him.

That desire is clearly evident in his work created in the 1970s, such as *Blond Curls* (1975, p. 101), *Ted is Gone!* (1975, p. 137), *Coldfinger* (1975, p. 114), and *Beautiful Hair* (1975). It was at this time that he began to write stories about his models and other musings on the wide margins of his prints. It was a practice he developed early on, giving himself plenty of room to share direct thoughts that could not be expressed in the image alone.

By the early 1970s, he had settled into his own apartment and began to think about becoming a black-and-white photographic documentarian. In his mid-thirties, he inherited a modest sum of money but sufficient that he no longer had to work. This allowed him the ability to make photographs full-time. By night, often drinking heavily, he cruised the meat racks and bars; he developed negatives and made gelatin silver prints during the day. Most of his photographic knowledge was gleaned from the *Time Life Library of Photography* (1978–79) and conversations with the professionals at a local camera store. He also spent a lot of time looking at work by other artists, such as Mark Morrisroe and David Hockney, as well as early Byzantine art. He read and reread works such as Homer's *Iliad* and *Odyssey*, Edmund Spenser's *The Faerie Queene*, and almost everything by William Blake.

During the day he would also shoot models at his house. One model, Rick Wilson, said, "Those that knew Amos's body of work also knew that a studio sitting was a pretty big deal … The studio had a bright white wall and floor plus many lights … It was so fucking hot. Never an offer of a glass of water. I can still see his glass of iced beer with the beads of condensation running down the sides. How I wanted one but was too focused on what he was doing."

For the next twenty-five years, Amos did little to exhibit his work or present it to others. Although he was very proud and attached to the body of work he was creating, he was somewhat reticent about sharing it with others—perhaps because he knew so much of the imagery was tied to the less-than-respectable subculture of the male hustler and meat rack world.

As he aged, however, he developed an interest in having his work seen by others, especially by those in art and photography institutions and curatorial circles. By that time, he knew he had created something truly unique. He was quick to say, "No one has ever seen work like this!"

Through a chance encounter in 1998 he met art historian and curator Michael P. Mezzatesta, then the head of the Nasher Museum of Art at Duke University, which led to an exhibition at Duke and the publication of *Baltimore Portraits* (1999) by Duke University Press. It was at that time that he hired an agent, who helped him secure a publication with St. Martin's Press.[2] Those successes led him to a friendship with Charles Leslie, one of the cofounders of the Leslie-Lohman Museum in New York City, who offered him several exhibitions over the following years.

In 2005, at age seventy, Amos turned over a new leaf in several significant ways: he stopped both drinking and making new images. His time for cruising the meat racks and gay bars had also ended. However, he was not done with his work. For nearly two decades more, he revisited his stories and updated them, often with additional research and informed reflection. With the tireless and loving assistance of his life partner, Bill Badertscher, a model he met in 1985, Amos rewrote the stories longhand and then refined them on his computer.

Amos also began to work with Baltimore artist Julien S. Davis, himself a fine art printer, to make new inkjet prints of images that were created as gelatin silver prints. Davis made more than five hundred new images, all of which were printed. Meanwhile, Bill amassed all the of digital images he could find of Amos's work. It is the collection of all of those resources, more than fifteen thousand documents, that serves as the basis for this book.

A storyteller by nature and writer by training, Amos compassionately foregrounds individuals who others may care to judge. But he brought to life the figures in his world without a scintilla of moral judgment. In his writings he reflects the reservations and prejudices that would be expected of someone who grew up in a privileged suburban life in the mid-twentieth century. Was he challenged by reckoning with his own sexual desires in with a world that villainized those who had a same-sex attraction? And did he develop a transactional element to sexual encounters? Of course. But in his photos, Amos asks us to see those around him (and us) as people and individuals, without second-guessing their motivations.

Beside his own journey through relationships and alcohol abuse, the stories in his artwork document and describe the 1960s cultural revolution, search for sexual freedom, AIDS, drug abuse, broken homes, abusive parents, urban gentrification, politics, and sex work. In

HIPPY FESTIVAL, C. 1969

particular, we see how dysfunction and abuse are handed down from generation to generation. At times, the stories are funny and poignant, while also personal and caring. With a unique writing style that incorporates influences from the 1960s and 1970s such as Jack Kerouac, William S. Burroughs, and Jean Genet, he breaks grammatical strictures and norms to make his written word more closely resemble vernacular speech. Look also for his free and abundant use of historical and contemporary references—everything from Homer to Roy Rogers.

With generous and supportive help from Amos before his passing, I have collected most of his written work and a robust selection of his images to tell a story of gay culture across a long period of time in human history—more than forty years—in a particular place. While situated in Baltimore, this story could be of any midsized Western city in the latter part of the twentieth century. The story is a self-recognized sense of sexual "difference," albeit without a label or public recognition. It shows the corners of the same-sex world and the sex work that many men explored to find companionship, support, and intimacy.

This is the story of one man's journey as he discovered his own differences and personal desires—a man who had the ability and foresight to record his trail in both images and words. This is not a history of LGBTQ milestones, gay pride marches, or U.S. Supreme Court decisions; rather, it is what happened while those events transpired around us.

1. In 2019, when his memory was still very sharp about details from those early years, I asked him if he had seen mid-century homoerotic publications such as *Physique Pictorial*, *Grecian Guild Pictorial*, *Drum*, and *VIM* or the work of Bob Mizer, Lon of New York, or others. He asserted he had no recollection of seeing any of that work at the time.

2. Amos Badertscher, *Badertscher* (New York: St. Martin's Press, 1998).

LOST BOYS—AND ALL THE REST OF US Rafael Alvarez

This book is a tribute to Amos Badertscher's documentation of "the queer underground" and the not-so-long-ago canvas against which he projected his work: the Queen City of the Patapsco River Drainage Basin. Mobtown. Charm City. Crabtown, USA. Home.

A little more than a half-century after Badertscher began in the late 1960s, queer culture doesn't hide anymore. At least not in Charm City. Back when the city was a postwar industrial powerhouse—manufacturing everything from ships to soap to Chevrolets—there were a few neighborhoods where queer could be queer without undue harassment. Downtown was one, where bohemians bounced between Martick's, the former speakeasy of lore at Mulberry Street and Tysons Corner commanded by Morris Martick (1923–2011), and Mee Jun Low across from it, a Chinese walk-up where artists, students, and folks on the margins could eat cheaply. Filmmaker John Waters tells of his mother—whom he once overheard affectionately referring to him as "an odd duck"—dropping him off in the alley alongside Martick's to be with people more like her son. It wasn't because Waters was queer that he wasn't allowed in the bar but that he was still a teenager (people brought him drinks outside). Said Waters of recent plans to replace the forty-five-year-old Rouse shopping pavilions with a pair of apartment towers: "I liked when the Inner Harbor was scary the first time … before gentrification. Sailors. Lesbian bars. The Block."

A stone's throw north is Mount Vernon, Baltimore's enclave of mid-nineteenth-century WASP wealth and privilege—emblematic of the "polite society" on whose far fringes Badertscher worked—long since the city's queer hamlet.

More a community than a neighborhood was the Block, Baltimore's fabled and steadily shrinking red-light district, where brothels had flourished well before the Civil War.

Just below City Hall, along the 400 block of East Baltimore Street, sailors from around the world could get fresh ink from Tattoo Charlie's and chat up bureaucrats putting off going home with another drink—just one more—or maybe see a juggler or a comic before true burlesque artists such Blaze Starr and Jean "the Harlow of the Block" Honus took the stage and took it off.

Around the corner at 213 North Gay Street was the Pepper Hill Club, a popular gay bar in the gray-flannel-suit Eisenhower era. Police raided it in October 1955—a decade-and-a-half before New York's Stonewall riot—and locked up 162 men for lewdness, assignation, and disorderly conduct, all based on reports of "men

THE LAST PHOTOGRAPHS #2, 2002

kissing men." A month later, all were found not guilty—including bar owners Morton Cohen and Victor Lance—by Judge James K. Cullen, who severely criticized police for an unnecessary raid.

And then there was the pre-Harborplace waterfront, where bikers were known to roar on their motorcycles into the front door of Elmer's Musical Bar at Pratt and Light streets and ride out through the back.

A mile east from Pratt Street's once-rotting piers and the watermelon boats from the Eastern Shore—past Little Italy, where it was prudent to stay in the closet if possible—was the anything-goes neighborhood I've known since birth: the authentic, Jack London sailing village of pre-gentrified Fells Point. It was there, at the age of six or seven, that I saw my first lesbian—butch, though I didn't have the language to know that then. This was about 1964, before hippies began moving in and virtually all of the 120 or so bars didn't allow women—or at least not women looking to make grocery money.

The neighborhood was a largely Polish Catholic enclave of seamen, stevedores, belly dancers, hot dog vendors, rope shops, street drunks called "smokehounds," and barkeeps, known as "the foot of Broadway." My parents were best friends with a family (Agnes Karcz Garayoa and her Basque husband, Simone) that owned Karcz's Cafe at 805 South Broadway. My father and Simone worked the Thames Street tugboats at the end of the block—just past the Port Mission, where those same smokehounds sang hymns for a bowl of soup—and we visited the bar often.

While the grown-ups drank and shot the breeze, eating steamed crabs and talking about old Spain and docking ships, I was allowed to go out front as long as I obeyed Mom's orders to "stay where I can see you."

There, I glimpsed my first openly queer person. The woman, chatting with friends outside a bar next door that would become the Whistling Oyster, had large breasts under a work shirt (the kind mechanics wear, name in an oval), dungarees, and black leather cop shoes. I remember being confused—even now it seems presumptuous to say the person was queer. And while I didn't say anything to my parents, I never forgot it, particularly the woman's "regular" haircut—combed straight back, short on the sides, and square across the back of the neck, just like my dad's.

Queer or not, the image would have been too tame for Badertscher's eye, which, as chronicled here and an UMBC exhibition that celebrated him 2023—settled on street hustlers (known in the local parlance as "chicken"), drag queens, club kids, go-go dancers, and drug addicts from the late 1960s to 2005.

A more likely candidate for Badertscher's Nikon would have been a 1960s South Broadway kid named Johnny Hamburger, an always-hungry urchin right out of Dickens. Johnny, to whom local barmaids sometimes gave new clothes and underwear, got his nickname from tugboat men who treated him to meals. When asked his preference, the answer was always the same.

Polite society in Fells Point? Maybe the big shots who did maritime business on the docks before going home somewhere north of the Cathedral of Mary Our Queen. Everyone else who lived along the streets and alleys branching off from the City Recreation Pier (now a four-hundred- to five-hundred-dollar–a-night hotel) labored in classic Baltimore fashion. That might be hustling hams stolen off a Danish ship, bringing bundles of rags to the schmata kings for a few bucks, turning a trick or cadging a drink. Whatever it took to make it from today to tomorrow.

"There wasn't anything unique about being quirky on South Broadway, so folks who were gay fit right into the mosaic," said William Prevas, grandson of the Greek immigrant who founded the Prevas Brothers lunch counter at Broadway and Fleet in 1898. Known for its Polish dogs, milkshakes, and stools planted right in the sidewalk, the landmark closed in 1983, when Badertscher was doing some of his best work.

"We knew them all by name—a guy from the projects named Clifton, who called himself Sophie; Cleopatra; a guy who called himself 'the Blowfish,'" said Prevas. "We grew to like them and took offense if outsiders were abusive. They were our queers."

A note about captions and story titles

During his lifetime, Badertscher made more than ten thousand prints from images he created. For the most part, from the period of the mid-1970s to the early part of the twenty-first century, those prints were made in his home darkroom in Baltimore, where he developed the negatives and printed the images resulting in gelatin silver prints. In nearly every case, they were printed on eight-by-ten-inch high-quality photo paper. He often used large white borders in his work, so actual image sizes vary considerably.

When he began to write on the prints, he viewed each one with handwriting to be a unique object. He would often use the same title for different images of the same model or from the same shoot. In other cases, he would write different things on separate prints of the same image. He did not use a system to edition his prints; he simply made the number of copies he wanted and wrote on them what he felt appropriate at that moment.

Over the years, prints were given away, sold, or in some instances lost. Starting in 2010, Badertscher began to donate prints to the Leslie Lohman Museum in New York. The museum presently has over three thousand Badertscher prints in its permanent collection.

Around the same time, he started working with another artist, Julien Davis, who began to digitize Badertscher's gelatin silver prints, capturing more than 525 of Badertscher's original prints. Davis also made new inkjet prints. Those images were printed on either eleven-by-fourteen-inch or eighteen-by-twenty-four-inch high-quality archival paper. Numerous prints were made of the digital images. Over the years, Badertscher approved the final versions of the digital files, including light, shadow, and other attributes, and the quality of the new prints from the digital files.

On nearly each of the prints made from the digital files, Badertscher wrote a story about the subject, often with additional information he had received or reflections of his current thinking. Invariably, he also penned the date of the original year when the image was made. As a result, an image may present text relating to events that occurred after the date of the image. It was during this period that he reworked many of the original stories contained in this book. He continued to request new digital prints to write on and rewrote stories up until a few months before his death, in 2023. As a result, not every image caption matches the title of the corresponding story.

Beginning in 2015, Badertscher began donating prints to the ONE Archive at USC Libraries in Los Angeles. In 2023 his estate donated a significant number of prints to the University of Maryland, Baltimore County, Albin O. Kuhn Library Special Collections.

As you review the captions in this book, you will note that some images are designated as being from the ONE Archives, Leslie Lohman, and UMBC. The images presented are the from the prints contained in those collections.

Other images are identified as being from the Estate of Amos Badertscher. In these instances, the image presented is from the digital files Badertscher worked on with Davis. In other instances, the source designation is identified as Amos Badertscher Studio. In those cases, a digital file was made from a gelatin silver print in Badertscher's possession at the time of his death.

Where a number appears after the title, it represents a distinction for a particular image in circumstances where different images were marked with the same title.

Hunter O'Hanian, December 2024

PROLOGUE

When I was a young "boy" and had finally made it to prep school in the third grade in the mid-'40s, each Saturday my father would take me over to the Towson Theater to keep me occupied for a few hours by anything that came along in the cinema department, and then he'd walk down a block to the Maryland Restaurant Lounge and hang out with his buddies. I was so young and innocent, and I could easily have been kidnapped, masturbated, raped, or sucked off in a '40s theatrical bathroom or any random combination of the above and I wouldn't have known what was happening; no, really.

But this wasn't too probable in Towson, Maryland at the time. It was a small quiet town to the north of Baltimore. Thanks to FDR we had a post office with a Works Project Administration historical mural, very poorly painted with little to no perspective but certainly historic and positioned exactly over the business end of the post office. Across the street the original part of the courthouse was built on the old Bosley estate and up to about 1875 slaves were sold on the courthouse steps.

My father was known as "Doc" and he knew almost everybody or almost everybody knew him. He could get a loan from the bank with a signature and a handshake. When he was finished with the Lounge he could just come up and walk right into the theater, say hello, and collect me or me and my brother. During all those abusive, confused, tedious years, I never knew what he did in the lounge or what he was drinking but by the time he picked me up I could clearly tell he had had too much of it. One Saturday, when I went to the bathroom a man was inside and then asked me about peeing and penises. I can't possibly remember what I told him. The usual, I guess.

Nobody was ever arrested for drunk driving because there were only 2 policemen, and the driver was usually a friend of at least one of them, so they'd just bring you home and that was the end of it. In the theater on Saturdays, it was always the news and a D-grade serial, and I really loved all of it and I knew every gumshoe and cowboy in Hollywood. But by far my very favorite cowboy was Roy Rogers. All the rest of them just didn't cut it. In my own young and desperate way, I guess you could say I was in love with him. But I was also desperately in love with his unexplained female accessory, Dale Evans. And there was also that old unshaven "Gabby Hayes," their funny and grumpy and loyal sidekick. Every legitimate slick overdressed musically oriented deodorized cowboy known to man had a sidekick. In a very few cases it was an Indian. That was the best the studios could manage in the '50s.

Roy and I quickly became the best of buddies and for at least an hour before I went to sleep in my quiet totally dark bedroom where I would invent these fabulous and endless adventures involving not a horse but a long tube-like train that only Roy and I had access to and through an underground tube we could be propelled in 15 minutes directly to Texas. The train was just the right temperature before air conditioning and cozy and impregnable surroundings, and we were safe from any evil or any catastrophe in the universe.

On the way to Texas, we'd talk incessantly and discuss everything there was to discuss as well as our own personal agendas. It was us against the world and especially the bad guys and other cowboys. We could fix anything, and everybody knew it. Little did I suspect that these two celluloid overdressed characters would eventually become charismatic, practicing "Born Again Christians" and hence eschatologically and politically my mortal enemies. But fortunately, by then I was beginning to develop a totally secret sexual behavior of my own that at the time was not only illegal but also subversive and disruptive to the capitalist heterosexually establishment and thereby threatening the very root and fiber, the very foundations, if you will, of the Puritan American Dream. But it wasn't my fault entirely because I had never had one sexual experience before I reached 24 years and even at that I had to be talked into it. I didn't even imagine that a sexual act or a sexual relationship could possibly exist between 2 males and especially a younger one.

A wife and kids and grandkids were the only options conceivable back then! A girlfriend and the locker room and a sports letter on your sweater! I was forever thinking of all those painful and confusing years in high school and anything else connected with it. Later on in life I made it my all-consuming self-imposed mission to put as much space as possible between myself and this adolescent nightmare. That wasn't very hard to do especially with a little help from my damaged acquaintances and my perverted exploits. Can you imagine the guilt? Can you possibly imagine all the energy and frustrated desire of a teenager accumulated over 24 years? Can you just imagine what could possibly happen when I was finally released into a working-class Baltimore neighborhood when gay identities were hardly invented, and a blow job was a blow job was a blow job. So many hustlers, possibly wholesome, inverted, or perverted or dangerous, hedonistic, but all needing attention, maybe a place to sleep, a blow job or a lift and money. So many young and not so innocent partners in crime. The treasures seemed endless, and I knew no tomorrow. These were the days and the lives and the ecstasies that very shortly in America would live in infamy. You Know! The Gay Identities, of course!

Ship of the Damned, 1962

The Ship of the Damned is a mighty big ship,
It goes at a leisurely pace.
There're no promenades or steerage space.
You've paid in advance the price of the trip.

Devious Pathways, 1983

When I was in prep school and college it was another dimension entirely. There were no cell phones and hence no cell phone addicts yet in America. You talk about drug addicts and Huxley's "SOMA" (a mind control drug, a pacifier—"Brave New World") as well as no rigid and crazy and scary sexual Classifications to be afraid of. The words "Fruit" and "Fairy" and "Flit," in the '50s, (the 3 f-words)' were unpleasant to hear if pointed in your direction, but mostly they only meant "weirdo" or "outcast" or "queer," which only meant that you didn't fit in.

I first learned what the word "faggot" meant my first year in college! and all of this stuff leaving the real "Homosexual" in the woodwork having a field day because nobody in Baltimore or anywhere else realized what perverted and filthy and scandalous sexual acts they were accomplishing! Specifically teen-age hitchhikers. Back then kids didn't know what a homosexual was in the first place was as well as a Heterosexual. One day I went to the dictionary in 7th grade and looked them up and was proud that I was learning something on my own, but it never mentioned anything about the Sex Stuff!

For boys as well as for girls, the only conceivable plan of attack was boyfriend or girlfriend, and it all helped a lot if the boy had a big "School Letter" displayed on the front of his "School sweater!" And then it was "Married with children." And then Uncles and great uncles, uncles twice removed, uncles with Lou Gehrig's Disease or dementia and or hardening of the arteries and aunts with severe bladder dysfunction, uremic poisoning and emphysema and depression because they knew they would never live to see the return of the 17-year locusts, and then grandchildren, golden retrievers, sanitary napkins, etc. all came tumbling out! But fortunately, so many others found out "devious pathways," by accident, dumb luck, or ignorance, and all the time being blissfully unconscious, specifically teenage hitchhikers if paid a little money!

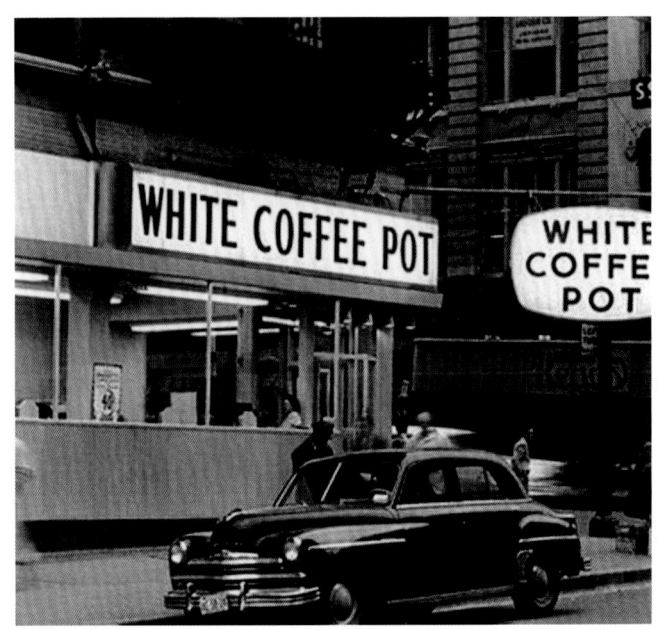

WHITE COFFEE POT, 301 WEST BALTIMORE STREET, BALTIMORE, MARYLAND, NOT DATED (C. 1956)

Steps of Fantasy, Sin and Desire

Especially during the '50s, '60s, '70s and '80s, marble front steps were much more than a superior launching pad of dreams for sex and desire. If one possessed all the stories, personalities, motivations and needs of all the boys who had stood by or sat here, you could write volumes. These steps were a sex magnet for decades. Whatever those steps were attached to, they were directly across the street from Patterson Park and along Patterson Park Avenue. Once the "gem" of Baltimore City, the park's whole south border running right alongside "Eastern Avenue," the east side was a hustling mecca for countless decades.

White Coffee Pot

The "White Coffee Pots" all over Baltimore City in the '60s, '70s, and '80s served much more than hot coffee, cold "Cokes," hamburgers, and sandwiches. They were strictly a Baltimore concern and were always located at corners where there was plenty of foot and car traffic. This particular "Pot" was located in south-east Baltimore at the corner of Eastern Avenue "the Avenue" and B'way. The year was 1976 and 1977. If you were looking for a hustler, a few of them were usually sitting right there behind those large plate glass windows and looking directly at you, convincingly occupied with a beverage or hamburger, or casually leaning against the well-lit side running along "Eastern Avenue." All it took was direct eye contact and a slight knowing movement of the head to make a connection.

The Age Gap! Nuclear Exasperation!
"The Age Gap!," "The Age Gap!," "The Age Gap!"

If I hear that idiot expression one more time, I'll puke! The Age Gap is the whole point of the relationship! But what else can you expect from a Puritan Culture in America! Even the Cowboys and Indians knew better. The newspaper boys, the telegraph boys, the elevator boys, the powder monkeys, and the stable boys used to. So, put that in your stuffed turkey this year as well as your little nut cups.

Pornography

For me the word pornography doesn't exist. It's a label fabricated by those people who need to hide from Reality. Human behavior in every part is both fascinating and instructive. Even the self-destructive parts.

Something You Have To Get Out of Your System, late 1960's

Wyman Park, just 4 minutes away from the "Baltimore Museum of Art" hosted a hippy festival. At night the park became the busiest uptown meat rack in Baltimore City. It was peace and love all the way like finding a new pathway for Humanity, and a lot more. A lot of long-haired Jesus duplicates, psychedelic mushrooms, and LSD for mental explosion. "Tune in, turn on, drop out", just one variation. The Harvard professor and the "Merry Pranksters", the magical bus "Further", insanely colorful, a "bummed out" ecstasy or nightmare.

"Are you bombing with me Baby Jesus?"

"Jesus is God's Atom Bomb"

"Can you lay some bread on my stomach, Man?!"

"Never refuse Bread."

"Don't drop the soap" if I remember correctly.

Finally, at last, by the end of the '60s, "The Summer of Love" in San Francisco: too many people from all over the planet, not enough toilets and drowning the town, a whole lot of them looking for drugs and love and sexual consummation. A lot of it ending in addictions and sexual promiscuity, depressions.

Does Humanity ever learn anything from anything?? !!

Apparently Not! No! No! No! No!! It doesn't! To answer the question. No! It's just something you have to get out of your system.

No Hands, n.d.

So, one day, the sun is out, and I was cruising around Wyman Park in the late afternoon, and I see this cute guy sitting by the steps directly across from the Baltimore Art Museum, with some girl and another friend. He was obviously closely watching the passing cars and then nodding in my direction. This was the uncomplicated code adopted by Baltimore boys when they were interested in "going out." So, I pulled to the curb, he walked over smiling, super friendly and casual. He said he wanted to make a few dollars, and could he get in and we could talk. Somehow, I wasn't sure about this one, probably because I was stone sober and also because over the years, I had come to realize the hard way that sometimes the most charming and charismatic person can be the most unstable and dangerous - and obviously all it takes is the wrong kid, just one time. This is before I'd ever heard of schizophrenia.

So, we talked a few minutes through the window, and I said I wasn't sure because I was supposed to meet someone else who seemed to be not showing up. So, he says OK. I drive around the park a couple of more times just thinking, weighing the odds but this was just too tempting a prospect.

I finally returned and pulled over by the same steps; he nods a second time, walks over to the car and hops in. Looks like a real winner. So, we continue driving around the rest of the park following the road which, at that time, bent casually to the right heading down 29th Street. He keeps talking as we're traveling for about two or three blocks and then he looks directly at me and pulls this knife, holds it close to the base of my neck so nobody on the street can see it happening and says keep driving, he'll tell me where he wants to go.

Very shortly 29th Street heads slightly downward for a very long block with a big intersection at the bottom. So, I figure if I don't do whatever he's going to tell me I'll either end up stabbed and robbed, knocked out or god knows what. So, I panicked, fortunately, and did the only possible thing that presented itself under the circumstances other than waiting for a miracle. I slowed considerably, opened the car door which he never expected (and neither did I), jumped out of the moving vehicle which then continued slowly drifting down 29th. I can't imagine what he was now thinking inside a driverless car with all the attention this was beginning to generate.

So, he jumped out. My attention was never really off the car which I was still able to catch up with. When I did, I jumped back in, and my mind was mostly numb and oblivious to anything else. Intense fear and the threat of disaster will instantly suck up all the attentions as effectively as the vacuum of a black hole, a reality suggested a lot earlier by St. Thomas Aquinas and later expanded and given poetic credibility by Dante around 1300, although suggested might not be applicable because they meant it.

Once inside the vehicle, a Dodge Dart, I slammed the door and probably drove back to my apartment on Madison. I don't remember exactly; it was over thirty years ago. Thirty-five maybe. At any rate I was done for the afternoon. It makes you wonder.

Roy Rogers in the Industrial Park c. 1975

This happened, probably in the early '70s but truthfully, for me, that whole decade was absurdly accelerated.

One night I was coming out of an uptown bar in my usual illegal condition just after last call and I was definitely ready and at my peak for this kind of activity. In twenty minutes, I was driving down Eastern Avenue at Patterson Park, facing a seemingly unlimited supply of young guys looking to "go out", make a little money, walking, watching, sitting, signaling on all the corners, hitch-hiking, whatever.

I saw this blond guy who was sort of hitch-hiking, wearing a coat, so I pulled over, rolled down the window, he looked good, so I let him jump in. For some reason I didn't feel like driving all the way back to my apartment on Madison, so we drove around for twenty minutes and shortly located this empty industrial park full of railway spurs and loading platforms. There were a lot of these in the area surrounded by lots of working-class housing with shining marble steps and litter free streets. A safe place to visit but seriously boring and believably unimaginative.

We pulled close to the center of this freight yard or whatever it was, I stopped the car, and the guy says he's gotta take a piss. It was probably cold, so he closed the car door when he got out to do it. He was out there a while and when he got back in, he had in his right hand the longest silver gun I had ever seen, except in all the Roy Rogers westerns I watched as a kid.

Anyway, it was definitely happening now. Of course, because of the habitual intoxication, I didn't really comprehend the danger, so I opened the car door and got out because I didn't know what else to do but I suppose I looked like I was trying to escape because he got out the other side, pointed the gun at my head and pulled the trigger. But nothing happened. He looked quickly at the gun and said, "don't you think there's a bullet in here!", opened the gun, took out something that in the bad lighting looked like a bullet, waved it at me and was putting it back in the gun.

Recalling this episode decades later I was thinking that maybe this was actually some kind of pellet gun, but I wasn't waiting around to find out and took off running. Whether he fired again I'm not sure, but I was doing my best to get lost in the streets around the working-class houses with the marble steps and I obviously made it because I didn't get shot and never saw him again. Shortly after I found a pay phone and was coherent enough to call the police. They asked me where I was, and I must have told them because they said they'd send someone around and shortly a cop actually showed up in a cop car and found me. I couldn't get in fast enough and told him what happened, but I didn't mention everything, and these were the days when cruising the meat racks was a constant reality of Baltimore city life. This was the '70s.

So, he said we'd drive around, check out the industrial park, the streets in the neighborhood and look for the car but I couldn't imagine how we'd find anything, considering the fact that the keys were left in the ignition. Finally, we turned a corner and there was the car sitting passively just at the beginning of an alley with the lights on, the motor off, the door open and the keys in the ignition. I don't know if some higher "authority" could be implicated here but even in those days any fool would have to consider the possibility. So, at the end of all this the cop discussed the dangers of picking up strangers and about being more careful in the future. I agreed with everything. And then there is nothing quite like this sort of experience to induce instant sobriety. But predictably, like a helpless idiot veteran sex junkie, I went right back to "the Avenue" for a last check; it was close by anyway and only about 3:30 A.M. I picked up this kid named Harvey, but a kid with a surprisingly deep and sensitive voice. I learned later that night that he liked men and lived in a housing project with his father who made a habit of locking the phone up when he wasn't there to make sure people like Harvey never used it. I also didn't learn whether the man was employed or what other habits he had to make the life of his only son more unbearable.

Weeks later I found Harvey a number of times around the same corners along Eastern. Whatever else you might know about Baltimore it's a relatively small place with an endless, sometimes inventive, capacity to sin. And as I suggested earlier, you certainly have to consider the possibility of something or somebody lurking around out there, above, or below, watching over and protecting my own particular stuff.

The Birth of Venus, n.d.
The Abduction from Tros

The traditional positioning of "Ganymede" and all the necessary equipment in the Italian Renaissance. Ganymede was a Trojan prince: young, exceptionally beautiful, and apparently available. You can see why "Jupiter" just snatched him up right away and into the heavenly realms of "Olympus" and made him his new "cupbearer."

So far, so good. But in order to do this "right away," he had to get rid of "Hebe": His wife Juno's deserving and legitimate daughter. Juno, the "Queen of Olympus" was already royally pissed about Jupiter's obsessive philandering and not just lately and now This!!! Her beautiful daughter replaced by a Boy!!! AND a mortal at that!!! "What's this 'xxxxxxx' world coming to!!! (She said). and now, Juno really had It in for the Trojans. And then there was that other matter referred to as "The Judgement of Paris!" The Trojans were incorrigible!

Her daughter replaced by a boy?!!! So Now! "She" really had it in for the Trojans! You already know about the 9 years' War named after them, the Trojans, which they lost, and She brutally pursued brave Aeneas, the only son of the Trojan king, Anchises, on his long voyage over the perilous seas all along the way to Italy on his Heavenly pre-ordained mission to found Rome. And much more!

AMOS BADERTSCHER WASN'T GAY Jonathan D. Katz

David sometimes had a girlfriend although not often. But this was a hot Saturday night and he had nothing to do. He just wanted a few beers and a good time. But these were the late '60s and same sex contacts were still very o.k. and well before the "gay identities" were invented and were tightening their grip all over America. Everybody would now be defined as either "straight" or "gay." The beginning of the end.
—Amos Badertscher

That the artist Amos Badertscher unironically labeled the advent of the gay liberation movement in 1969 a catastrophe for him and his art making is, on the face of it, ironic. After all, his work seems to be among the most unambiguously gay in the short history of LGBTQ photography. But he was serious in his assertion, and what he characterized as his loss in the wake of gay liberation is, as I hope to demonstrate, both a motor and leitmotif of his decades-long career.

Prior to 1969, he noted, any man was potentially available erotically for the right price—a product both of the period's still-fluid boundaries between homo- and heterosexuality as well as the degree to which money could transform the erotic into the merely transactional.[1] Badertscher had long before perfected picking up hitchhikers and wanderers, asking if they wanted to make a little money, and talking them into performing nude for his camera. But with the increasing viability of a specifically gay politics, and its defining principle of minority liberation, the previously undefined grey zone of casual homoeroticism snapped into technicolor clarity, and an inviolable boundary line between gay and straight emerged—in short, everything changed. In the early 1960s, before gay liberation, another man's come-on was either flattering, ignored, resisted, or acted upon; after the slow advent of gay liberation at the end of the decade it would come to mean something quite distinct, such that it could be met with real danger. And that's because before 1969, to find another man attractive said something about you, but nothing about the man you fancied. In the years after 1969, on the contrary, it signified that you assumed the man in question was gay, too—a potentially scabrous insult that was often met with violence.[2]

Today, thankfully, that reactive propensity towards violence is diminishing. Under a social order that is increasingly queer—which is to say it refutes any meaningful or essential differences between queer and non-queer sexualities, or perhaps better said, refutes the idea that heterosexuality is an unassailable combination of nature, norm, and divinity that makes homosexuality inherently unnatural, deviant, and heretical—we are growing closer to understanding sexuality not as a core essence, but as a taste. And tastes do not result in classifying, policing, and persecuting people. You can like or dislike what other people like, but you can't really justify discriminating against people with different tastes—that is, unless you're a partisan of the Christian Right.

The great irony that lies at the heart of Badertscher's art is that the emergence of that boundary line between sexualities which he found so distasteful is now slowly dissolving. He was, in short, queer avant la lettre. What was once a distinctly unique position has been reborn in today's era of the queer as an emerging social norm. For many, desire is all about a person, not a gender, and they thus refute all categorizations of their sexuality.

Until his passing at eighty-six, Badertscher had lived through most of the defining definitional crises of sexuality of our time, and as we'll see, his once distinctly minority position has now become mainstream. But more than that, I argue that the recent "discovery" of Badertscher's work is a product of its increasing clarity according to the most cutting-edge version of sexuality today, that he not only anticipated our present queer politics, but equally, that under the regime of gay liberation politics, his art was distinctly anachronistic, even backwards-looking, for its apparent refusal of sexual borders—most centrally the one between straight and gay.

Most of the young in Badertscher's work were straight-identified—however gay they might appear, including engaging in gay sex acts. But the photographer is patently uninterested in anything approaching a mapping of sexual difference or distinction. Instead, he photographs young men and women, whatever their actual sexuality, as homoerotic icons, generalizing a queer vision, or standpoint epistemology, that suggests his was not a minority aesthetic but the dominant one. Even the most heteronormatively masculine men are feminized in his pictorial world, if only by being positioned as erotic objects in a sexist system that correlates erotic availability with the feminine. Butch women, femme men, nonbinary and trans identifications, and of course drag and gender fuck-play are central to his practice, a queer vision of an alternate gender reality that has no truck with the dominant codes.

But by no means do all of his images of gender dissidence feature actual gender outlaws. His representation of gender is no more essentialized than his representation of sexuality, as if a textbook illustration of Judith Butler's arguments concerning the performative quality of gender difference.[3] The palpable eroticism that infuses the resulting photographs is doubtless a reflection of the photographer's own desire, but it can also—and this is both the problem and the promise of Badertscher's art—migrate towards the audience as well.

None of this overtaking, and queering, of the visual field would matter very much if the resulting photographs were simply gay erotica. Such erotica is legion, and while it's important to the queer world, it rarely merits inclusion in art exhibitions because it so clearly targets particular audiences and addresses them to the exclusion of others. Badertscher, like his predecessor, the great photographer George Platt Lynes, performs a particularly difficult alchemy: through his art, the patently queer becomes aesthetically seductive—not just to other queers, but more generally. An art so firmly and manifestly rooted in his queer vision nonetheless crosses so many sexual barriers and trip wires that it paradoxically achieves a broad, less differentiated aesthetic-erotic charge. His is an art that actualizes the utopian queer promise of a world without boundaries, at least in terms of sexuality. In and through his photographs, Badertscher reverses the rule of sexual differentiation and segregation that has been naturalized at least since World War II. We can grasp, albeit only fitfully and partially, that queer dream, which holds that sexuality is no longer ground for the policing and controlling of people based on their desires.

As fetishized beauties, his models seem to occupy a privileged sphere, young and striking, free and self-possessed. Archetypes of youthful flirtation, it is as if, on the cusp of that transition from adolescence to young adulthood, they can now revel in their newly discovered seductive power. This lush visual seduction is clearly a result of his subjects' particular confidence and charisma before the camera—they manifestly sense the photographer's (and, by extension, our) desire and exploit it—but also of his innovative, formal strategies. In terms of composition, Badertscher is masterful. There is simply no equivalent to his *A Shocking Case of Trans-Lateral Positing #1*, (1988, p. 19) in either fine art or pornography. Depicting a model on his back revealing his asshole, it is the echo of heterosexual porn's infamous beaver shots, but with an important distinction: this pretty, hairless youth is manifestly male, yet presents himself as open

1. Amos Badertscher, phone conversation with the author, October 16, 2020.
2. The so-called gay-panic defense asserted that the mere assumption that a man was interested in you could legally justify his murder. It has been used countless times to condone homophobic violence. Federal bills to outlaw it have consistently died in committee, where they have been blocked by Republicans as recently as 2021. See "Gay and Trans Panic Defense Prohibition Act of 2021 (S. 1137)," https://www.govtrack.us/congress/bills/117/s1137, retrieved September 11, 2021.
3. See Judith Butler, *Gender Trouble: Feminism and the Subversion of Identity* (New York: Routledge, 1990).

A SHOCKING CASE OF TRANS-LATERAL POSITING #1, 1988

to any and all comers. Normative masculinity is at its essence defensively constructed, which is to say closed-off and implicitly in competition with, and even a threat to its audience. The men in, say, Robert Mapplethorpe or Herb Ritts's photos are bigger, stronger, and more masculine than any of their viewers, male or female, could ever be. Badertscher's photos offer another kind of masculinity. With his eyes closed, his head to the side, and his soft ass presented to the viewer, the figure in *A Shocking Case of Trans-Lateral Posting #1* is the materialization of a most unusual paradox, an aggressively passive image, a penetrable masculinity. It employs so many of the elements of heterosexual pornography but inverts them, recasting the object of desire as male without regard to the viewer's self-professed sexuality.

Still, in yet a further complication, this pictorial sensuality rooted in seductive and charismatic subjects is abruptly contravened by the artist's narrative storytelling in the photos' margins. In stories by turn tragic and cruel, Badertscher chronicles the lives of these working-class youth barely surviving at the outside edge of the social margins. Theirs are often shocking, if numbingly repetitive, tales of abuse—sexual and otherwise—and parental neglect, with side trips into drug and/or alcohol dependence, crime, disease, poverty, and the accompanying profound social alienation. While in some sense a familiar catalog of postindustrial urban social ills, the abstracted and generalized quality of this knowledge is brought into unmistakable relief before the flesh-and-blood subject in front of Badertscher's camera. The artist engineers a disorienting and discomfiting disconnect between the erotic charge of the subject and the pathos of the life his text then adumbrates. And that discomfort shades into a moral dimension, as the youth we've been ogling suddenly emerges as an symbol of a painful social history, a casualty of the inequitable distribution of resources. In an instant, what was first an easy pleasure suddenly darkens. But as much as we may want to blame the photographer for, say, "exploiting" his subjects, we can't shake the feeling that not only is Badertscher hardly responsible for life's inequity, but more importantly, that our recognition of this social injustice is courtesy of his work, that absent these photographs, these boys' lives and deaths—and indeed most of them were dead long before their time—would be completely invisible. A large percentage of these images are eulogies, as the photographer's writings attest.

ART DISRUPTERS #2, 2002

A casual glance reveals that Badertscher's models are the opposite of the professional models deployed by Bruce Weber and his ilk. Rarely are they classically beautiful; their bodies are seldom pumped and almost never gym-toned. Poverty is inscribed in their physiognomy, as are unhealthy habits. We see intravenous needle track marks as well as some images of active heroin injection—not to mention smoking, drinking, and other abuse. The subjects are the opposite of healthy and wholesome, the cultivated image of American beauty generally encountered in fashion photography. They are not only poor, they look poor, from their fashion choices to their habits, their bodies, haircuts, and teeth. Rarely has the white working class been pictured in this way, not as pitiful or stoic victims of their economic circumstance seen in the work of Walker Evans or Lewis Hine, but as proud exemplars of a marginal social class uninterested in either our pity or sympathy. Indeed, Badertscher relates that some of these boys were exposed to sex work by their own fathers, who had themselves earned extra money this way. Their working-class Baltimore neighborhood, cheek by jowl with the Baltimore Art Museum and Johns Hopkins University, was almost a mirror image of that privileged, tony world, and substance abuse, violence, crime, and poverty were its chief defining traits. Badertscher was himself a very heavy drinker and smoker, and his models saw a reflection of their own compulsions and dependences in his equally casual relationship to personal health. For much of the period of his best photography, considerations of safety were far from his mind. Indeed, he made no bones about his own addictions, and their frank acknowledgment might very well have deepened his models' comfort with him.

It is a familiar artistic trope, this pathos of the good-at-heart sex worker trying to make the best of a lack of options, but Badertscher takes it one step further; he balances this depressing picture of Baltimore's social reality with the countervailing utopian promise of his subjects' refusal of preconceived definitions, rules, and categories. What emerges is a deliberate paradox, albeit a familiar one. Those most weighed down by need are also the most likely to violate social strictures, directives, and decorum. Thus the paradox animating these images is that these pictorial paeans to agency, autonomy, and aggressive social dissidence were born of poverty, marginality, and a distinctly classed notion that the body was the only engine of value its owner possessed. Yet out of that contradiction,

4. See Lucian Truscott IV, "View from Outside: Gay Power Comes to Sheridan Square," *The Village Voice*, July 3, 1969.

Badertscher nonetheless locates and celebrates the pioneers of a still-nascent social order where the seemingly rock-solid binaries of gay and straight, male and female, cross and recross until their polarity shorts out; what's left is the visionary promise of the world Badertscher knew before 1969, before "gay" was pried out of sexuality and hounded into its own small corner of the world.

But it's a complicated political and ideological admixture, this mingling of real need—the very obverse of freedom—with the depicted image of freedom from convention and social expectation. Perhaps that's why a consistent aspect of Badertscher's photographic practice is self-portraiture. Only rarely does he depict himself solo; most often he images himself in a mirror in the act of photographing, or more rarely touching, his models. Sometimes they sit on his lap or recline at his feet. Other times, though he includes his own image taking the photo in the mirror, the real pictorial node is in the interaction between these two figures, one ostensibly the photographer. The mirror itself is hardly pristine, and its scars lend a different aura to the reflected image, as if it's both part of the real world and yet also an otherworldly place outside of it, one where internal scars are externalized.

Generally, in these images, Badertscher is as nude as his models, and narcissism is clearly far from his mind, for his older body and frame are in notable contrast to the rest of the youthful figures in the photo. But his reflection does two kinds of important work. First, it challenges the trope of the privileged tourist gawking at the less fortunate by making the photographer a participating observer, a subject of our gaze no different than any other model. Second, the mirror itself acts as a kind of surrogate for the viewer, a reminder that what we're seeing isn't "real" but a crafted staging, complete with its stage manager. In the photograph, the real world's clear, rigid, and defining social hierarchies are stretched and challenged. Importantly, this happens at both the level of simple representation, and at the more abstract, metaphorical level, where the photographer reveals himself to be even more abject than the models he hires.

Amos Badertscher's young adulthood unfolded in the context of the social foment of the 1960s, although of course Baltimore was hardly San Francisco. Still, youth culture helped to make homosexuality, at least in urban contexts, not only increasingly visible, but increasingly accepted. Among hippie young men,

accepting another man's erotic overtures, whatever one's usual desire, was practically an ethical imperative, lest one appear irremediably straitlaced and square. At that time, normative masculinity was keyed to the military, and by extension, to the unpopular war in Vietnam, so hippie culture favored feminized or form-fitting outfits, bright colors, long hair and patterns, face paint, glitter, and eroticized sartorial codes such as a bare midriff that had long been the exclusive property of straight women. To be a young man in the 1960s then was to understand masculinity as less defensively constructed than before, with an ethos of openness to erotic experimentation. But this same acceptance of sexual diversity in youth culture met stiff social and legal sanctions from society at large, and it was that very backlash that gave rise to a nascent gay liberation movement, one which culminated in the Stonewall riots of summer 1969, riots that caused queers to have, in the words of Allen Ginsberg, "lost that wounded look that fags all had 10 years ago."[4]

The rise of Gay Liberation was the final nail in the coffin of this amorphous, demilitarized zone between gay and straight. It meant that men like Amos Badertscher could no longer entice good-looking young men to pose nude for a little coin, for now the act of so doing was branded as unambiguously gay. Hence, he saw this development as a tragedy—one, as I've argued, his life's work has been dedicated to undoing. But on the other hand, Baltimore was unusual among American cities in hosting, a relatively unchanged, very old model of a hustling subculture, long after most American cities had policed it out of existence. In Baltimore, even as late the beginning of the twenty-first century, there were certain parks, squares, and streets where young men looking to make money could find willing clients. So, in his photography, Badertscher did the logical thing: he simply switched from young men who were more or less of his own social class to poverty stricken, marginal, drug-addicted youth with real monetary needs. And as he began to newly explore the social underclass in the post-Stonewall world—a culture that, as a scion of a middle-class family, he never knew—he developed an intense combination of erotic and social interest in its inhabitants' lives. But more than that, through art, he glimpsed a means to turn back the clock, to refuse to reify sexuality and gender as the ground of a defining difference among people, but instead stretch these categories to include all variations. Badertscher once photographed a man's asshole such that

his body hair assumed the familiar triangular shape of a woman's genitalia. It is a delirious image, a dangerous image, for it acts, like most of Amos Badertscher's work, as a solvent to the essential coordinates through which most of us, gay and straight, continue to live our lives.

IMAGES AND STORIES
PART ONE: VISAGE

Directly in Front of You-Know-What, 1996

Self-Portrait, 1974

I made my first Self-Portrait in 1974 when I was 38 years old, and I looked pretty good and just beginning. Back then my photography studio was right in front of me: an empty white wall, a large white sheet on the floor. Lighting, a gift from the Sun, but only between 10:30 in the morning on a bright day and 2:30 in the afternoon. Most of my street models slept over. I wasn't about to be hunting them down very early in the morning, and especially with a bad hangover from the night before and I didn't trust them to show up where and when they were supposed to. All of this wrapped up into one package was my own private Art School. Thank God I never set one foot in a real one where, naturally, they would have tried to "straighten me out! " Get me off on the "right foot," as they say! Whose foot? The right foot! Try telling that to Jackson Pollock, even on a good day, and be prepared for a little excitement!! So, my vision was never corrupted! I got a little help from some professionals in the photography stores I went to. Also, by reading every page of the "Time Life" series on Photography: all 12 volumes. Now there you go!

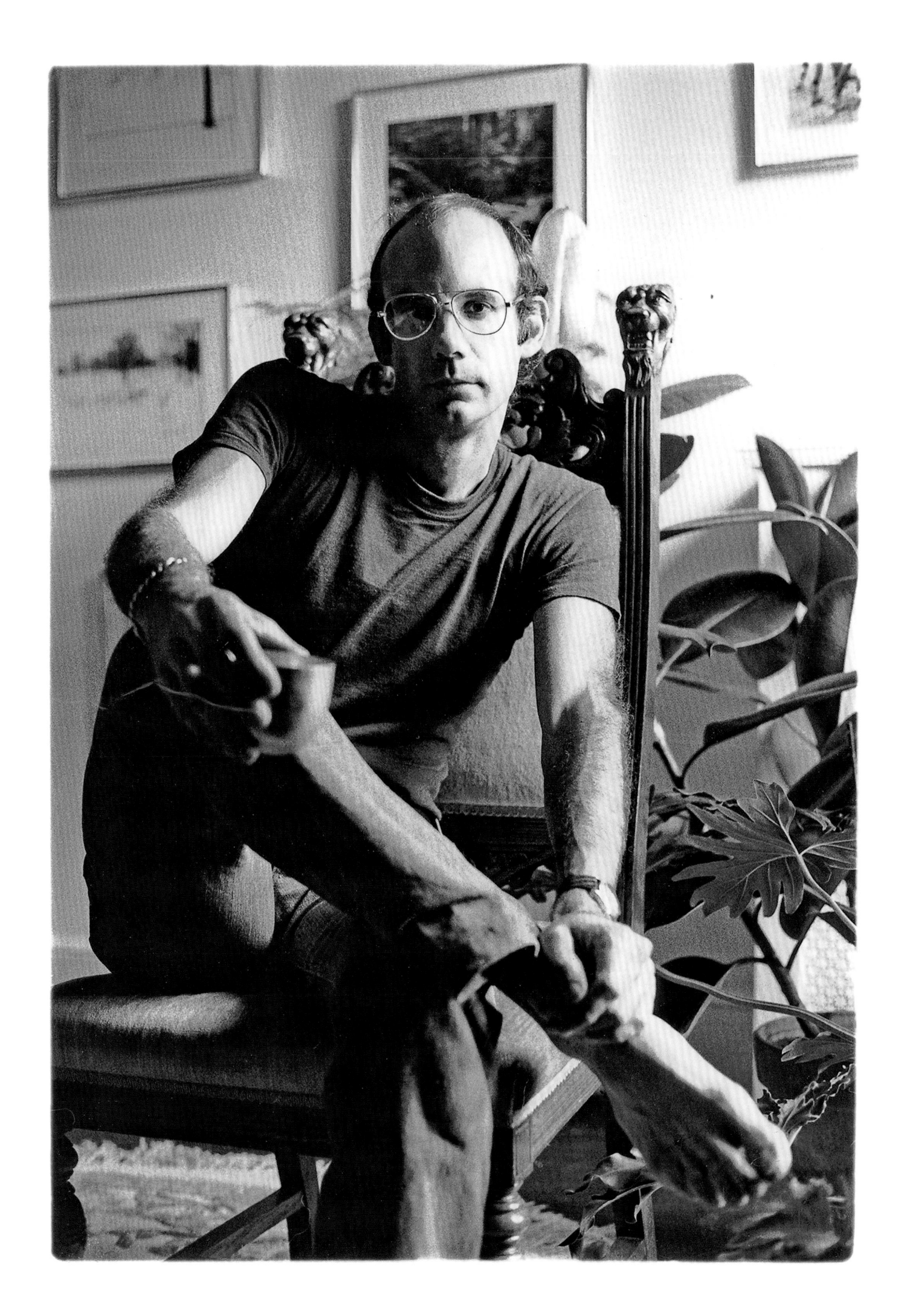

Hey Lost Boy, c. 2001

This greeting on the pavement, close to and almost under I-95 (Baltimore-Washington). My 2 models that day, Danny and Victor, walking about 10 yards in front of me. This now was the land of the homeless, drug addicts and villains and the legitimately disaffected. Thank God I wasn't one of them. Yet! Baltimore was a city of slogans, eagerly encouraged, wisely or not, by a very popular and dedicated Mayor, Martin O'Malley. "The Best City in America" is my favorite. It was too easy to laugh your guts out with that one.

A year later, it was followed by "Charm City" and "The City That Reads." Sweet Jesus! and each one of these things painted carefully and brightly on every transit stop bench so that any visitor or conscious citizen couldn't possibly miss them. "Best," "Reads!," But what city was he really talking about? It didn't make sense. Was there another city named "Baltimore" in America or Disneyland I was missing?

I knew one or two things about American cities, even about Hollywood, the canyons, the open prairies, the bee-loving, hamburger-eating black bears, the Eastern Shore soft crabs, the sunflower Bees, the body lice and bad teeth, the junkyards reaching to Heaven, the squidgy islands of colorful indestructible plastic as yet unnamed, unmentioned as yet by the Travel Agencies! Endless bottles of "Sun Screen." "Roy Rogers" franchises, Gabby Hayes, and the "Cowboys," most of them infected, smelly, and "freedom loving!!" Ahh! "Freedom Loving!!" and Oh Boy! you know what that means! The siren call of the "National Rifle Association" even after all the mass shootings and school killings that just multiply like a virus or a Jack rabbit on steroids! The kindergartens next?! Even after there's no human being left on the planet to do the shooting!

It would take a brave dedicated soul like Dr. Alfred Kinsey, decades later on, to straighten it all out, academically speaking, of course. Somewhere between all this and the mayor and his city, I learned that now there was a small gang of psychopaths in this very same industrial wilderness and right under this interstate, who were killing some of the homeless people, when, according to Martin O'Malley they should have been reading. But don't ever think that the homeless are harmless! "Man!" Quickly, I ran back to read once again a few of the slogans that had been so carefully painted on all of the transit stop benches just to make sure and, Yes! they hadn't gone anywhere, nobody had changed anything, the slogans were still not making sense but at least not peeling or anything. I was about to give up but then I remembered: mayors and slogans just come with the cities and shopping malls, there was just one Baltimore City in America, thank God!

Queer Studies—When Ignorance is Bliss, n.d.

In the '50s, '60s and '70s hitch-hiking was the coolest and the fastest way to get there, to California or just a few blocks or a few miles down the road. On one side it might permit more readily a sexual adventure without the danger of being defined as "homosexual" or "queer." These were the days when there was no sexual identity to worry about, Period! You just did what you did and not tell anybody about it. Some however did and just brought them along the next time. But just a little after "Stonewall" the shit really hit the fan in America. The new words were "fruit," "faggot," "homo," just up America's alley. A Puritan culture always needs fuel, something new to get hysterical about. Even little kids fighting on a neighborhood street corner used them. The death knell of hitch-hiking! By the way, "thanks Stonewall! Thanks a lot!"

Sometimes while doing this, the hitch-hiker was offered an opportunity to make "a little bit of extra money" or even just a full pack of cigarettes. Allowances were not there or never enough. If the driver looked pretty "normal" and "safe" they usually asked, "How much?" About anything was enough. Nobody else would know about it anyway unless you told them and many did. If it was in a small community like Towson, you'd find that some of their friends were willing to check out the same "opportunities."

But unfortunately, all this was gradually changing and then by the end of the '70s, disappearing entirely, at least in Baltimore, anyway. And these just happened to be the very same years that the "Queer Identities" were being more clearly defined and it was becoming more obvious to most American males that they now had a choice, you had to be either "this" or he had to be "that" and you sure as hell didn't want to be "That!" But remember, these were still the years in America before the forging of the new gay identities after Stonewall eliciting a Pandora's box full of unintended and unfortunate consequences.

After college, I lived in the "maid's room" in my mother's house, brought a few hitch-hikers home and took Polaroids. Although my mother would meet some of them from time-to-time, she had no idea what was going on in my room.

Identical Twins, Mid-1970s

Their spot was always on the wide steps at the corner of Baltimore Street and Patterson Park Avenue. Late at night, sometimes alone and other nights together. From even a slight distance it was impossible to tell them apart. Except by the color of their eyes; one of them green-eyed, the color of Hope, and the other one a deep blue, the color of angels. Price about 5 or 10 dollars, depending. STOP! Discretion advised!!: As soon as one of them got in the car, one of his friends on the street shouted, "Don't forget to get Blowed!" Rating: ?

They never spoke unless spoken to.

I Met this Slight Boy in Mary's, 1977-98

I met him in Mary's, a bar owned by Cal Shuman, a local celebrity who also performed fantastic comedy shows some weekends and one of the very best friends of Tallulah Bankhead. He was sitting with an older gentleman, a dumpy working-class man from Hampden, because that was the only way he could get in. Hampden, the site of the John Waters film, "Pecker." He told me later on that sex was more than plentiful in this supposedly "straight," blue-collar, working-class neighborhood. I believed him. Still, he was harassed in his own neighborhood. When he showed up for his first photo session, he said that the cab driver had tried to pick him up. I didn't ask him but I'm sure he'd already made a date. At 15, he hustled the Wyman Park Dell, just across the street from the Baltimore Museum of Art. At 17 he tried to obtain breasts and then adopted the name, Marilyn Mansfield, I guess he was trying to cover all bases. When old enough she began working at the Tic-Toc Club, a topless Go-Go bar on the Baltimore "block." And said he was much more popular than the "real girls." She befriended and then worked for Blaze Starr at her Two O'clock Club just across the street from the famous "Gayety" porn theater for about 6 years. And all this stuff just a few blocks up from Central Police headquarters. Blaze, of course, was nationally known and a celebrity and one time said she had had a "quickie" with "Jack" in a closet.

 Eventually Marilyn acted in adult sex films both in L.A. and NYC. Now, in 1998, she lives with her "red neck" boyfriend in Hampstead, Maryland, way north of Baltimore City. When I asked her how does he deal with the "sex thing," she said, "Oh. He never goes down there."

Drugs Were Never Part of the Equation, 1967

Luis was quietly sitting on a corner step of what looked like an entrance to a liquor store along Fleet Street. Fleet was just one block away from Eastern Avenue and Patterson Park, the 2 busiest meat racks on the east side of Baltimore City. Working-class hustling was so ubiquitous and especially on weekends and so uncomplicated and rarely danger-ous and so much a part of working-class neighborhood tradition dating way back before Lincoln. The police tried to ignore it when possible. They probably knew some of the boys anyway and were known to expect favors. The average age of the boys was about 17 and most of them just wanted to make a little money for the weekend. In these years street drugs were never part of the equation. Some just wanted to be or needed to be out there for various reasons. For a while the price might be a deuce or a little more, a pack of cigarettes or just the sexual adventure: for fun. Working-class life could get pretty bor-ing. Most parents just didn't care, some glad to get rid of them and they had too many other things to worry about even if there were 2 of them.

Some fathers and uncles had probably hustled the neighborhood streets before. It was all pretty uncomplicated for so many years in this city. Baltimore was not NYC or another big city where all the "needs" were much sharper and survival primary. All the politics and the confusing unnecessary burdens of "sexual identity" had not yet been invented as well as the words "exploitive" and "victim" and "predator." But this was all coming down too quickly and especially after "Stonewall" and slowly forging a sexual hysteria and the destructive "guilt" of a Puritan culture: The death of street hustling, the death of hitch-hiking anywhere.

Saturday Night, late '60s

David was hanging out on Baltimore Street across from Patterson Park, a prime hus-tling area. He lived somewhere in Highlandtown with his father, a man who had once worked in the Baltimore shipyards before they left town. And when these major employ-ers left town and went overseas, they took all of the life-time occupations for fathers and sons and the excellent company retirement plans with them. All the Baltimore distinct working-class neighborhoods with the gleaming white marble steps and obses-sively clean streets, never recovered.

David sometimes had a girlfriend although not often. But this was a hot Saturday night and he had nothing to do. He just wanted a few beers and a good time. But these were the late '60s and same sex contacts were still very o.k. and well before the "gay identities" were invented and were tightening their grip all over America. Everybody would now be defined as either "straight" or "gay." The beginning of the end.

A Nice Arrangement, c. 1985

This took place sometime in the late '80s. in one of Gary's houses. It's possible that he had met Paul in a gay bar and then suggested that Paul (or whomever he was or whatever he was, usually living with one man or another), live with him for a while as he restored the house. This was possibly the best offer Paul had had in a long time.

He was a nice boy but jumpy and you didn't want to surprise him in a bar by tapping him on the shoulder from behind. One of Paul's small jobs was to feed and generally look after a large, damaged cat named "Orchid." The white plate on the floor to his right by the elegant sofa contained a few unidentifiable objects and some fossilized small dark stuff which was hard to ignore because it was foul and a foolproof invitation to the usual number of small day creatures in Baltimore that came with the house and then replaced a little later on by a whole passel of small night creatures and each one of those bugs just loved this arrangement even better than Paul.

Odalisque, 2003

His initials, "PCP" were inscribed on his chest if you look closely, the last of the reclining Odalisques on the east side of Baltimore City in 2003. He was peaceable, erotic, fluid, not armed and dangerous, cool, carnal, accommodating, relatively slim, far too casual, somewhat dependent, and lazy. He moved when the Spirit moved him to move.

The hustlers all lived in Baltimore City and after a while I felt like one of the family. Take nudity off the porn racks and put it where it's unexpected, it's shocking. Why not put something new in your bedroom tonight!

A photograph is always a kind of oblique self-portrait, which simultaneously shows reality and the person who is recounting it. You could have fooled me! You experience countless moments of joy in your private life today.

Glasses Carl, 2001

Carl was called "Glasses Carl" because as a kid he wore glasses in a working-class neighborhood. Soon after Carl was moved to Ohio with his mother, he got bored and just wanted to return to Baltimore, hook-up with his stepbrother, Bonzo and all his old buddies in the neighborhood. So, somehow, he managed to get back to Baltimore, but it wasn't 6 weeks before the "Home Detention People" found him, and it was off again to Ohio.

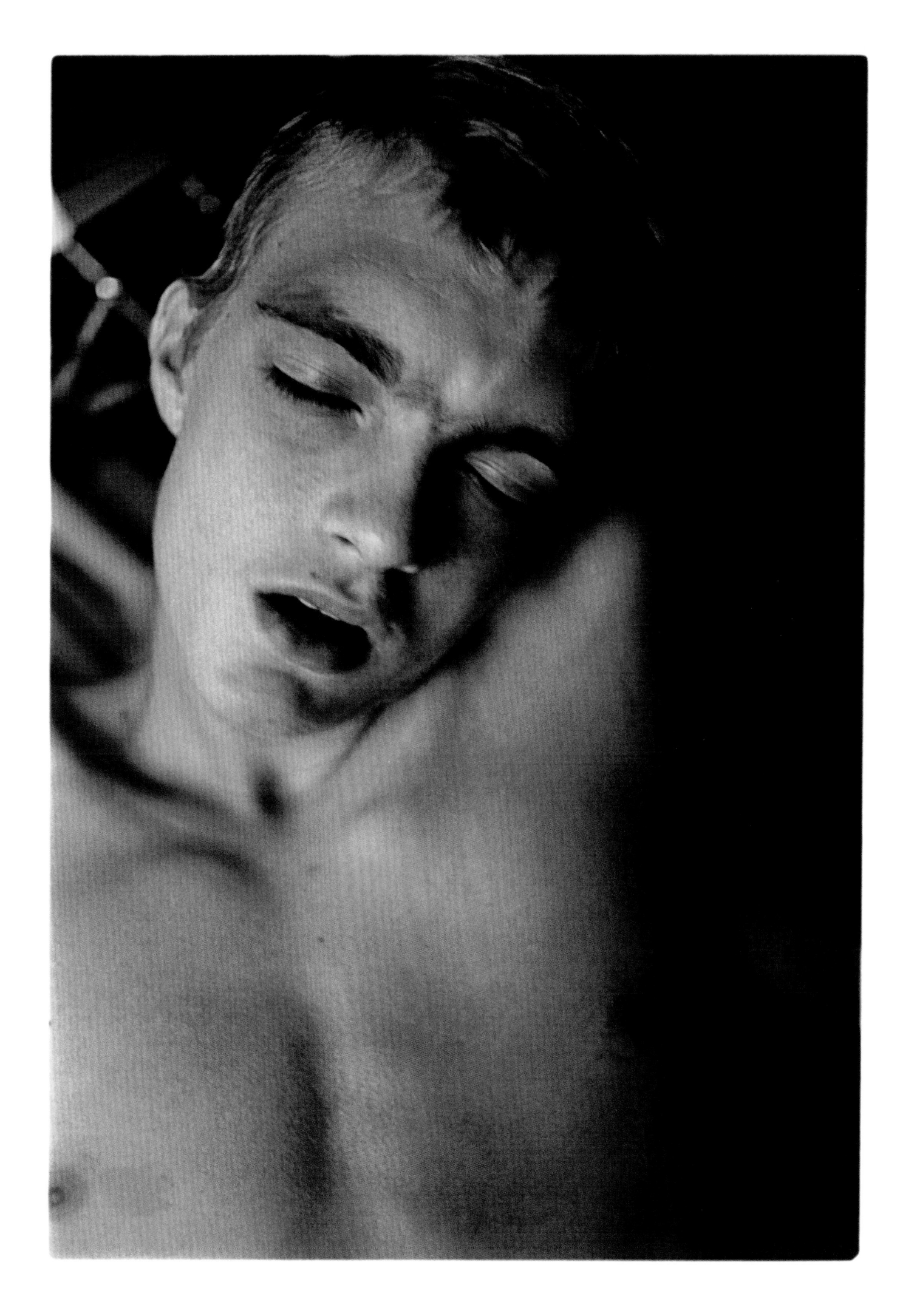

What About That One?, 1975

Todd had too many personalities and the lightest fingers in Charm City. He lifted a window curtain right next to me and I never knew it until the owner of the apartment pointed it out. He always carried a big white bag over his shoulder and holy crosses and the sacred implements of the Mass were never safe. Thank God "Miss Toddles" never made it to Rome. But Todd was an early genius of thrift store chic and the Roman churches had too much stuff in them anyway. I took him to dinner and at some point, all the glasses on the table began disappearing until only this large glass pitcher of water was left. And I said, "What about that one Todd?" Ha! I was dinning with a master. But for a restaurant that kept its cash in a cigar box I guess paying attention to the glassware was not a priority.

Abandoned by his mother at 10 years old and the lonely product of a children's home, his was an outrageous fantasy world, manipulative, cold, and inventive. Todd was on the streets of Baltimore like the Mt. Vernon meat rack, pocketbook, and makeup, hustling for drugs, cash, and sex before he was 14. Here he is in 1975, at 21. Todd's life became increasingly violent and erratic (and what part of his life wasn't erratic) through drug and alcohol use and he died of AIDS about 1986 and not too many people, including Todd, gave a shit.

One Hippy and the Witch, 1972

Slim hippies were still around in the early '70s.
One of them sunning against some rocks in a reservoir.
Below him a beautiful clear river, holding
a few large, green, moss-covered snapping turtles.

The very beginning of summer 1972, I had just quit my job of 9 years teaching in a private school and I ran into this boy, a hitch-hiker along York Road coming out of Towson, an obvious hippy. He was wearing a tall black stove pipe hat like President Lincoln, a long, elegant earring in his right ear, the guitar of course and his jeans an infinity of colorful patches that looked like something put together by somebody's godly rebellious grandmother on acid. All of this an extravagant indicator of the disaffection and protest of the late '60s and still around in the early '70s. Sexual ambiguity in addition. No wonder he wasn't getting a lift.

His name was Tom and he turned out to have been an ex-student of mine I had taught in the 6th grade in 1966. He had just graduated from an elite well-known military school, just north of Baltimore City. It was no wonder he had been sent to a military school by his hardly amused family as his last name alone was known all over Towson and certainly in Baltimore.

This was his first summer of freedom. Fortunately, whatever a military school was supposed to have done to him hadn't worked. Now he was hitch-hiking nowhere in particular, so he ended up living with me for about 4 weeks. In the process he now became the very first nude subject I had ever photographed outdoors.

He had suggested a large field in the county surrounded by woods just south of Goucher College. An old girlfriend had taken her dates there on weekends. Today, that same field is the site of a massive office and condo complex and just across the street from an even more massive shopping mall. America was well on its way to becoming just a country attached to a shopping mall.

Another photograph was made a few days later in the derelict old Fishpaw residence in the same neighborhood where my own family was still living since 1939. In the late '40s Mrs. Fishpaw was still living in it. By then she was old, gnarled and ugly, could barely walk and all the kids in our neighborhood thought she was a witch. So just like in an actual movie, behind the bravest boy in the neighborhood we all walked up the 28 cement steps from the road to the house and knocked on the front door just to see.

Tom was hitchhiking. A black stove pipe hat, totally patched jeans, a large beautiful earring in his left ear: "A Hippie."

"The Hippie" 1972

It turned out i had taught him in the 6th grade at a private school in Baltimore County. He had just graduated from school & this was his summer of freedom. Nowhere to go so he stayed with me 4 weeks.

An Unfortunate Success Story, 2002

Andy G. had an exceedingly miserable middle-class life in just one of the uncountable ways that only a middle-class life in America can be miserable. He skimmed through a number of public schools and was finally sent to a private school in Baltimore in the 7th grade and it was there that the academic and the athletic miracles were supposed to happen.

But the chief accomplishment on the agenda was for him to become a top lacrosse star like his very abusive father had been. His father was always telling him almost every day, how worthless he was and how he would never measure up. His grades were miserable, and he hated lacrosse and was asked to leave after one year. Once officially out of school he began using and selling pot and other drugs at rock concerts around the country. "It started with pot, then 'ecstasy' and I found my passion with OxyContin. I loved that doped up feeling and before I knew it, I was constantly down. It never seemed like a big deal because I always had so much money but soon it took its toll. I ended up getting about $54,000 stolen from me by a close friend."

Finally, he came back to Baltimore, broke, in 2002 and now living with his divorced abusive father in an east side working class neighborhood. In no time at all he found the nearest gay bar, Quest just a few blocks away and right away began aggressively hustling men, never taking "no" for an answer. And he found a couple of really good ones. He spent a few more years in Baltimore, hustling, selling, using and "copping" on "The Hill," which was the north side of Patterson Park and what seemed like every hour, every day, while living with some older man in the neighborhood. At this time, he wasn't even sure if he was "straight" or "gay."

Soon he was getting arrested for very aggressively hustling Eastern Avenue, even in the middle of the day, loitering, prostitution and once resisting arrest and spending nights in the Baltimore Detention Center, accumulating a significant rap sheet. Other than that, he was pretty bright, very confused, very aggressive, fearless, frenetic, inventive, charismatic, and totally fucked up!

So, in a few years it was getting too hot for Andy in Baltimore and with a warrant out for his arrest, he split for California and couldn't safely return to Baltimore. Once on the west coast, he somehow managed the seemingly impossible and got off drugs, put his natural aggressiveness and his knowledge of using and selling brilliantly to work, eventually creating a very lucrative enterprise, growing and distributing pot. Now he had more money than he knew what to do with!

It did appear that finally he had it all together in spades. He was even planning to legitimize his profits and open a fleet of "sno-ball" stands and there was no doubt that he would succeed brilliantly at this enterprise too. Now he was making plans to marry his girlfriend, by anyone's definition, a nearly impossible "success story." But, even now, his past life proved a template for death. Two weeks away from the ceremony he died of an accidental overdose, probably a mixture of fentanyl and heroin in April of 2012 at 30 or 32 years old.

Gary and Dennis, 2004

Many boys on the east side knew each other or had served time together in "Juvi." Gary had just gotten out of "Bookins," the "Baltimore Detention Center." He was there for missing too many dates with his probation officer. No accidents, no distractions, no catastrophic catastrophes! "The blindness of Fortune," Dante 1300.

If "Fortune" is not blind, it ceased to be "Fortune." Dennis was a good friend. They would tell tales about each other. Gary had just gotten a large tattoo just between his belly button and his pubic hair: "Menace!" If you "KNEW" him as well as I did, you'd understand why! You can see just the tiniest fraction of it peeking out from under Dennis, on Gary's right side!

The Two Mikes, 1998

"OK…Mike, now listen…just move your body a little bit forward…just a little… tighter…
OK…good…just hold it. OK, now, look a little mean…no, …that's too mean…just look
a little more serious…you know, like you're really going to torture him a little…you're
thinking about it…ok, both fingers on the tits too…perfect!…just keep your fingers
there…all right…now wet your lips a little…ok, good. Now just hold that…now Mike (the
second Mike the one below) …just look at me and I want just a little smile…no, just a lit-
tle bit less…like you know in your heart that you are going to be really tortured…but you
don't want him to know that…just thinking about it…ok…perfect…now wet your lips
a little…ok…now don't move…just look at me…ok… right at the lens…OK, hold that….
(CLICK!)…all right, fabulous! You guys are too much."

Great Bird Man, late '70s

Ken and his older brother Victor lived in a slim row house on Miles Avenue in Remington, a small working-class neighborhood about 15 minutes away from Johns Hopkins University. He was calm and peaceable, and he and a few friends had built a small hideout in a big gulch by the railroad tracks so they could hang out together and do their thing and mostly get away from it all if they wanted to. These were the years before drugs had arrived to ravage the city and street relationships were so much easier, less conflicted, less desperate. Less guilt too, before the emerging "gay identities" began to take hold.

Later on, the house he and Victor had lived in, along with 2 others, totally collapsed: a harbinger I suppose. The land they had been on is now, in 2017, a little vegetable garden.

The Abandoned Body Shop, 2003

What a great title. It sounds just like a title of a poem from a last collection of poems by the Greek poet, Cavafy. But it's not. Instead, it's an old building, destructed, lost in the vast wastelands of west Baltimore.

 Under the interstate I-95, Baltimore in one direction and Washington in the other. You can go in two different directions whenever you needed to but not at the same time, it's a problem. A place where murders happen or at least they try to and where street prostitutes from Wilkens Avenue bring their "johns" for a quickie and one time I saw a girl spit it out through the open car window. And all of this checked out rarely by Baltimore police.

A Divining Rod for Disaster, 1998

Sean lived with his mother and her boyfriend and two brothers in Brooklyn. His mother was well-meaning but always working each day and it was impossible to control the lives of 3 adolescent sons, a 4th already in jail. The house basically belonged to him. Sean had this uncanny ability of hooking up precisely with the wrong kinds of persons—like drug dealers, check forgers and pimps, some of them doing an occasional burglary on the side. Sean had almost died at 19 of alcohol poisoning.

He had a sleeping pad in the basement to use when he came in late, meaning any time before noon. Sometimes he just stayed briefly with an older man. Already he had tried robbing a few houses in the neighborhood. One time when the police were called and found him, he couldn't remember where he was or how he got there. Now addicted to drugs, sometimes heroin, he still continued to be with his buddy Billy to score and use drugs. In 2004 or 2005 his mother's brick house on the east side burned to the ground.

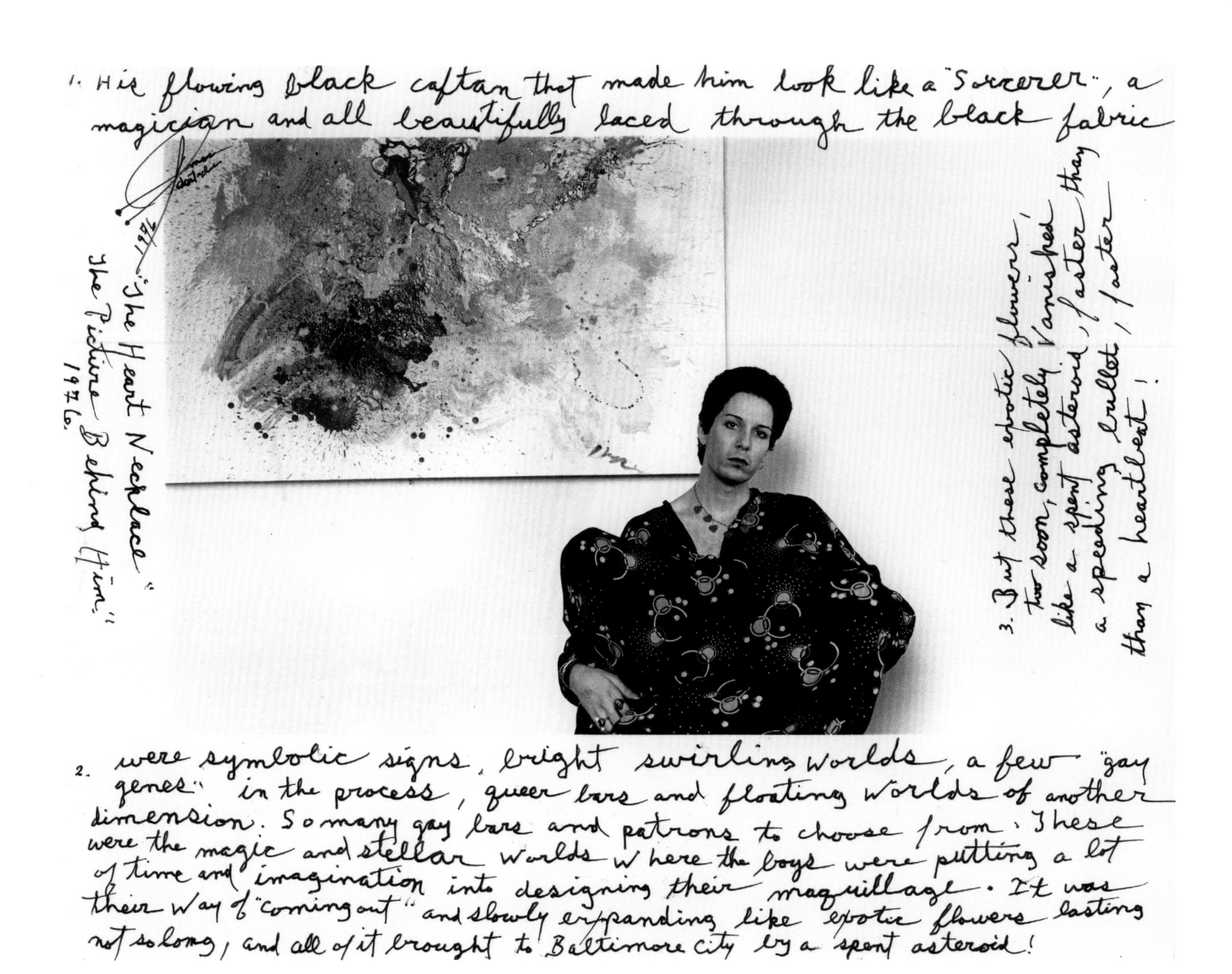

1. "His flowing black caftan that made him look like a "Sorcerer", a magician and all beautifully laced through the black fabric

"The Heart Necklace" "The Picture Behind Him." 1976.

3. But these exotic flowers, too soon, completely vanished, like a spent asteroid, faster than a speeding bullet, later than a heartbeat!

2. were symbolic signs, bright swirling worlds, a few "gay genes" in the process, queer bars and floating worlds of another dimension. So many gay bars and patrons to choose from. These were the magic and stellar worlds where the boys were putting a lot of time and imagination into designing their maquillage. It was their way of "coming out" and slowly expanding like exotic flowers lasting not so long, and all of it brought to Baltimore City by a spent asteroid!

The Heart Necklace, 1976

An early subject for my camera in the mid '70s Larry was so quiet, a recluse. He lived on the 2nd floor, a pharmacy below him where he worked a few hours a day in lieu of rent and right across the street from the busiest corner of the Mt. Vernon meat rack including all the young boys who worked there and the slowly circling cars. He rarely left the building. When he did it was mostly at night in order to get to the Hippo, or maybe Leon's.

Otherwise, he was as gentle as spring violets. He always wore a large brown delicately flowing caftan wherever he went with large galaxies sewn into it, exploding stars and crab-like spaceships. He also wore earrings, lots of rings on his fingers and always his cherished gold "heart necklace" that followed him everywhere. But now for a time he was living with this guy named Chuck, a self-obsessed, volatile, deluded painter who imagined himself the next Clyfford Still, money and fame still on the highway. It reminded me of the film "Man of Flowers." It was that day Larry showed me a large, messy-looking wound, thanks to Clyfford Still; a swollen dark purple bruise on his left arm with touches of red, violet and orange, just whispers of cinnamon and saffron.

A Philosopher, 1976

The good Elliott. One of the true Baltimore crazies. Like Diogenes, he had his physical and metaphysical problems. He was a shrewd and successful antique dealer, his shop on South Charles Street. It was his price or no price. He was difficult, alienated, and reclusive and only somebody as crazy as he was could deal with him.

Unlike Diogenes, Elliott's living quarters were untended and falling apart—a slightly collapsed environment. Inside it was pretty dark, water-stained walls, small holes in the flooring, leaking appliances. You just had to be careful. You had to be living on or near the margins in order to be invited to see it. Like Diogenes he was bitter and caustic and so in conversation you had to be careful. His displeasure was for life. One afternoon I said something wrong to him innocently and from then on he never talked to me. To say something wrong to Elliott you didn't even have to try.

Near the end, his mind began making those windy detours so familiar to the intelligent and inspired paranoid. He dropped dead the summer of 1989 at 53 of a heart attack, his mind fortunately unencumbered by conventional moorings. He wasn't found for a week, and I never heard about it.

An Obsession, 1976

In 1976 I was 40 and the one thing in life I was always looking for and never found was a genuine boyfriend. Too many attempts and too many failures. Too many bouts with depression. I'd counted. Then one night in 1976 I had just walked into the Hippo in my usual condition and right there on the dance side was this boy with a small group of friends, I guess celebrating after a poetry reading. It didn't take long for me to convince him to "Let's go someplace else." And we did. Keith played the piano in a small group of musicians and tonight had a gig in the county, so we went all the way out there to hear him.

His name was Ken and had an Italian name meaning "little town," I think. He lived in a small town in New Jersey, so there you go. He was in Baltimore studying writing at the "International College," whatever that was. In a few months this program would take him to Ireland for almost a year and then to London. It would be a long while before he'd return to Baltimore.

Of course, I was obsessed and depressed and I wrote him almost every day. I even flew over to see him in 1977, my first jetlag. When he finally returned to Baltimore, my nerves were a mess. But Baltimore, it appeared, could not contain him. His future as a writer was not to be in Baltimore or with me. He only wanted to live in San Francisco, a city of gay men. Apparently, he needed that. He left me with a thin pamphlet of 4 of his stories, each not more than a long paragraph, really. Book #16 of 75: for Amos, love Ken. And as he liked to say, written by "a boy with a small voice." But you can't be a successful writer and write anything with a "small voice." More like the reverse. Eventually, at least, I drove him to the Baltimore airport. When he boarded and I just watched his plane standing there as if in a dream. It was only 20 minutes but more than enough time to stare in disbelief at what I was losing. When it left the runway, I kept staring way beyond the point when there was anything to stare at. Well, the year was about 1981 or 1982 and I was a few years older and never saw him again. But these were the very years when another "gay disease" was just beginning to claim its first victims. In the beginning I just thought that somehow there would be a new medicine to take care of things, yet again. But there wasn't and now Ken was living in a whole city of gay men. And his habits were not going to change any time soon.

The Guitar, 1976

Billy just showed up on the Mt. Vernon meat rack, early summer 1976. He was now living temporally with a man in a Baltimore high rise, "Sutton Place" but other times with a friend. But you could usually find him each night in the same areas around the rack or close to Leon's, looking for a pickup after "last call." He always seemed to carry a guitar with him over his right shoulder. That guitar was like his very soul, his only true friend and constant companion in a lonely and loveless life. He was around most of that summer and then he vanished as quickly as he had arrived.

Time Travel, 1983

Take one glass plate negative made by the famous German photographer, Baron
Wilhelm von Gloeden in Taormina around 1898 or 1901. Take time and carefully reprint
it and it will look exactly like this one. Now no traces of ageing or the brownish yellow-
ish colors of dying leaves and now so crisp and fresh and friendly, you'd swear it was
made yesterday. You would never recognize it as one of the Baron's photographs at all.

A Love Life!, 1978

Keith's boyfriend at the time, Mark, shared this apartment in the south-east section of Baltimore City close to the Cross Street Market. He was a slim "punk" wearing tight-fitting black everything and often using the punk words "skuzzy" and "smarmy" and wanted to become a rock star. Keith probably met him at Leon's, and their relationship began right there. In time the relationship inevitably became chaotic and tense and sometimes getting physical because both of their lives were constantly borderline, chaotic, and intense. It never helped matters considering Keith's drinking habits and his penchant for sleeping around with any boy he had a mind to sleep around with. But there was definitely an upside to this madness in that it always supplied an opportunity for the exquisite, perverse, and erotic pleasures of making up. But a few years later Mark decided to move to New York City as the first step in pursuing his music career and when he had made enough money by working in a Borders bookstore in the west village he moved to London. The relationship was over. It was in London that he found out that he was HIV positive and at that time there were little to no effective medications available. And he died in 1992 at 32 years. Some recordings of his music might possibly survive. The punk words "skuzzy" and "smarmy" disappeared so quickly and now, along with Mark, are remembered by almost nobody at all.

He was Junior, 1973

It looked like he was allowed to go anywhere, any time of day and stay anywhere as long as he wanted to. Nobody cared. Where was he living and who was he living with? What was he eating?

The corner of Eastern and South Montford was well populated almost every humid evening and many days by enterprising boys usually on the front steps of a red brick, somewhat busted up, abandoned public school building. And I remember that all the windows on the second floor had been broken and some little holes in them like the size of a stone. It's amazing how such little things like that so casually noticed can trigger a whole raft of additional memories.

And now some Orthodox church has replaced the abandoned school building, a clear sign of atonement. It was 3 A.M. in the morning, one hour after "last call" in the uptown gay bars and right there at the corner at Eastern and Montford was a hand waving. "Looking for a hustler?!!"

Junior, out of school, was already into alcohol and glue. This was just before the drug epidemic hit Baltimore, the gay sexual revolution backlash and the resulting block-watches and police busts. Hustling in the old free-wheeling style began to dis-integrate—a reality no one anticipated, least of all the participants. By the end of the decade, it was gone.

Too many years later I would now think about the great Greek and Renaissance sculptors, Cellini, and Praxiteles, and where did they get their beautiful models? Their young apprentices, probably, or right off the streets and alleyways of the neighbor-hoods?! Remember this the next time you and your family travel to Florence or Rome.

He Never Lacked for a Place to Stay, 2002

He was one of the few survivors, miraculously, mentally, and physically still intact, of heroin addiction in Baltimore City—even although he had said at an earlier time, he would die a junkie.

Abandoned at 12 by a neglectful, abusive alcoholic mother, as she had abandoned all her sons to the streets, he survived very successfully with an older man in Dundalk. He had spent time living with older men, until, as he told me, "I got tired of their shit!"

His best friend, Tony, introduced him to the processes of hustling along "The Avenue." Later on, a step-brother probably introduced him to heroin and his girlfriend too. He always took pride in his clean, trendy clothing and flawless appearance. In a radically different environment, he would easily have passed on a prep school campus.

It took him so many years before he finally defeated all his addictions and from there on lived "clean."

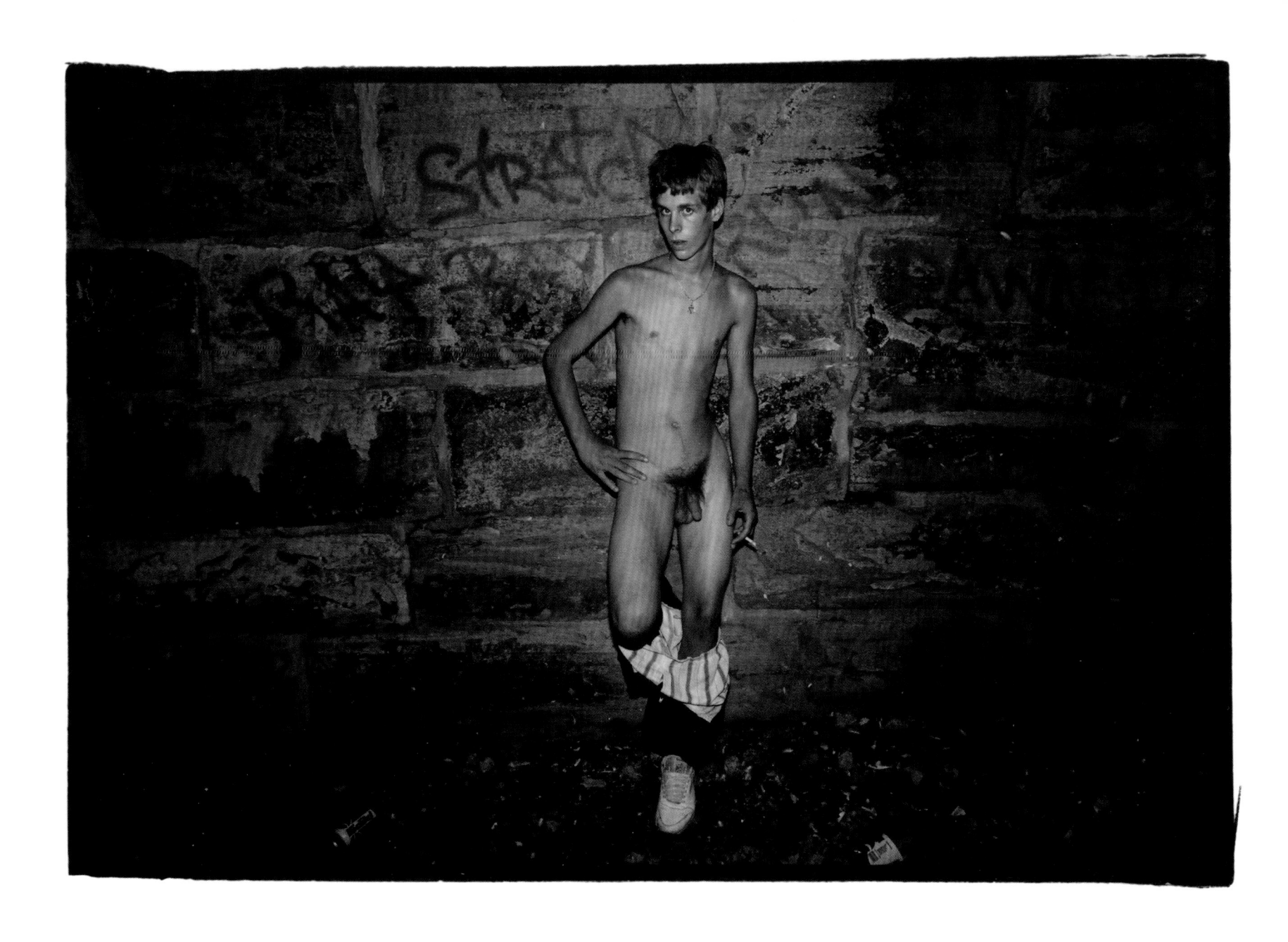

Wafting Away, 1995

By 1995 Bobby was living with his older sister just one block off Wilkens Avenue on the west side: a totally lost soul seemingly waiting around for the next thing to happen. His only concern was to get a little money to survive another day - constantly heroin. He would steal as much as he could easily get away with, or sometimes hustle along Wilkens, even rarely traveling across town at night to see what was happening outside 2 uptown gay bars and sometimes even along Eastern. Like so many street hustlers in Baltimore he never talked about a girlfriend and all his sexual contacts were seemingly with men. If anyone was interested in girls, you'd soon be aware of it.

It's hard to say just how much of his family Bobby had left or if he even had a coherent one to start with. He had begun by using glue inside the largest cemetery in Baltimore City at 12 and now it was heroin. Probably from the use of dirty needles he became positive, and I was told he was crying when he found out about it. As time passed, he became a slimmer and haunted presence, his increasingly prominent eyes desperately watching the cars coming along the streets at night as if his life depended on it.

Too Close to Wilkens Avenue, 1996

Bucolic setting on the Westside. Pastoral. Not crack but heroin had been the option.
Re-habs, jail, parole officers.

 Timmy was frequently found on varying corners along Wilkens Avenue in 1996. He
was calm and curious and knew everything that was going down in the neighborhood.
When I drove through in the afternoons he always waved and made signs to me with his
invisible camera; Click! Click! I knew what he wanted. I doubt if he had had anything
remotely resembling a home life and I never asked exactly how or with whom he sur-
vived. He might have used drugs. But everybody else in the neighborhoods knew Timmy.
A few years later I found him in a well-known east side gay bar, and he told me that he
had found Jesus. I supposed he was finally getting whatever was left of his life together.

J.E. and his girlfriend, 2001

It was pretty hot and J.E. and I had to wait right there on Wilkens Avenue for his girlfriend to show up from a date. She was good looking and popular on the streets, relatively together, a sweet personality and no detectable marks or anything like that. But unfortunately, this was more than enough time for two police to show up in a patrol car and ask "What you doing, John? On vacation?" (ha ha.) " No, I'm waiting for my girlfriend to show up." "What's she workin'? Haven't seen her." The police knew everybody on Wilkens, and everybody knew the police. And they'd always keep an eye out and get to know any new one coming along. Occasionally they'd have to arrest somebody just to keep a body on their toes. Needless to say, I was nervous because I had not brought my medications along and I had some important stuff to do later. Sometimes the vice squad would put one of their own out there on the corner and just wait to see what would happen and these girls all looked like they had just popped out of Playboy or like an upscale hooker in Las Vegas. You had to be brain dead to approach one. Shortly his girlfriend came along, and we were back in business under Interstate I-95.

Born 1984, 2003

Shane had just been released from a detention center in another county for robbing a local convenience store, in the snow, in his own neighborhood. The tracks led straight back to his older brother's apartment, two blocks away where he was staying because there was no place else to go.

Just outside the front door it was the drug zone; prostitution of both sexes, during the day; muggings, a few killings executed at night. It would have been a blessing to fall off the edge of the planet, which was exactly what he was afraid of.

The local police knew all the neighborhood boys and girls by name: "Hey John! Why are you standing on that corner, you on vacation? And where's your girlfriend? What's she working? (not a question.) Tell her we miss her. OK!" Sometimes the boys would chat with the cops, the enforcers, at the curb through the open cruiser window. Mostly gossip, slightly proud of this apparent relationship. Always hoping for something real dramatic to happen. To somebody else. Usually, they didn't have to wait long. What else was there to do over here, anyway. They were all neighbors. Life was always out on the street.

Shane's life had been all about abuse and absolute neglect; like his father was a violent alcoholic, very physically abusive to his mother, but at least he was no longer around anymore. Shane had been hustling in one way or another since his early teens, but not only for the money. It was also about getting some attention, maybe a little love, a search for a structured and totally supportive environment with an older man. Just surviving; not in jail, not overdosed, not dead was the most significant accomplishment in life over here; by Wilkens, on the west side of Baltimore.

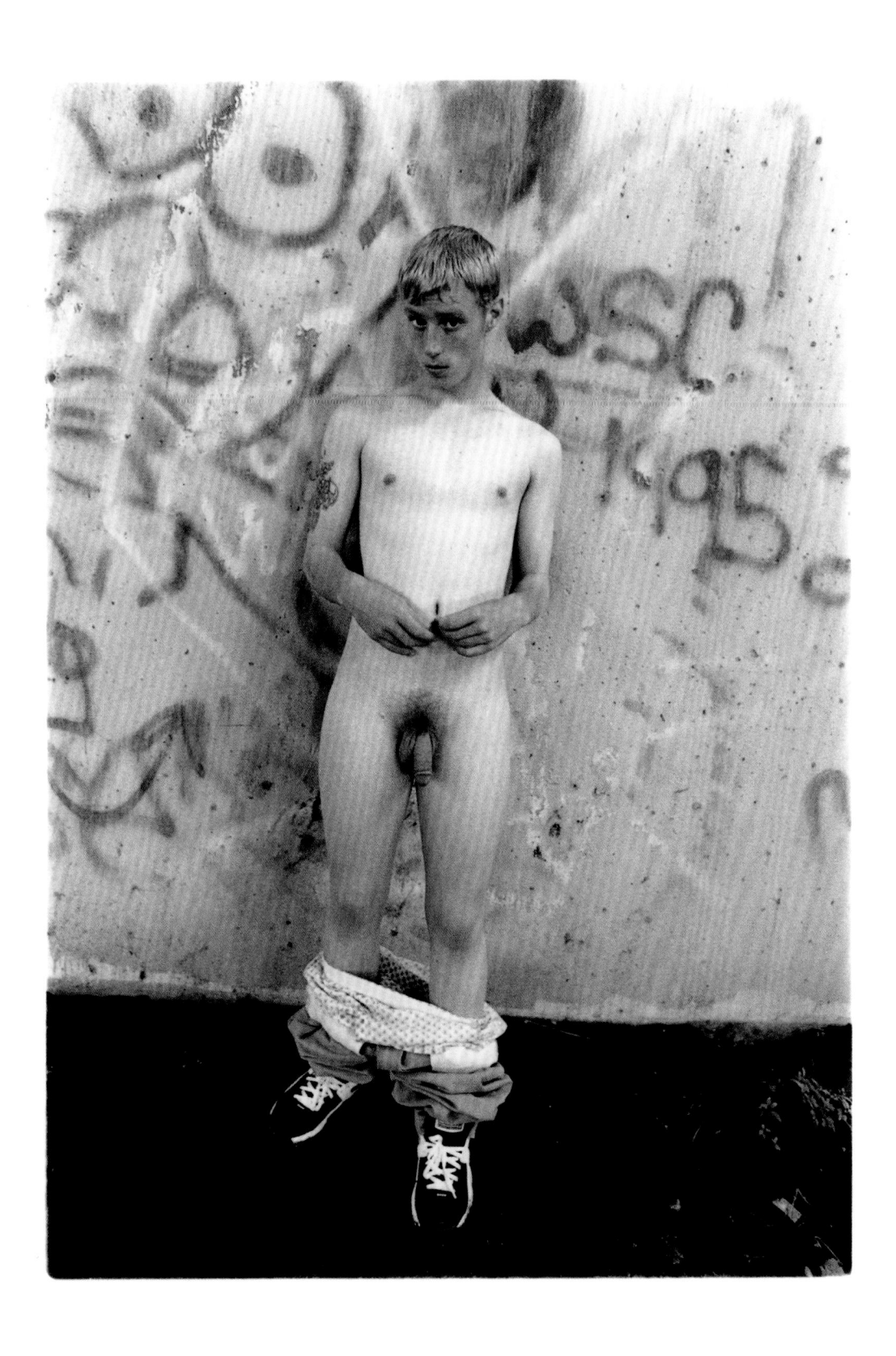

D.L. on the West Side, 2001

Danny was born in 1982 and has been pretty much on the streets, using drugs and hustling men probably before the age of 15. He basically lives with his mother and with whoever else is living with them at the time. But it's impossible to imagine the always changing dynamics of what passes for his home life. It was usually composed of a forever shifting collection of family, various friends, and relatives. It was an atmosphere that was chronically chaotic and contentious. This also included 2 dogs, one cat and his girlfriend. A few drugs. What Danny and the large family existed on I had no idea.

He has had several girlfriends and 2 sons, one born in 2000 and the other 2001 but when his girlfriend threatens to leave him, he threatens suicide. Truly, a life so entangled and fractious and fragile. Danny freely admits his bi-sexuality and is always looking for the older man who just might ensure continuing shelter, food, some illusive stability and hopefully a little money for drugs; a sedentary life, a soft body, waiting for the next man, the next trick, the next thing to happen.

The Twice Asked Question, 1996

Josh hated the City and had only come into it from Baltimore County to live with his father in a west side neighborhood. He had never used drugs but almost all of the boys he had met thus far were addicted. The parked trailer that he's standing in front of seemed to be abandoned in this large intimidating landscape so close to and almost under I-95. Like one homeless man had been murdered in the vicinity and a number of the girls working Wilkens Avenue in the afternoon would bring their dates here. Police never around.

He was the 2nd model I had photographed nude who had asked me exactly the same question: "I'm not going to get in any trouble for doing this? Am I?" I told him, "No!"

The First Day, 2001

Brian lived in or around "Pigtown" in S.W. Baltimore. In late 19th Century, pigs were driven through this neighborhood on their way to the freight yards. From there to the slaughterhouses and then wrapped meat in a food store and maybe on sale on the weekends depending. Their souls another issue. But you can't put a soul on sale even on weekends!

Brian had been raised in a house with his alcoholic parents who cared nothing about where he was or what he was doing. He frequently found himself on the streets by the age of 12 or 13 and just beginning to learn how to hustle and later on looking for drugs. By now, in 2001, he lived in a trailer park with his girlfriend and young son, Brian Jr. Both were being supported by his girlfriend who had a steady job working in a pharmacy. He was always missing court dates, constantly committing petty robberies, and pawning the goods to pay for the drugs, even if those goods belonged to his girlfriend, new clothes for his son or very close neighbors or an unsuspecting "john," like me, for minimum amounts of cash.

The very first day I photographed him he attempted to steal my ancient cell phone by wrapping it up in his sweater on the floor of the car, but I was a little faster and smarter than he was and retrieved it. The price of doing business! It wasn't too long after that that he was arrested in 2002 and did 13 months in jail and then successfully completed one whole year of probation. He was so proud to show me his diploma. By now he had decided never to see the inside of a jail again!! Somehow, he managed to stay off heroin, get a new girlfriend, daughter and in time, began looking for employment. Ironically, the girlfriend who supported him for so many years, became addicted, stealing drugs from the pharmacy where she worked and now is in jail.

Notice the raised chin, a signal of confrontation, a gesture significantly necessary if you planned to survive in the rough west side neighborhoods of Baltimore City! Despite all this, I knew Brian for almost 10 years. The very last day I ever saw him I had just bought him a brand-new expensive air conditioner for his new apartment.

Chubbs, 1993–2009

Charles under the Remington bridge, it was about 24 minutes away from the Johns Hopkins University on a good day. He was born on the 4th of July 1972; his sign, Cancer: A masterpiece of total neglect and abuse. If he ever did a day's work in his life it was by mistake. His parents used and sold drugs and it wasn't too long before he was beginning to develop his own habits. He frequently ran away from home and school, spent time in "juvie" and was hustling by 13 or 14. A little older and he would be in and out of emergency rooms, alcohol and drug rehab and jail. "Chubbs" liked being photographed not only because he was getting paid in cash, but it was also the first time anyone was paying him any attention and these photographs were his only legacy. When I saw him a few years later in the neighborhood, he was now on crutches, his right leg missing from the kneecap down. Not too many years after that he died of a heroin overdose, about 2009 at 37.

The Trash on Both Sides of Him, 1995–2001
A Lost Civilization

Steven on the seemingly endless, "No Mans' Land," under I-95. No 911, you can't describe where you are. Where murders happen. Where the homeless, the criminals survive. Where the few girls "working" Wilkens Avenue in the late afternoon bring their "dates." I saw one of those girls, one time, roll down the car window and spit. The place checked out almost never by the police unless there's been a murder. Right to Steve's right is one homeless shelter and nobody home. The trash on both sides of him attests to a lost civilization.

The west side neighborhoods had deteriorated into drug economies and prostitution, but it was still a great place for hustling. Within a few years Steven's family moved to West Virginia where it was probably safer, with better employment opportunities.

The Wall, n.d.

"Jesus Christ will save you from Hell!"
Heard it before?
If you are interested!
Under I-95
Washington – Baltimore
I'm Just Say'en!

Sometimes It's Impossible to Avoid Heaven, 2003

It was in one of those cavernous New York gay clubs, mid-'90s, The Tunnel and inside
the earth was racing and at some point, that evening I became aware of a stunningly
androgynous gay boy who was wearing a complete outfit exactly like this one. Only
the thin straps in front were going up his body, over the breast and shoulders and then
in one slim black line down the back, slipping hypnotically through the pale buttocks.
The fabric was nearly transparent and not one square millimeter of his flesh was not
seen; a white flesh, obscenely electrified by the lights and held in a kind of startling,
erotic, destructive suspension—the cold whale of Ahab pulling eternally his body and
soul to Perdition.

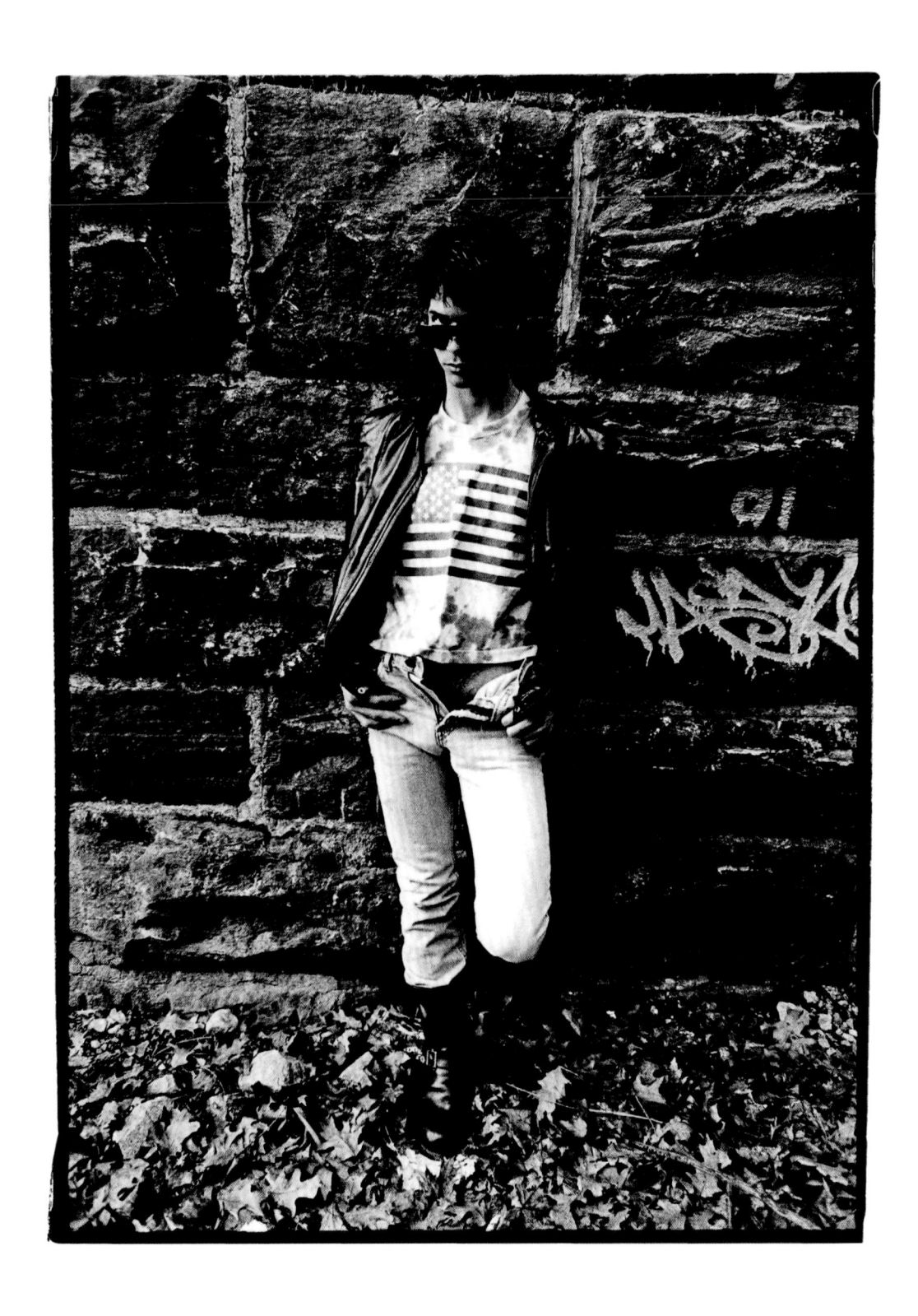

Captain America, 1994

"Captain America," finally back in Baltimore in the early '90s. Born February 1971, since the age of 15 when his parents split up and his girlfriend died, Billy was now at loose ends. He told me he had "a way with" women, alcohol, drugs, and cars which he called his "Fire Chicken," "Mustangs" and "Tempos." Oh! And firing cocaine. Filed under "a way with." He talked "straight" but most of his friends were "gay." If you knew him, you'd know he went every which way. Exploring life's options.

A Natural Actor, n.d.

When I first met Dennis across the street from Patterson Park in 2001, he had just turned 18 and had been frequently sleeping on transit benches along Eastern Avenue.

Dennis was always so thin maybe due to all the alcohol, drug use and being HIV-positive. Of course, he never really cared or grasped all the stuff he was up against and always tried to avoid the hospital and his social workers and hardly followed through on his medications and then got addicted to methadone. Dennis was never able to follow any schedule of medications or counseling and he didn't like to be told what to do anyway. He never knew where he'd be even an hour from now. Often, a week would go by without a bath or change of clothes.

He had lived in abandoned houses but when he tried to live with his alcoholic and drug addicted, abusive mother in one of her constantly shifting locations with one of her constantly shifting roommates posing as boyfriends, the relationship was toxic. They might have just had their 500th or 600th screaming fight. They fed each other's addictions. She helped supply him with drugs and alcohol. She said he's all I got and I'm all he's got. His father OD'ed in a crack house.

He'd tell me frequently about his "Boss." Of course, he didn't work but maybe his stories were meant to show me that at least somebody really needed him and accepted him. He could reproduce almost any behavior instantly because he wasn't connected to anything of his own.

This is Dennis in somebody's working class back yard about 10:30 P.M., unnoticed. As usual, the evening was hot and humid, just one block from Eastern Avenue.

He casually would be sitting on some solid object cooling his warm buttocks on the cold stone on a hot humid summer Baltimore evening or leaning the same buttocks against a cool wall, either standing on a corner or in shadows. How lucky could a stone or a wall get in a hot city? If you want to know more about warm buttocks on cool stone, read Strato or Catullus, they'll tell you. But sitting or standing on or against anything was pretty much all you could do in these working-class neighborhoods anyway. Not reading Proust.

R.I.P., 1999

He was destroyed before he even got to the street and then it was like going off the planet. Marty's father lived in another part of the city with his motorcycle and a new girlfriend. His mother, an alcoholic and drug addict, part time dancer and prostitute didn't have any time left for her three children. He had a younger brother and a much younger sister. Marty's brother, Jeremy, was his only true friend and constant companion.

You might see the two of them "horsing around" on Eastern Avenue at 3 in the morning. And then, the following year, Jeremy was killed by a woman running a traffic light at an intersection in an area notorious for drug sales, his body slammed into a corner mailbox and the next day it was crowded with graffiti: "R.I.P. Jeremy Love You."

Some more years passed and his addiction to heroin only got worse and he was "positive" through frequent use of dirty needles. By then, if he could be seen at all it was frequently in Patterson Park, a place to score and inject, at the corner of Eastern and Patterson Park Avenue sitting beneath a tree in complete view of passing cars in the hot afternoons. At times he would hang out at the very last of the gay bars, Quest, on the east side of Baltimore.

R. and B., 2001

Very rarely did you see Robbie on the streets of the east side and especially along Eastern Avenue. He was so skittish like a wild rabbit in an open field of hounds always afraid of being seen by the wrong person, like somebody who would hurt him. Maybe by the police or by some other neighborhood boy who might think he was a queer hustler along Eastern Avenue.

It was hard to know where Robbie was living at any given time: with a mother or a grandmother or just some friends. Maybe he never knew who his father was.

However, he must have trusted his friend Bonzo long enough to hang out with occasionally. Naturally both boys identified as "straight" at the time, but neither ever had a girlfriend and all emotional and sexual connections had been with men.

Robbie never knew a father and just existed with his mother and older sister. He never knew what to do with himself, but he needed money. So, he decided to work with some drug dealers. He was never the brightest bulb in the room and right away he was found cheating on drug deals. In 2011 Robbie was executed behind the East Point Shopping Mall, probably a bad drug deal.

Jasper Johns, 1998

These boys were best friends. Street loyalties shift fast at this age. Ross just had a son. Gary writes to him later that year from juvenile military camp in Western Maryland: " ... the Real I miss you Bro. I know what it's like not having a dad and you don't want your Son knowing what it is like ... Gary AKA Lucky of Highlandtown."

Ross himself has no parenting and neither did his three brothers, Charlie, Eddie, and Randy. These boys used heroin and are frequently in trouble with the law and often had to travel across town to visit their probation officer.

Oh!! and by the way, that large piece of "Art" they are standing in front of, outside, under I-95, could possibly sell for, at the very least, 10 million in NYC with the right name attached.

Johns was really interested in trying to imagine a new set of possibilities for painting and did so by playing with the subject matter by creating paintings that at first glance don't look any different than the actual objects that they represent. Outsider art that IS truly outside!

For Johns the common shooting target that the mind already knows. The same with the American flag.

The Last Photographs, 1999–2010

By now Marty would often disappear from the streets. I saw him one afternoon sitting in Patterson Park under a tree with a group of his homeless friends, at the corner of Patterson Park Avenue and Eastern. I waved him over and took him to a fast-food place nearby on Eastern. I forgot the name although a lot of boys hung out there. I gave him some money but neglected to ask where he was sleeping and who his friends were. About the heroin. He died in a crack house in 2010.

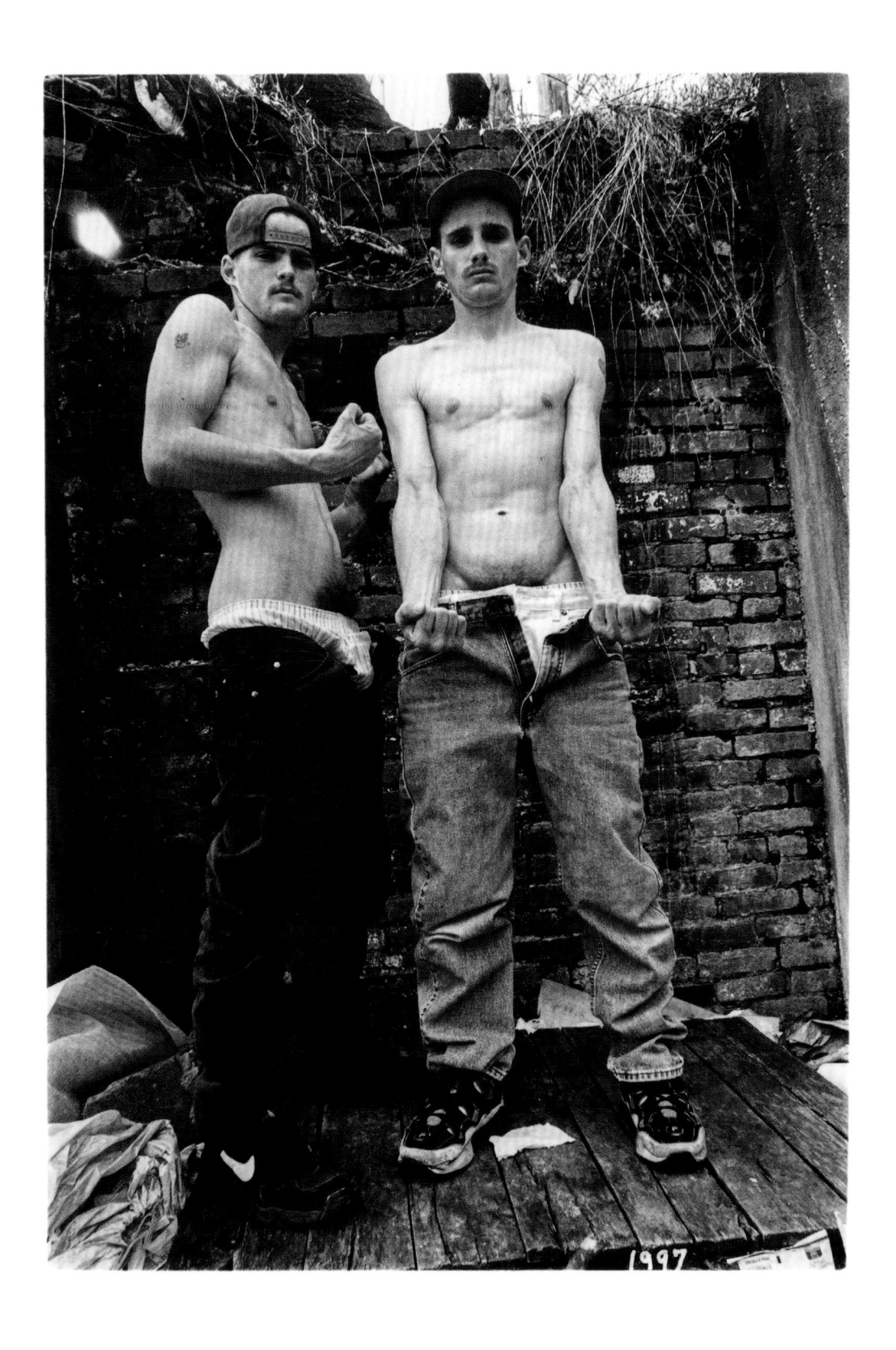

Stephen & John, 1997

They could have survived on the streets anywhere in America. They were tough little M.F.'s and they played for keeps. They were a tough pair. People you did not want to piss off or threaten! They learned early how to survive on the street.

They sometimes stayed with their mother, but they were stealing things from the house and had to leave. So, they lived sometimes with an older man or an older woman, at times in abandoned houses.

If they liked you, you had the best protection on the west side. They knew intimately the west side neighborhoods, the west side streets since they were young teens. They learned to keep their eyes on the streets for anything moving or otherwise.

They were desperate and vulnerable junkies who somehow accumulated just enough money to score and then they too became a mark just after the deal was done. Finally, they all learned it was safer and more profitable to be nicer to "fruits" than to rob them!

Dangers, Charms and Challenges, 2004–19

We failed to notice a police helicopter circling overhead. We were lucky for sure. Drugs were so available in Patterson Park: buying, selling, using either out in the open, on benches, among foliage, around natural depressions. In 2004, gentrification had not yet set in, but it was coming.

But now, about 15 years later, one summer in 2019, 10th and 11th graders from "Friends School," a private Quaker school on Charles Street, right next to the Catholic Cathedral, were enjoying the green landscapes, climbing inside of the famous "Pagoda," doing some headstands in the sun. A whole group of them spending 2 days crisscrossing the City to explore their hometown's history, its hopes, charms, and challenges and learning a little about the court system. "We watch 'real people' come in and if they can't pay their bail they are stuck in jail and could lose their jobs." Somehow, incarceration and jobs put together in the same package were always a wild combination for Baltimore City. "Even going there just once shows the judges we are keeping an eye on injustice. It's interesting to see something relevant to society, to see peoples' fate determined by a judge." Looking closely at the "Friends" kids cavorting in Patterson Park you can easily see the original gray granite stone pathways that had served generations of Baltimoreans well and the kids are sitting on a few of them.

The green park benches on which Dennis and Marty had been sitting in 2004 ran right along these same pathways and that Pagoda was directly behind them. Marty died in 2010. Dennis died in 2015. Like his father, in a crack house.

The Homeless are Not Harmless, 2001–06

One summer, I was photographing Dennis and his friend Marty who was already home-less, under I-95, exit 52, Russell Street north, right turn only. It was "NO Man's Land." Just considering all those people out there in the wilderness: sometimes the police, some-times an aging ex-hustler or two, one of them I once knew and now looking like Charles Manson. The homeless criminals or at least those who at best can do criminal things, those who prey on the homeless, those who are just hiding out and those who will rob you or stab you for nothing hoping to get something. Every one of them homophobic of course, at least officially, so any genuine homosexual who just happens to be in jail even for the weekend ends up in isolation. Or die! How did I, a very sheltered, very talented upper middle-class gay photographer and writer with college degrees get away with all this shit for well over 4 decades!?? What!

Dennis had no money but somehow his shoes were always bright and spotless. He always left his very dirty white socks, threw them actually, on the unpainted floor of the screened in porch belonging to a man he happened to be living with in the county at the time who worked at Social Security. If he even intended to wash the socks "later on" it always turned to be the longest "later on" in history, meanwhile that man from Social Security just bought him new ones.

Under the highway, there was this remarkably damaged and dirty sofa, some small tables, and a few chairs. It turned out to be a homeless man's living room.

Dennis quickly found a very sharp knife wedged way down between the side and a cushion. Both boys were sitting naked on the sofa when we noticed this guy coming fast from behind a huge concrete pylon supporting the inter-state and heading in our direction.

I told my two subjects to quickly put their clothes on and let's moooove!!

The boys grabbed their stuff and got the last zipper pulled and the last laces tied. We hid behind a screen of non-pedigreed bushes, and then all of us headed out fast in the opposite direction. But the guy must have had more dangerous items than chairs and the sofa in his living room than we hadn't noticed and was now coming around the bushes with a baseball bat in one hand and a machete in the other. Definitely, things were not looking good. Fortunately, that summer, I had been faithfully jogging, along with all the drinking and the bars and the cruising and the two boys were young and fast.

I had my cell phone but calling 911, I quickly realized was useless because I couldn't describe where we were because I didn't know where we were and if the guy caught us, it would have been goodbye and useless anyway. Dennis turned twice and got in a couple of quick missiles. If you were a "believer," maybe a couple of church missals would have been much more effective.

Finally, as the three of us approached the very borders of civilization and I use this term absurdly and loosely, the guy finally gave up. He had certainly made his point and he didn't want witnesses. One or two homeless men had recently been murdered here. A land of the misbegotten.

As the years past, Dennis lived with some older man in Baltimore County. He called this man his "Uncle."

Only one time (a strange moment) Dennis told me that he wished for someone to love him and take care of him. That sometimes before going to bed he would use a little more alcohol and drugs and wishing he would not awaken. I'm sure he wouldn't remember any of this, and if he did, he'd deny it.

Knowing something about his personal history, his HIV status, and his hopeless list of addictions I swear I don't know how he's alive today. And yet, he was always my constant subject for 5 years. A fluid and mobile personal identity allowed him, like a brilliant actor, to instantly and innocently assume any role, as if he needed to exist inside the life of another person.

Walt, 1998

Walt had always lived in Remington, at the time, a working-class neighborhood in Baltimore, on Huntington Avenue with his mother, grandmother and probably his sister. His father lived in Hampden since he had left the family when Walt was 10. Like so many boys in the neighborhood he identifies as "straight." Walt did a lot of stuff in order to survive, beginning in his early teens, eventually doing a lot of time for car theft.

1993

But all his physical connections,
emotional connections, have
been with men.

gay →

Here Walt is 20 years of age. A Remington
His father left the family when he was 10
and the dominant woman in his life were
his mother, grandmother + older sister. Like
most boys he sees himself as "straight" but has
been hustling since 14.

Billy on the West Side, 1998

B. had been abandoned by his mother when he was very young. He never knew his father. The only family he had left in a life of absolute neglect was his grandmother. Sometimes she would allow him to stay with her in a small row house in one of the west side neighborhoods and try to take care of him. If he couldn't stay there, he would stay in a row house on a hill farther west just off Wilkens populated by a shifting body of rootless addicts a few transients, and a few prostitutes, along with his younger sister Ruby who always had a place to go when she wasn't working the Avenue. He and Ruby were basically homeless. It was an unimaginable situation that wouldn't last long. In a few years both he and another friend, found out they had HIV.

And then there was Billy's best friend, Sean, who would make the long, time-consuming journey across the city from his house in Brooklyn, a small south Baltimore working class community, to hang out with his best friend Billy so they could get heroin and hustle together. Almost all of Billy's other significant contacts were with older men.

So Proud of His Body, mid '90s
His Main Source of Income

Mike never knew his father, was abused, and neglected in the foster homes he managed
to live in. He quit school and could neither read nor write. Because his mother was an
alcoholic, he hustled men from the age of twelve to thirteen to pay for his food and clothes.
Basically, he lived on the streets most of his life. Occasionally some of the boys would see
Mike getting out of an older man's car so they called him a punk in his west side neighbor-
hood. Sometimes he lived in abandoned cellars with one or two friends.

At the suggestion of a friend, Mike moved to Washington where he danced nude
at Wet and then, for a while, became a professional "Call Boy." He began to use and sell
heroin, a habit he was never able to break.

When he finally returned to Baltimore, he became a dancer at Atlantis. One night,
while doing his laundry, he passed out from an injection of heroin, and his head fell into
the water where he drowned.

Purple Mountains, Fruited Plains, 2003

Johnny was born in 1983 and was a serious crack addict. He has basically lived on his own since the age of 16. His father had abandoned the family when he was 2 if there was still anything left of a family to abandon. Since then, he has been in and out of a number of juvenile and psychiatric facilities, and jail. At first, he has the manner of an intelligent charmer, convincingly masking the anger and the violence and destruction within. He was so friendly, funny, and cooperative.

He functioned most successfully in a controlled environment. Any structure at all had been totally lacking in his life. He was obviously bright with a great sense of humor so one day I was telling him how friendly and easy to work with he was. But somehow the praise seemed too much for him to handle and then, out of nowhere, he said, "You know I'm a schizophrenic." I didn't know exactly what he was talking about and anyway I didn't believe him. How could that possibly change things between us? When I finally got home, I should have run right into my kitchen and grabbed my Webster's revised dictionary, second edition. But I didn't!

He was just so friendly, cooperative, witty, and smart. And yet, all this time, from some interior eye, he had been silently sizing me up, looking for weaknesses. And of course, they were there, all of them. But I never knew exactly what schizophrenia was. I knew it was bad or not good. And then, just following his last release from jail, I learned to regret it. And yet for others he was still honey in a wasp's nest.

To say that Johnny was an angel was like saying the Pope and Osama bin Laden were playing golf. In truth, he was more inside of jail than outside. They could have saved everybody a lot of trouble and just kept him there in the first place, if not for his own safety. How could anybody object? How could just one more prisoner in a land drowning in prisons and drugs and violence possibly matter and it was really keeping America safer?

Little Steve, "Big Daddy"

"Big Daddy" was living just off Wilkens Avenue on the west side of Baltimore City. Steve never used drugs, was quiet, easy to know. Mostly friendly, sometimes sneaky, a boy with a short fuse. He never worked in his life and if he wasn't living with his parents he always seemed to be living with a new girlfriend and in a different apartment. What they were living on was a mystery. Who was paying for it?

Because of his size and his weight, he called himself, "Big Daddy." It says so just over his left nipple. He hustled randomly and was quiet and friendly and for a price he could hook you up with any boy or girl in his neighborhood, along "Wilkens."

If there was any gossip to know over there, he knew it—The Hedda Hopper of the west side neighborhoods! If things got a little "tight" for him in his neighborhood, like a slippery eel he would slip out of trouble, with a grin, before it found him.

Steve was a glutton for attention. Obviously, he was in love with my camera. If there was a camera around in his west side neighborhood or on Wilkens, "Big Daddy" wanted to be in front of it. "I can't talk now, I'm being photographed!"

When he broke his left wrist the summer of 1997 and had all of that fresh virgin white plaster cast just sittin' there on his left arm, he had a field day! In "no time at all" it had been signed by anybody moving on 2 legs in his neighborhood.

"Get a good copy of "Sexual Behavior in the Human Male" by Dr. Alfred Kinsey and Read It!". All of it!!

Dr. Kinsey will explain to you if you're gruesome enough everything you always wanted to know about "Beastility"

When they navy ships docked in the Baltimore harbor with real real sailors in the 70's, it was amazing how many of them so quickly found a lot of the gaylars esp. the "Hippo"

Brother, 1979

He was playing pool one night at Connie's Masquerade on Boston Street, the most exotic neighborhood gay bar in Baltimore. The twin bartenders were either Man or Woman. Maybe the third or fourth sex, things get easily out of hand today in the gay world! If you let them.

If it didn't happen at Connie's, it didn't happen anywhere. He was attending an Experimental School on Cathedral Street less than 2 minutes away from the Enoch Pratt Free Library. Happily, he wasn't a cup bearer in Olympus. And happily, he spent the night and all of the next day.

"I am broken with longing for a boy by slender Aphrodite"
Fragment #102—Fragments of Sappho

Blond Curls, 1975

Joseph came with a friend one summer weekend in the '70s to Baltimore City to check
out the streets and their possibilities. They rented a cheap room on Eastern Street close
to what is now Martin Luther King Blvd. They used inventive financing. Only Joseph
unpredictably made it back a week later.

Disaffected Youth from the Reagan Years, 1987

Each year Baltimore City celebrated the "Art Scape" festival in the heat of summer. One year the tall Alex attended. He presented a startling appearance for that time in 1987 with his tall black mohawk, his saffron robes and a long white cape flowing down his back. Written on that cape in black and in a shaky hand he had listed just a few of the grossest failings of standard human behaviors, in his opinion only, like unending war, hate, violence, torture, greed, disunity and intolerance and the resulting fears and consequences that all this generated were just the main ones. Listed under this bad stuff he proposed instead, peace, love, kindness, generosity, tolerance, i.e., Nirvana. He was young. Nobody seemed to read his offerings. Instead, it became just another unique curiosity at a seemingly avant-garde and noisy Baltimore festival.

When Alex arrived for the first time, he had this exquisite Mohawk which just barely fit into his parents' old Mercedes which he drove. The second time, still the old Mercedes but not the Mohawk. Now with his head shaven he looked like a "Hari Krishna," calm, beautiful, meditative, monastic.

The third time, still the old Mercedes, but now he was wearing a light brown Polyester suit, just slightly too large, poorly fitted, flat in so many places. Something he could have found in a thrift shoppe and perhaps made for somebody else.

I could hardly believe what I was looking at. But I knew right away what all this was portending. Now he belonged to another world entirely. A world that I had, fortunately, rejected so many years ago.

Unfortunately, the black hands of the human brain, already fashioned and finely tuned by a few million years of evolution, had been there before him. The brain's ultimate design and soul purpose was to ensure human Survival and whatever else it took to make that happen. Kindness, love, tolerance, and peace had nothing to do with it. On the contrary, the Survival and "whatever it took" permanently insured that war, hate, violence, greed, intolerance, and injustice would become an absolute part of the equation and a binding force that held all tribes and civilizations distinct and together and, for varying amounts of time, successfully. If all of Alex's proposals were implemented tomorrow or at least by the weekend, it would mean the end of Western civilization as we know it. It would mean the end of everything, period.

Fortunately for the World nobody at the festival was reading it.

"What a piece of work is Man"

An Early Patron, 1975

Roy was one of the early patrons of the "Hippo," a few years after the Stonewall riots. Previous to this all the gay and bi-sexual and lesbian bars in town were tucked into small local ethnic neighborhoods and at various times had to deal with some local hostility and police harassment. But this bar uptown was finally providing a space featuring the very first glimmerings of specific gay identities and the creative costuming and the inventive performance that often went with it. A photographer's dream!

Roy was now living temporarily with Stephanie, a very popular and dynamic girl who just loved to hang out at the Hippo every Saturday night. In those days the patrons of the uptown bars, especially at the Hippo, were putting a lot more time, effort, attention, and imagination into designing their maquillage.

Roy had just recently been arrested for having sex in a public bathroom. Very fortunately Stephanie's father was a powerful attorney in Baltimore, and he had succeeded in having the sex charges dismissed.

One Saturday night, I and three of my friends used Stephanie as a battering ram to push open one of the doors to the Hippo and onto Eager Street, just after "last call." She loved it!

Once out on the street, there was a long white wall running along the north side of the Hippo where patrons would stand for maybe an hour looking for a "pick up" for the night.

Roy was so quiet, popular but still vulnerable but fortunately there were a few people who wanted to do things to help him. Specifically, two older men who got him into a good hair design school and paid for it. It was uphill from there.

Things Change, 1981

Wade turned up on the northeast corner of Madison Street and Park Avenue in the late summer of 1980. He had just turned 18. He came just to make some money. The beginning of the '80s saw a radical decline in the old-style street hustling as the prevalence of drugs and gay awareness were taking their toll. The type of hustling that replaced it was more desperate and emotionally dysfunctional. It had already become more dangerous.

Boy in a Black Shirt, 1976

For about 2 or 3 years, Michael, blond and peaceable, always seemed to be in or standing around the "White Coffee Pot" at Eastern and B'way from about 10 'til maybe 3 in the morning. Of course, he always had his intimate regulars with whom he could easily spend the night. It was as if the "Pot" was really a second home, assuming he had a first one. He wasn't going to school, that's for sure.

Not once did he ever talk about a girlfriend or anyone else in his neighborhood. Not once did I ever see him with a companion hustling around Eastern. And his real "sexual identity" at the time in 1976 was hardly important. I just assumed or wishfully imagined that he was just another straight hustler needing money. Only now, 40 plus years later, did I realize that all his emotional and physical connections were with men.

They Didn't Come to You, 1992

Tracks opened in D.C. around 1984. It was just one of the many gay bars located within a vast area of abandoned and decaying warehouses in the S.E. section of Washington, close to the old navy yards and almost within sight of the Capitol building. The rents were cheap, and nobody could complain about noise. It was all a sketchy area and when you left your car, dark figures would emerge from the background and offer to watch your car for 10 dollars. But why would your car need watching and suppose you had only a 100-dollar bill available?

Tracks was the most original, inventive, technologically stunning, and outrageous gay bar for its time. It was the best show in town! Any race imaginable, any sexual persuasion just had to show up there. A few of the patrons might have looked like they had just come out of the moldy woodwork for a night, but mostly glamorous and intriguing. One customer said: "If it hadn't been for 'Tracks' I would have been a basket case or I would have remained in the closet."

There were usually 2 or 3 lines just to get inside the place. As the doormen checked you out and took some money, anxiety, and anticipation had a lot of time to grow. If the lines were too long, it became intolerable and any gay "masochist" in line would have been in Paradise, as it was free.

Once inside the door it seemed much darker, and you could just smell the darkness as well as hear it and it was loud! And right to the left was a stage or dancers. In 1992, it was usually Jason on the stage, the energetic, accommodating main dancer. Blond and just the right amount of flesh in the right places. A loose body that sucked attention like a "Black Hole." Each crack and crevice stuffed with green bills, not too many "ones."

At Tracks there were so many new personalities. Maybe each person had adopted one and others several. I would have been so relieved and happy to know what each of these adopted identities were all about. I'm sure that in "real life" these adoptees were pretty quiet and subdued, removed personalities and so protectively personal.

At Tracks, Jonathan and his friends usually sat in the same location at the same bar when they went there. You had to come to them they didn't come to you.

But intimacy and the cohesion (if you can use this word to describe a gay club) and the inspired lunacy and bizarreness of Tracks was unrepeatable. There was the brightly lit volleyball court for one thing ringed by a series of bleachers. "Sista Face," a large grand odalisque of a hostess, reclined on the bleachers and controlled the keys to the V.I.P. room.

Tracks lasted 'til July 1999. It was the right place at the right time. It is remembered as the biggest, coolest night club in the city. The best party in town. "Straights" knew it was gay but they couldn't find anything like it anywhere else.

When Tracks finally closed the entire circus moved over to "Velvet Nation" or simply, "Nation." It was so much cooler and larger, so large it might have accommodated "Olympus" and you had to stand in 1 of at least 4 lines to get in there. You could count the number of bars there was no one to do it for you. It seemed that the same groups of people were always standing at the same bar each weekend, almost sitting in, or standing by the same chairs, holding Court.

I was reminded later on in years of all the outrageous bars in London in the '70s and '80s: the "Bat Cave," the "Wag Club," "Sacrosanct" and finally, "Taboo," the adopted home of the brilliant costume designer, the startling if not insane performer, Leigh Bowery. He and his friends like "Trojan" would spend so many hours just preparing to go out that by the time they finished preparing there was no place open to go to.

Sean of Club Charles, 1984

For about one year, off and on, Sean was a frequent patron at Club Charles, formerly known as Wigwam on Charles Street. For Baltimore, this bar, somehow, was supposed to be a pretty cool place. The bar was also a magnet for young first year art students from MICA.

But the real genius of the place was the bar owner and bartender, Esther Martin. A wild woman who banished pain with doses of alcohol and unlimited charisma. This was her mission along with improving your vocabulary. One of the beer taps behind her said so. In addition, she was the most politically incorrect bar owner within shooting distance of North Avenue, AND, the bold architect of the Cunt-Hair Martini. She supplied the essential ingredients fresh on demand. For those patrons she liked especially, the inspired alcoholics, she allowed a bar tab and a few of them got pretty serious.

As for the friendly, agreeable, and beautiful Sean he vanished finally and as quickly as he had appeared. Sean was a beautiful narcissist and his mother a psychiatrist on temporary leave from the boundaries and redundancies of Middle America.

Going Out, 1976

If you had just arrived and were new uptown in Baltimore, and needed food, cash, and a bed quickly, there was always the Mt. Vernon meat rack. One of best corners was at Park and Madison but any corner was good. They had served generations of hustlers and by 1976 prices ran between 10 and 20 dollars. There are few people around anymore who will remember these times in the city when almost any street, any corner, any alleyway, any church, or school steps would serve as a pretty successful meat rack: a reality specific to Baltimore, by the way.

Why not remember; well, the dead can't remember. The drugs from the experimental counterculture of the '60s and then the polyester hedonistic '70s finally had no place else to go except the streets where they mangled and ravaged the city. By the end of the '70s addicted parents were producing addicted children, all in a race with death. All the old street economies, the erotic passions, all illegal, sometimes dangerous didn't even have the time for an honorable and graceful extinction. The times we thought would never end were here.

A Chaotic Life, 1983

Kevi was lost from the very beginning. He lived in Remington, a small working-class community right next to Wyman Park and all the hustling that was going on there right in the neighborhood was hardly noticed. Kevi was one of 4 brothers, all of them hustled and the oldest in jail for murder. The parents, or rather the mother, the only adult left, was totally at a loss as to how to manage anything in her own life let alone the lives of her 4 children. It was always chaotic and a lot of screaming because everybody wanted something but there was no way to get it.

One-time Kevi was bitching about the time the police came to the house to collect him and they did this at 6 in the morning. Of all his daily disasters why did he tell me about this one? Otherwise, Kevi was quiet and friendly and calm considering his circumstances. He was probably arrested for stealing because most of the time he had nothing. As time passed, he lived mostly in the neighborhood, possibly with another friend or with a man he had met somewhere. I found him a few times in the early '80s staying briefly with someone in Pimlico which was in Baltimore County and far from Remington. And now he looked rough and intense, obviously scared and confused by all the inexplicable things going on around him. Kevi never had a girlfriend, and every bit of his sexual and emotional connections were with men. He just vanished somewhere in the later '80s and I lost track of him. In those times I had never even considered his sexual orientation, but many years later and with a lot more knowledge and experience, I did.

Coldfinger, 1975

David came from a typical Baltimore working-class neighborhood. As a younger boy he was constantly ridiculed and harassed, sometimes physically, by most of his peers in this neighborhood because of what he was. Actually, he's quite good looking.

His only dream was to become a Woman, at any cost, which he eventually did, completely. He wanted nothing to remind him of his past as a boy: His image, his name, and all the pain that went with it. Only these photographs remain.

A Small Arsenal, 1984

He looked very much like his divorced mother, her light, delicate features. Her voice, fragile, hesitant, questioning. Her nervous smile on too many occasions. There was not the slightest doubt but that he was her son.

Living at home in the expanding jungle of middle-class suburbs north of Baltimore, just before we started taking photographs, he pulled out from both pockets, slowly, sheepishly, and incredibly, a small arsenal of drug paraphernalia and then laid it all out somewhere in the room, meticulously: clearly not intended for scrutiny.

His Heart Wasn't in It, 2005

A friend found Casey all curled up and sleeping in his clothes on the floor in the laundry room of his large apartment complex. Casey had so many troubles with a father who didn't like him in the first place and now had kicked him out of the house completely, leaving Casey with no place to go.

This friend was kind and sympathetic, compassionate, if not a little crazy, perhaps living on another planet perhaps and he let Casey live with him for about 3 years. But all this time that Casey was living with this man it simply compounded his "confusions" about many more issues than he had bargained for, just one of them being finding out his true "sexual identity."

He tried hustling at various times with various men. This experience was so dramatic and traumatic, and I'm putting every bit of this politely!! But his heart really wasn't in it. And now he wasn't even sure whether he was "straight" or "gay" and he was really afraid it was the latter.

But finally, at last, to bring this truly complicated "Odyssey" to an ending without Homer's directing and constant kibitzing, it turned out that Casey had never been Gay in the first place as everybody else, including Casey himself, eventually found out! So much better than anyone could possibly have imagined. He and his new girlfriend established their own family "with kids" and so they lived happily ever after!

A friend found Casey all curled up and sleeping in his clothes on the floor in the laundry room of his large apartment complex. Casey had so many troubles with his father (who didn't like him in the first place and now had kicked him out of the house completely, leaving Casey with no place to go!

This friend was kind and sympathetic, if not a little crazy and living on another planet, and he let Casey live with him for about 4 years.

2005
"Happy Endings for a change."

Thomas Dozier Fischer
2005

The Reincarnation, 1985

Barbara knew she was the Reincarnation of Marilyn Monroe. She was compelled to
unveil this secret on too many social occasions and was going to become famous in
about 2 weeks from the date of this photograph.

Timmy was all about fashion and design. She was a Wild Woman! He had a big dark boyfriend named "BB". The best way to describe "BB", was big and intimidating. "Iago" in a dark alley at mid-night!

A Wild Woman, 1977

Timmy was all about fashion and design. She was a wild woman. Timmy had a dark-skinned boyfriend named "BeBe."

 Timmy didn't want to die but he almost killed himself 3 times. Sometimes after a night at the Hippo, the largest uptown gay bar on the site of the old Chanticleer Ballroom, he'd temporally forget what a road was.

Boys and the Streets of Baltimore, 1977-2017
A Song of Thanksgiving

Baltimore street hustling, going back for so many decades, was a city-wide tradition. One boy initiated another boy, a friend, or a brother or for those who were just curious. Fathers and uncles had probably done the same. The local residents if they chose to be aware of it at all mostly didn't care. The culture of hustling was almost too common to register on the culture Richter Scale. Occasionally a particular robbery or a rare brutal murder would shut down the meat rack for a time but within less than six months everyone was back in business.

If you didn't know what was happening, what these boys were doing, it didn't exist. There was nothing they could do about it anyway. Even the police had better things to do than worry about some faggot and a punk who'd be right back there on the street anyway. Some even accepted favors. There were no street drugs to speak of, but they were coming.

Roy and his older brother Rob were just 2 of the most popular and consistent boys in the mid to later '70s. On weekends and some weeknights, one of them or both could be found near Clinton Street, a spot where Eastern Avenue begins to go uphill, and this is why the working-class community was called Highlandtown. They were so honest and friendly and engaging they often had their "regulars" and often spent the night. They were just looking to make maybe five or ten dollars to finance the weekend.

As far as anyone suspected they were "straight." They both had girlfriends. They probably disappeared from the streets in '78 or '79, about the time when drugs and increased violence effectively shut down traditional practices and location.

If you really wanted to stretch the definition of "family," the Baltimore boys had their city all to themselves. Another basic reality is that a good percentage of the hustlers were in reality gay themselves. Mostly the "johns" didn't know it or wanted to believe it (for them it was necessary not to) and the boys clueless. But "going out" with an older man was the only easy way to experience "same sex" sex. So often they needed a father and the "age gap" was the whole point of the relationship. Try to explain that one in America.

Finally, it might be hard to believe for a "Normal Citizen" but in those days it was a simpler world. Street drugs and AIDS had not yet arrived to take lives and ravage the city. And as for the "Gay Identities?" Well, fortunately they had not yet been invented as far as the streets of Baltimore were concerned. But not to worry, that shit was all coming down very shortly.

Bagboy, 1983

A first year MICA student in Baltimore in 1983, he had somewhat of a groupie following.
It was the plentiful blond hair that you wanted to crawl into, designed specifically to
cover an eye maybe two on occasion; a cool, simple, and sensitive earing in his left ear
and a heavy and innocent unique and melodious accent that did it.

A Boy Across the Street, 1996

He and his sister sat on the front steps, seemingly each other's only friend. Almost every inch of his bedroom and part of the basement were covered with his pictures and posters. A large white cat slept on the floor. There must have been at least 10 toilets in the house, even one of them in his bedroom!

Crab House Busboy, 1975

Ricky was typical of the boys hustling on the east side around Patterson Park throughout the '70s—a very different era in American cities. Highlandtown was still ethnic, white blue-collar, the boys usually lived at home and prowled the streets because it was cool, their friends did it and it yielded them lots of spare change for Saturday night.

This was before gay liberation took off and most adolescents and their families became aware of male sexual deviations—when your high school teacher, your beefy gym instructor or charming local priest might be gay and you too if you didn't look carefully at your own behavior and reputation. This reality went a long way to killing indiscriminate and very ubiquitous street hustling. Highlandtown neighborhood block watches and police alerts were shortly to follow. It was also just before the street drugs and AIDS began to seriously take hold, initiating the social devastation of the '80s Most of the drug addicted kids desperately hustling in the last of the '90s and into the 2000's were born during the very years '80, '81, '82, '83 to seriously addicted young parents, most of them no longer around. Ricky worked part time as a busboy at the Old Obrycki's Crab House and Seafood Restaurant in the 1700 block of Lombard St. established in 1954, that burned down sometime in the late '60s. Or maybe it was the new Obrycki's in the early '70s. At any rate, he was definitely from the old school hustling.

New Boys in Mt. Vernon, 1976

One night two new boys, a blond boy named Randy and a slim exuberant Irish boy named Shawn, showed up together hustling on the Mt. Vernon meat rack. A warm and very humid Baltimore evening came with it. The north-west corner at Park and Madison, with its white marble steps and maximum lighting had been ordained from the beginning for hustling.

The Only One, 1985

We met in 1985. He was the best thing that ever happened to me. I could not survive
without him.

She Knew Before He Did, 1982

His grandmother had just died, and his 3 sisters all had boyfriends and certainly not interested in Stoney.

One Saturday night in 1982, Stoney was working the Mt. Vernon meat rack. He lived way over on the west side of Baltimore City with his mother. He never knew his father and his mother really loved him, but she was always working so hard all day and weekends and even some holidays and the rest of the time either shopping or cleaning and then needed sleep. She had told him that she knew he was "queer" before he was 10 but in a nice way.

One Saturday Night, 1981

One Saturday night Darryl appeared hustling the Mt. Vernon meat rack.

On this very same meat rack I picked up my very first hustler in 1960 but I had to be pushed into it. I had never touched a man's penis before. I was 24.

This time Darryl was wearing some long white tube sox with little black rings at the top.

Bruce from the West Side, 1997

Bruce: born 1978. Here in 1997 at age 19, just one week out of shock trauma after being brutally beaten and robbed by 3 teenagers one night in his decaying west side neighborhood. Bruce's mother had deserted the family when he was 3 and so his brother and younger sister were being raised by the father.

 When his father worked, the kids were left alone. Bruce was just so quiet and sensitive, and you could see sometimes confusion, fear and the lasting sadness in his eyes.

Historical, 2001

One afternoon in September 2001, I saw Thomas just sitting on some steps of the last row house at the corner of Catherine Street and Wilkens Avenue. He was 19 and right away he told me that he had been hustling since he was a boy, had had sex with his younger brother who was now hustling the same areas that he did, and he liked older men.

You might see such a face as his in some anonymous daguerreotype or ambrotype photograph of a farm boy or a young Civil War Yankee soldier around the 1860's: the same immobile and expressionless face, the slightly startled and intense staring eyes, and that beard. Sometimes that "Napoleonic look," indicating the gravity of the historic occasion. And Thomas was otherwise quiet and friendly, and I never saw him again. A few years later I learned from one of his old friends that he had overdosed while shooting cocaine in an abandoned house with his girlfriend in 2003. Rather than calling the police for Thomas, she was scared and ran from the house and only informed them 2 hours later. Now Thomas was dead.

Her Only Indulgences, 1979

Sandy, the mild prostitute at 18. Her haunt was "Eastern Avenue," supplying services to men needing people like Sandy. Initially, a sexually abused child from "Armistead Gardens," public housing in Baltimore City.

In her room were two framed photographs of terribly deformed children. I didn't ask but they were surely her siblings. Sandy was uneducated. Her only indulgences in life were a few beers and fun with her friends and later on a little witchcraft. For prostitution she earned a few months in prison. Her last years were lived with "Drag Queen Mary" on "Monument Street" and she died in September 1993 of AIDS at age 32.

M. H., 2000

Born in November of 1980, Melanie lived in Highlandtown on the east side but still fre-
quently hustled along Wilkens Avenue on the west side because that's where her boy-
friend, V. who also hustled, lived. Her father had abandoned the family, such as it was,
when she was 1 year old, and her mother became an alcoholic and coke user.

When I drove Melanie and V. home, they asked that I pull the car over on a corner
in their neighborhood. V. pointed out at least 3 corners in his neighborhood where heroin
was currently available. Each corner was staffed by one boy at a time from a larger rotat-
ing gang of teenagers. You pulled up to the corner, talked quickly and when he came back
you gave him the money and you received a package. You were done.

Melanie quit school in the 9th grade and began using heroin at 15 and now had to
hustle on the streets to pay for a 150 dollar a day habit. She did a little time for prostitu-
tion and possession. Her few attempts to get clean have been unsuccessful.

Michelle, 2002

Tony's girlfriend Michelle from the very end of Curley Street, a quarter of a block from Patterson Park. The street was named after a very popular Archbishop in Baltimore and so many residents in this working-class neighborhood were Catholic. Tony often lived in her basement as his parents were severe alcoholics and he wanted to live anywhere but home. Her younger brother lived with an older man somewhere in the neighborhood. Eventually she and Tony had 2 children and one of them lived. They both became addicted to heroin and for a while they hustled by the N.E. corner and sidewalks around Patterson Park, alone or together.

 Michelle, age 20, told me that one time one of her "steadies" had offered her a dollar a minute for her time.

135

George Orwell: 1984, 1984

Bobby never knew his father and lived with his mother and her girlfriend in "Armistead Gardens" a large project considerably east of Baltimore City. Bobby was curious about everything. Already he had written a little bit of poetry.

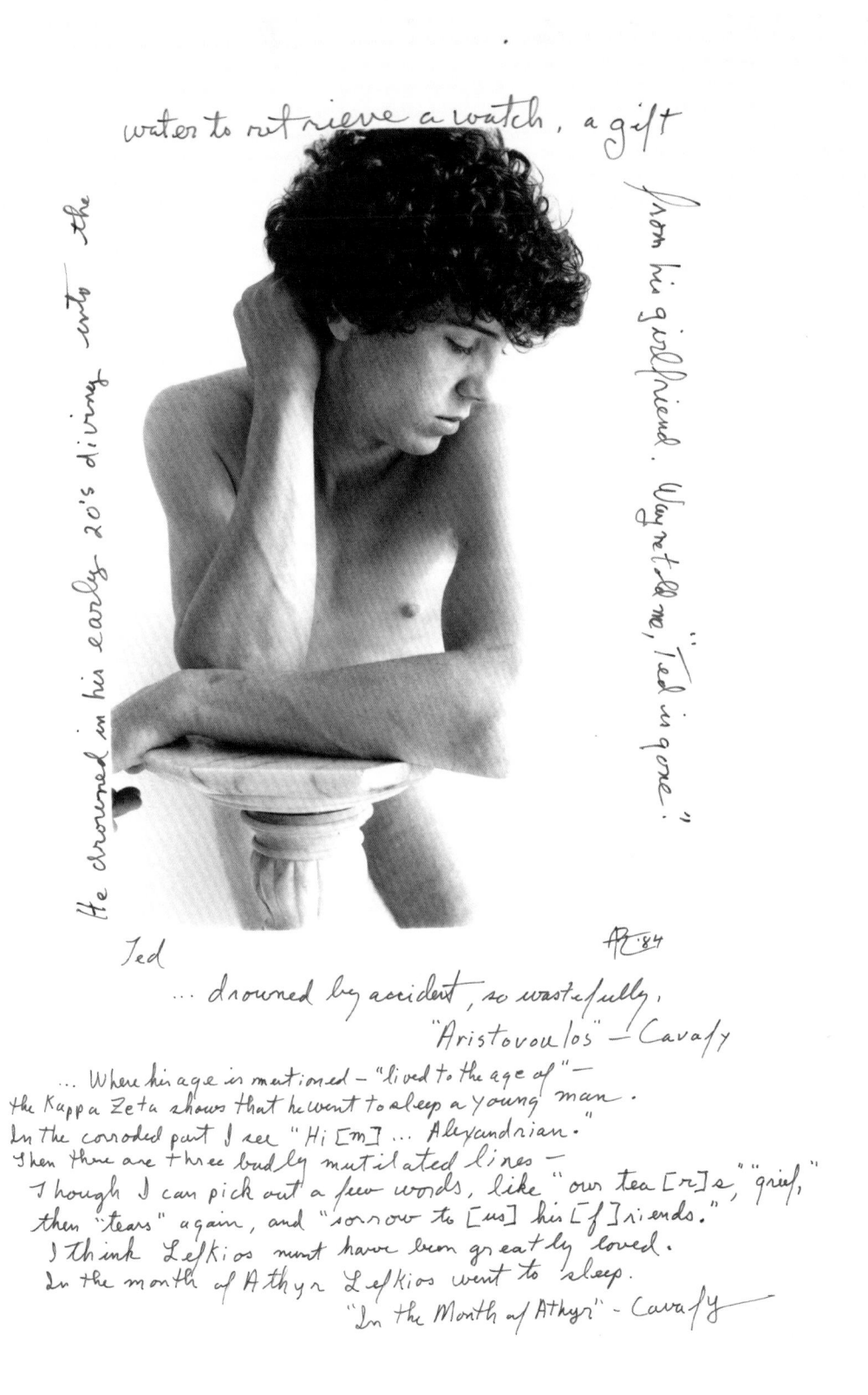

water to retrieve a watch, a gift
from his girlfriend. Wont tell me, "Ted is gone."
He drowned in his early 20's diving into the

Ted AP '84

... drowned by accident, so wastefully.
"Aristovoulos" — Cavafy

... Where his age is mentioned — "lived to the age of"—
the Kappa Zeta shows that he went to sleep a young man.
In the corroded part I see "Hi [m] ... Alexandrian."
Then there are three badly mutilated lines —
Though I can pick out a few words, like "our tea[r]s," "grief,"
then "tears" again, and "sorrow to [us] his [f]riends."
I think Lefkios must have been greatly loved.
In the month of Athyr Lefkios went to sleep.
"In the Month of Athyr" - Cavafy

Ted is Gone!, 1975

He hated his stepfather. At the beach he and a few friends had rented a small boat.
They had been heavily drinking and at some point, the beautiful wristwatch that his
girlfriend had given him for his birthday fell over the side of the boat. Ted jumped in
to retrieve it and never came up.

 At the funeral his girlfriend placed another wristwatch on his arm in the coffin.

Did Some Time, 1977

I met John in Leon's in 1977 when he was 19. He spent 4 days in my apartment on Madison. He left Baltimore for some place in Pennsylvania. "…when I left Baltimore, I ran into this chick and she fucked over me in more ways than one, so I was working for her father's security company, Globe Security and I ended up robbing the company of $38,000."

He wrote me a long letter and said he got on heroin and bought himself a 1971 Plymouth Barracuda with the stolen money then returned to them $37,000. He was arrested 3 weeks later and ended up at the State Correctional Institution in Camp Hill, Pennsylvania. He got 1 and a half to 3 years.

When he went up for parole, "…the Board fucked me over and gave me 15-months more to do. So, I was very hurt and upset and I tryed to kill a parole agent. So, I was charged with attempted to kill a state official and the Judge sentenced me to 10 months to 2 years running consecutive meaning after my 1 and a half to 3 years! I miss being high and drinking and being able to drive my car and live freely! can you understand that I'm not a criminal…I'm not doing well and can't because I need things and can't get them with my looks! …So far, I'm $85.75 cents in debt and don't care, because I don't have it and can't get it from anyone! …I'm scared because if Someone doesn't help me pay my debt then they'll get other inmates to hurt me. Like breaking my legs or arms I'm twenty-two years old and never had a Broken Bone in my Body…I asked you to send me Some of them pictures. It's cool to do So I have a guard Who'll be waiting on them and he'll do anything I ask him to do. So please send me a few nudes or not nude okay? 1-nude if your sending me any! The rest must be presentable, okay? I'm on the Jail's Boxing team and my record is 13 wins 3-loses 8 knockouts and 1-decision I do this to keep in shape and to keep myself alive! Write me soon! I want to remain as yours Amos—But you have to decide and help me—if you help me out then I'll repay you in Bed once I'm out of Jail my word! Love Always 4-16-'79"

Willy and the Social Secretary, 1977

One night in 1977 we decided that Stephanie K. was Willy B.'s Social Secretary. This done as the three of us made our intoxicated way from the Hippo after "last call" to Leon's, with a more flexible "last call" just 2 blocks away. Otherwise, how would 2 gay guys explain her? Willy was first an artist, then an actor, a bon vivant and last a waiter, a big necessity if Willy was planning to keep the other dramatic if not outrageous parts of his life functioning. Unfortunately, the bon vivant part of the equation got spectacular amounts of attention thereby encouraging him to consume far too many intoxicating beverages and mind-altering substances. Instead of needing a Social Secretary he needed 3 years of detoxification. But fortunately, a near fatal disaster, a "brush with death," did the detoxification work for him. In about a year Stephanie drifted from the club scene slowly and Willy?—his slight, fragile, and vulnerable blond image is now preserved vaguely in the minds of a rapidly dwindling number of survivors.

An Early Education, 1978

Renee photographed on the second floor of Uncle K's huge storage rooms and loft apartment at the northeast corner of "Fleet Street" and "B'way." Behind me three huge plate glass windows, fantastic lighting. During a cigarette break and now standing right next to the huge and sunny front windows, bending a little forward, the two of us, Renee easily made the day for five "Fells Point" teenagers innocently navigating the sidewalk of "B'way" directly below us!

Shivers, c. 1970

He is the first son of a friend whom I have known since high school. He was born when his father was attending college but then he left because of this situation and a mediocre academic record. His mother was prone to mental illness and his father, my friend, a part-time musician, a drinker, possessed a frequently ungovernable temper. He began using drugs by the mid '70s, lifting all pills and substances, controlled and otherwise, from the cabinets of friends and relatives. His personal behavior has alienated him from all remaining family.

10 Noisy Little Terriers, 1975

When my friend Bubbles arrived in Baltimore, he was living with old Dr. Gunderschimer and his 10 noisy, obnoxious little terriers and the sizeable cook named "Bea," who also did laundry.

For about 4 weeks, Dr. Gunderschimer had this slim, elfin-like boy temporarily staying with him and "Bubbles" named Dougie. How he ended up with the two, I had no idea. So, one day "Bubbles" called me on his land line and said, "I have somebody staying with me you'll want to photograph." Whenever "Bubbles" called me like that and said "somebody," he really meant "Somebody!," knowing "Bubbles."

You know, whenever a "fairy" or a "nymph" is required in a play by Shakespeare today, they are mostly played by a man in his late '20s or even '30s something and believe me they look it! Never by a young girl or a beautiful and very talented androgynous legit-imate young boy who could easily pass as a "fairy" or a "nymph." You haven't noticed or cared, probably?! Even seen one of the actual plays, actually?

Beautiful Punks, 1984

Once, Robert and his lover Randy were 2 intriguing, beautiful punks on the gay scene around 1984. Both were striking blonds with exploding hair, and they always wore black, resembling two members of an exotic religious order on acid. You hardly ever saw them in any of the usual gay bars and I was simply afraid to approach them. Yet Bob was kind and generous and creative and I learned that he was fascinated by animal bones and pain.

When this duo finally split up, without Randy as an anchor, Bob was adrift and lonely and hardly employable.

Increasingly, he drifted into drug use and especially heroin. Old friendships were ravaged, and he seemed to disappear into the larger sea of Baltimore. He ended his life in 1992 from some kind of overdose shortly after he had been diagnosed with AIDS.

A Beautiful Face

He had just graduated from an elite Military School just north of Baltimore City. He was working in a liquor store for the summer. Just the right thing for Cavafy, the Greek poet, to tackle. Lacrosse is a very huge thing for colleges and prep schools in Baltimore. Actually, I was a legitimate "preppy" and I never knew it. I didn't know what dock siders were. I was thinking of shoes. If you knew me then you'd know this. Yes, I had a little trouble with high school. I was a ——! You got it. But I had talent!

If you had a big lacrosse letter on your sweater in high school, you had a girlfriend. That LETTER was the perfect aphrodisiac, like cat nip and if you were really good at it you made something called "All Conference." I didn't know then what it meant and I still don't and don't care to know. If you were actually on it or in it, this fact would be hauled out for years and years in each Alumni Newsletter until you were dead. And it would still pursue you into Heaven forever and ever. Like the "Sex Offender List." Let's see if I remember somebody on it or in it: yes, there was Al, whom I was in love with and his rough looking ugly brother Joe, there was Henry, somehow related to the Headmaster! Finally, Billy, the top student, the top lacrosse star and class President who married his high school sweetheart. Gees!

The Brother, 1982

Victor lived with his mother and younger sister right on the border of a very active
Baltimore drug zone. His father had left them when Victor was about 13. And yet he
still managed to get to school every day and take his little sister with him.

And God decreed he would be a wild donkey of a man and his hand against everyone and everyone's hand against him. He was responsible for all manner of Mischiefs, countless Infidelities, and a few Villainies!

One night while eating in an Italian restaurant in "Little Italy" he morphed into an "Iranian Hostage," for one night only, Saturday, after 7 glasses of "Southern Gin." Snail shells were rolling all over the table, supposedly in celebration. He said he had been almost starved to death in Iran and finally the dim waitresses believed him. Now he was a hero! He signed 4 menus and announced his plan to run for Congress.

Among so many other things he was an excellent framer when he found time to work at it. His studio was on the top floor of a framing and art shop. It was always in chaos. It was also a 5-alarm fire just waiting to happen! But if you were fortunate enough to see it, you'd know right away that it was a poetic and visual masterpiece. The very beginning of "Conceptual Art." A possibility. The shop he was working in was owned by a man named Paul, a difficult and bitchy Naval war Veteran from WWII. He had many Black boyfriends and encouraged Keith's unconscious fascination with chaos and disorganization.

Keith changed boyfriends like underwear. Sometimes he'd fall asleep before consummation! He was often brutal and abusive and unfaithful and they in turn were more in love. But he attracted so many cute gay boys who wouldn't give me the time of day. He had this hypnotic presence almost anywhere he went, a modern-day Rasputin. I could never explain it but it was a good thing to be seen with him in the Baltimore bars. Sometimes he witnessed the dawning of the day but there were many more times when he didn't. He was dramatically self-destructive, but that just made him more fascinating and popular. Finally, it was the switch from alcohol to drugs that eventually was his undoing.

He was a "natural aristocrat" from a working-class household and this reality haunted him for the rest of his lifetime. Therefore, he liked to get close to a "genuine preppie" if one was available. And then he'd turn right around and make fun of them behind their backs. It was a lot of fun to listen to. It assured his superiority. But I was a "genuine preppie" as well and I finally learned that I got the same treatment. But I didn't care. He was still my best friend. As far as I was concerned, his friendship was so valuable in negotiating the gay world in Baltimore City at that time. He introduced me to so many people and took me to so many places I would never have known or gone to if left to my own devices. He could sniff out any "after hours" parties like a bloodhound. He could easily spot any as yet unrecognized gems in a Thrift Store. Sometimes he called himself the "Baron" and sometimes "Old Baltimore Stock." I called him "Uncle K" and he called me "Uncle A." Following one outrageous episode, he fell on his knees, threw up and then went to sleep!

He could talk any landlord into anything, they just loved him, up until the month he didn't pay his rent, so he was constantly moving. He introduced me to a gin called "Knotty Head," a blistering concoction of gin sold in a small, clear glass bottle with small glass bumps all over it, hence Knotty Head, a gin very well-known to every bum and every wino in Baltimore City. But his favorite he called "Southern gin" a gin viciously put together by southerners anywhere below the Mason/Dixon line in direct retaliation for losing the Civil War. A gin so powerful that even a rock would turn you on. This gin made him crazy if not dangerous.

He could impersonate anybody or anything. One Halloween night it was Dick Nixon. He was so good at it that you'd swear you were standing right next to the guy, arms waving over his head, in victory, before impeachment! Another year it was Rose Kennedy, by now a very old woman, so old and her skin so wrinkled and the rest of her body falling apart! If any old woman was as rich as she was, that well known and head of a large and powerful and illustrious family, she was usually referred to as a "matriarch!" My mother was not a "matriarch," and neither was yours! Another year it was "White Trash." He was definitely in the right city for that one.

Finally, he was fascinated with the writings of Flannery O'Connor, Tennessee Williams and Carson McCullers as well as the paintings of any "outsider" artists in Baltimore. One of those artists was Morris Sokolsky. I only visited Morris once, when I had enough money to buy one of his paintings. Now I have five. Certainly, nobody else seemed to be buying them anyway.

One night, on a weekend, of course, we both had been heavily drinking and probably headed for Leon's bar a few blocks away, when we passed this large concrete parking garage. We, right away, decided it was necessary to urinate, so we went inside and "did it" right up against a convenient and large concrete pylon. Weirdly inspired by this undertaking we had a contest: whose stream of urine could travel faster and farther and periodically we'd go back and replenish them, sort of helping them along and cheering. Unsurprisingly we attracted a little attention. Some ordinary guy driving by in a small busted-up car, shouted, "You two are fucking crazy!" Well, life comes at you fast!

I had three Best Friends in my lifetime. Each one of them very intelligent, charismatic, inventive, and self-destructive. They were my angels. And now every one of them, dead. In a few years I will be joining them, hopefully "Downstairs." Going "Downstairs" is not for sissies! Once together again we'll probably be able to teach the "Guy" who is still running the "PLACE" a few tricks of our own!

In the end Keith was shot to death by two teenagers with a stolen Police "Glock!" He and his current boyfriend had been returning to his boyfriend's apartment after a night in a bar close by. His last words were: "Terry, Help me!" Police recovered the gun and the teenagers, both got twenty years! They should have gotten 20 lifetimes!

The talented and charismatic Keith Heppert; a for one night an "Iranian hostage", antique dealer, occasional artist, practicing alcoholic (speciality, "Southern gin") author of an unpublished monograph on putty knives, a reservoir of personas, last and only director of the S. No Gallery at 1730 Maryland Avenue, Baltimore and enfant terrible xxx-traordinaire. He was shot to death in August of 1995 by two sixteen year olds. He was 41.

AB 1976

Art Disrupters, 1999–2002

Michelle and Dennis that day were working the sidewalks bordering Patterson Park
along "Baltimore Street." It was a bright afternoon. They both knew each other very
well. As Tony's girlfriend, there was no trouble in the photography department.

 I remember pretty well, many decades ago in NYC, some images from the
"Saatchi" Collection where one artist had created somehow, a number of life-like sculp-
tures that looked exactly like this photograph. So, you can imagine! I don't remember
the name of the artist, but the stuff was disruptive for sure. Outside the Museum there
were bunches of old ladies, some nuns, some friends of Jesus, some Salvation Army
types, all of them begging people not to go inside, warning them of Hell, the whole busi-
ness of "Salvation!"

Billy, West $ Side, 2002

One of the stories Billy had to Tell Me: Billy told me he had 2 different fathers and 2 different last name names. Neither man cared anything about him, one eventually in jail for murder, so he drifted into hustling and drug use in the west side neighborhoods. There was not anything else to do in those neighborhoods anyway. His body now accumulating tattoos and showing the signs of total neglect.

This very hot summer in 2002 he and his new girlfriend were living inside of a large junked "Dodge Caravan" in an abandoned junk yard just a few minutes' walk from Wilkens Avenue. If they bathed at all it was usually at her mother's when they could locate her in the west side neighborhood. She sometimes gave them a little money, but all the rest derived from the streets along Wilkens. The tattoos and the other marks on his body were already telling a story.

His girlfriend started using heroin at 15 or 16 after her father abandoned the family and her beloved grandmother died. She lost interest in school, became rebellious, doing anything she wanted to do, any time.

A Life—My Angel!, 1975

Jackie as she was in 1975—the '70s, the best and the last decade for Baltimore. The period from 1960 to the mid-'80s offered a visual and sexual paradise as far as the streets and the gay bars were concerned and by some "Twist of Fate" I had been ordained to record it. Not just to record but to survive it! A photographer's dream! The streets and bars of Baltimore City, always a packed harem.

While still living in Baltimore Jackie was one of my best friends. Sometimes when together, we would trash the "Universe," Baltimore, and everyone in it, specifically. It was our Oxygen! Jackie was talented, creative, charismatic, and self-destructive. But all my best friends, as well as myself, were self-destructive in one way or another and now nearly every one of them, except myself, Dead.

She introduced me to so many people and took me to so many places I would never have known or been to if left to my own devices. If you ever went into a bar or a restaurant of a certain type with Jackie, right away everyone noticed. I am thinking about "The Old Tahiti," an intriguing bar in South Washington that had seen better days. It was just 2 blocks away from an old Greyhound bus station. If you knew anything about Greyhound bus stations in the '60s and '70s you'd know right away that this bar and the bus station, put together, were a wild combination! And then there was the "Chesapeake House" a few blocks away where all the cute young dancers were nude and receptive. This place was run by a testy and nasty old queen named "Augie." A real Ass and the hole that went with it! So, it wasn't too long before I was "barred," just one time touching the merchandise and a few other things! But, in truth, I never touched anything, I didn't have the balls to do it, but the guy sitting right next to me did! He must have squeezed a little too hard because the nude dancer had to get off the bar and recover.

But Jackie's real passion was "rockers," she had lived with and loved so many. But whenever one of them decided to leave her, she threatened suicide. The last rocker boyfriend, "Tosh," was living in Washington, not Baltimore. He had this large colorful juke box in the middle of the room and a large collection of colorful exotic snakes and lizards of all sizes and temperaments, some of them hanging on things, some of them crawling or sliding around the apartment, only a few of them left in cages. The hotel maintenance staff refused to go in there. So finally, when Tosh decided to leave her, the ending was traumatic and her attempt at suicide nearly successful. So, at last, she realized she had to get out of that life in Baltimore and Washington, escape somewhere else or die.

Her grandmother had just died and had left her a small, quaint little house in "Hazelton," a dull mining town in southern Pennsylvania. And now the life as she had always lived it was over. I visited her once; we went out to eat. No fabulous bars to go to. It was obvious she had put on some weight. The energy and the smile, the humor and the charisma were gone. A disturbing tear now and then. Her therapy sessions, Mondays, and Fridays at ten. After that I never saw her again.

Rat in a Cage, 2000

Branch was born in 1981 and had lived on his own since the age of 10. To take care of himself he sold drugs and later on, hustled men. He has a son but admits his bi-sexuality and has had several boyfriends. Briefly he danced at Atlantis. His seriously chaotic life has been a round of arrests for robbery and jail time and powerful and barely controlled emotions hover just below the surface.

"Sometimes I feel like a rat in a cage." He said he has owned 26 or 27 guns and been arrested at least 135 times. I had no choice but to believe him. He said, "going out" with "fruits" did not pay enough money and he started robbing small businesses: McDonalds, Burger King and in 2001 he robbed Quest, an eastside gay bar one block from Eastern Ave.

Talking about gay bars he also robbed Butt's and Betty's. He had been there frequently to meet men. I guess I was lucky.

Disappear, 1976

Bonnie was a young proud rebellious lesbian in 1976. She was eagerly seeking this identity and otherwise always quiet, very kind and helpful. But the persona and the casing hardly matched. If it were not for that hat and the striking black leather, you would hardly know she was there. Her best friend all the time was Aaron and the two of them would hang out at Leon's. It was so cool and comfortable to talk and meet friends there. And Aaron was so well known in the small Baltimore gay community and an organizer and supporter of local artists. He was also the first person and friend I knew who died of AIDS. One day Aaron just seemed to disappear inside a hospital and for a long time no one knew exactly why he was there. He didn't want visitors. This was in the early '80s, a time when people could still believe that AIDS was just another gay venereal disease and meaning another checkup, another thing to take medicine for. And even after he died there were just rumors floating around among his friends as to the cause. And quickly Bonnie fully rejected her lesbian identity that had once seemed so solid, embracing a new life and a larger set of friends: the Salvation Army. Just once I saw her on the sidewalk outside the Lexington Market on Paca Street, singing and asking kindly for some money.

Rough Trade, 1999

He came from a challenged working-class neighborhood, Remington, that had seen better days, but you couldn't call him working class because he was never working. He was obviously available, first, but also a pimp, a blackmailer, whenever possible, a bully who could barely read or write. He was a heroin addict who lived with a girlfriend who paid the rent. Just one time he actually worked for about a week delivering pizzas using her car. Sometimes he could threaten you or blackmail you if he could.
In a few years, this rough guy got rougher and rougher and could be seen in the old neighborhood just standing there just looking, with nothing to do, becoming a visual duplicate of Charles Manson.

First Time, 1982

Michael and his older brother were adopted. His new father was a volunteer fireman and the mother raising 3 small kids of her own. It was obvious he had never stood just naked like this before anyone, let alone a strange man with a camera. He had just taken all his clothes off and dropped them on the floor of the small kitchen just to the right of him, walked out and stood there so quietly, so peacefully, arms folded … watching me. All it took was 1 or 2 shots to capture his beauty.

If I told you this is a photograph of a restored wall mural of a beautiful accommodating slave boy salvaged from a suburban patrician villa at either Pompeii or Herculaneum, you wouldn't believe me. Besides, there is that one pair of very expensive Gucci Aviator sunglasses GG0016S, to account for.

An American Hustler in Baltimore, 1975

Mostly the boys came from the many ethnic working-class neighborhoods in Baltimore City and it's probable that this had included some of their fathers and grandfathers, uncles and cousins, brothers, and casual friends as well. In Baltimore hustling was just a time-honored tradition like you might say a family institution and going way back beyond the time of father Abraham and Walt Whitman. Way past the time of the Renaissance, Caravaggio, and the Ancient Egyptians. I'm guessing, but maybe past Methuselah and now I'm even wondering about the cave men. It might not have been called hustling back then but by any name at all it "was" hustling and always a reliable constant in all of gay history. At times even institutionalized and given a recognized and legitimate place in secular cultures.

Nobody ever traveled countless miles across country just to hustle in Baltimore. But they did travel those countless miles just to get to New York City, Los Angeles or San Francisco, big cities where things could get dangerous and desperate and hustling was almost the only means of survival. A lot of these boys had been hitch-hiking along the way so you can be pretty sure they had been hustling before they even got there.

In much earlier days there were the hordes of newspaper boys, messenger boys, the telegraph boys, the shoeshine boys, janitor boys, the grocery boys, the saloon boys, the shipyard boys, the streetcar boys, and the Union "powder monkeys" on war ships at the time of the "American Civil War" and every last one of them had plenty of competition. In fact, a very, very, very, short history of hustling.

On the streets there is always undeniable humor along with an Infinity of pain. The Language of Prostitution is the only means of erotic communication available to so many in our society of exploitation.

Mt. Vernon, late 1970s

One of the main places to hustle uptown was the Mt. Vernon meat rack. The rack pretty much comprised one entire block and 3 of its corners were especially active. One of the corners was directly in front of Grace and St. Peter's Episcopal Church, another at the busy corner of Madison and Park and a lot of the new boys in town sat there. And all this stuff was just 2 blocks from my own apartment on Madison Street. No wonder I never had to leave town for San Francisco or Rio. Madison Street ran east in those days and cars could circle the block as long as it took. In the early '60s the price was a deuce and the first time I had to be told what a deuce was. Not surprising considering my background. The most common street names were Shawn or Sean, Steve, Mike, Billy, and the boys came from all over town. If they had a home, it was usually just a place to sleep in, otherwise pretty uneventful and boring. Funds were spectacularly lacking.

For one or two humid nights in the late '70s Danny was sitting with his friend on the long front steps of what was then the entrance of the old Alcazar Ballroom and now a part of an art school. Neither of these boys on the historic long steps were looking dangerous. They were looking pretty good and happily waving. A little adventure on a Saturday night hopefully with some money attached.

The Boy in Collage with Flowers, late '70s

One night mid or late '70s I'm sleeping in my bed and it's about 3 A.M. and the phone rings and it's this kid. This was in the days when every telephone was personally installed by a Ma Bell representative, and you could never turn the damn things off. So, I said what do you want, and he says he wants to see me, and I say what for and he says he just has to see me, he'll never do it again and he needs 3 dollars real bad.

So, I say you'll have to wait at least a half hour and he tells me where to meet him. At some point soon in about half an hour I drive to the east side and meet him where he said. So, he gets in the car telling me he's been kicked out of the house by his mother, and he needs 10 dollars. When I get my wallet out at close to 4 A.M. a knife appears so fast at my throat it takes a few seconds to realize it's really a knife and he's holding it at my throat and it's really happening. Then he says he wants all my money and the car. If you can imagine.

In those days I was either drunk or recovering and semi-sober, but I was used to thinking fast in under this kind of pressure considering what kind of things on the streets I was doing. Somehow, I convinced him to let me drive around the corner onto a more populated road so we could talk as if this was going to solve anything.

So, we pulled up in front of this fast-food place, a common one around everywhere in those days in Baltimore but I forget the name, probably a Jack-in-the-Box where you could get a "jack" and soda, a "jack" and eggs or a "jack" and coffee. A "jack" was meat.

We stopped across the road from this establishment, and I insanely remembered that I knew this place because at one time at the end of an all-night street crawl with a friend before going home we came here to get a hamburger and soda, maybe around 3 A.M. I guess and I actually saw a single pubic hair on the countertop where the food came out. My friend confirmed that it was indeed a pubic hair, and we were equally amazed. But this was Baltimore.

I then continued talking fast again and giving him all my money and telling him that taking the car was not a good thing because unless he killed me, he would get caught definitely and soon. He thought a few minutes while I kept talking as a form of distraction like a brief comic scene in a play that's otherwise a tragedy and then he took my money, not all that much, left my wallet and me with the car and disappeared. Dumb luck that has always pursued me like a Fury for at least 60 years was still doing its thing.

He Ignored it for a Long Time, 1997

I first met Eddie on the streets of his own neighborhood on the west side about 1997, close to Wilkens Avenue. Always a big smile and a kind personality to match. He was now living with his grandmother; his own parents had abandoned him when he was 13. He did some hustling in his neighborhood and was now beginning to use heroin.

At the suggestion of a friend, he was now doing nude dancing at two strip bars in Washington: Secrets and La Cage. It was not an easy life. It involved a commute from Baltimore in his girlfriend's car each day and then back to Baltimore about 3 in the morning. The very noisy smoke-filled bars, the booze, the frantic men and boys, the groping hands for so many hours. Following all this, the dancers had to help with the clean-up so when he returned to Baltimore it was almost daylight. Now all "pumped up" for performance, gone was the slim lithe body, the hypnotic smile. He made a few porn films in Washington, one called "Master and his boys," 64 minutes, 75 dollars: "A Master whips his young slaves into willing submission. You will get worked up as he forces his slaves to act out his own wild and lustful fantasies!"

Gradually Eddie began to realize that he might be gay, a reality he had ignored for so long.

When he finally returned to Baltimore, one night in 2002 in his old neighborhood, he was brutally beaten by 3 teenagers, possibly a bad drug deal and sustained traumatic brain and rib injuries. He died in the hospital that same night, December 9th at 28 years old. Somebody managed to write a memorial and using his picture taken when he had just graduated from high school: the formal clothes, the hypnotic smile. It seemed a very promising future.

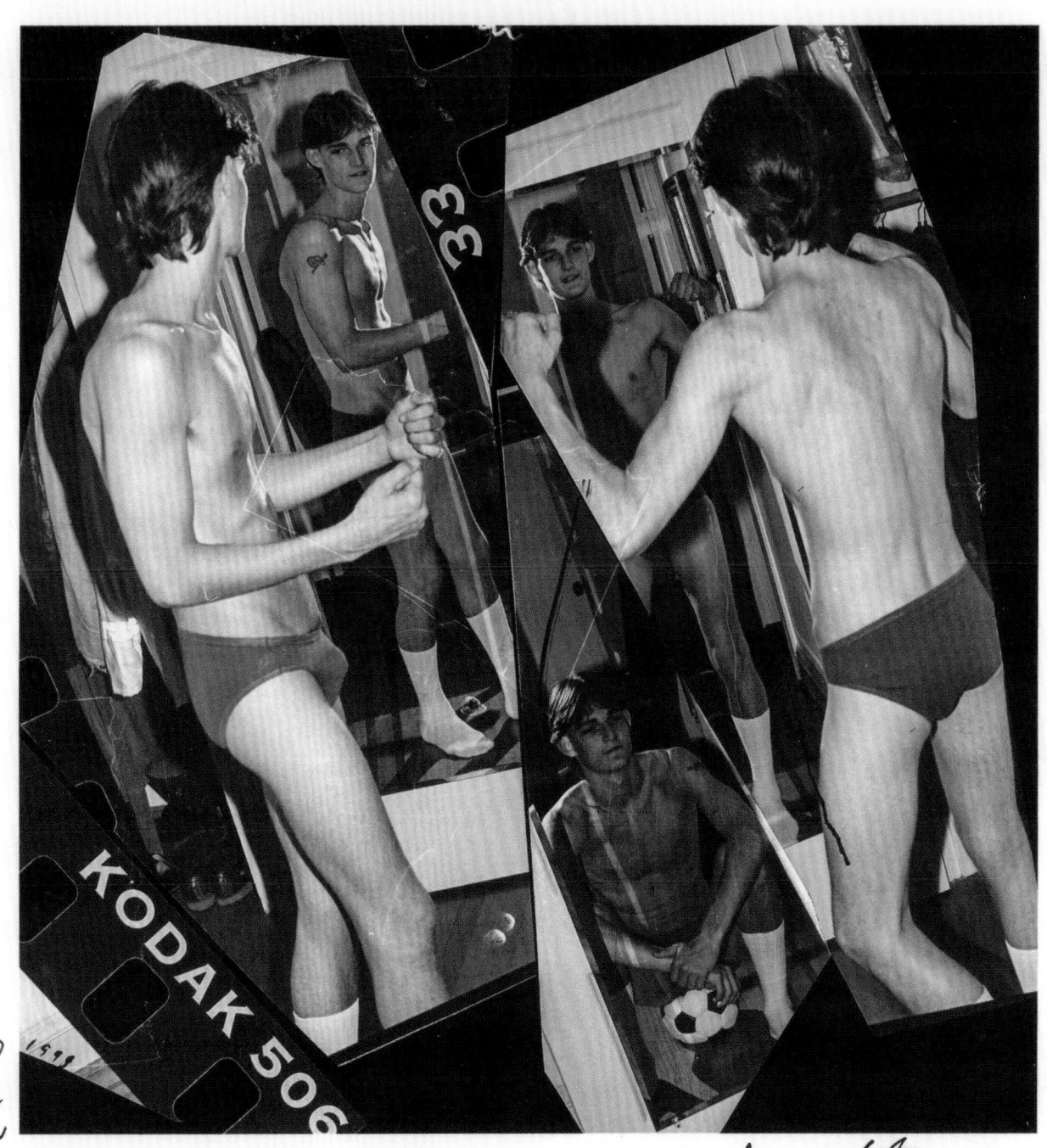

Eddie lived with his grandmother in a small west side neighborhood. I never asked him, what happened to your parents.

Billy of Baltimore Street—"Faster Than a Heartbeat," mid '70s

On Eastern Avenue, "the Avenue" boys would be sitting on the white marble steps of row houses, hitch-hiking in either direction as long as it took, knowingly signaling with their eyes and a slight movement of the head, their availability. Many men traveled to Baltimore from other cities and other districts, like the District of Columbia, to bear witness. They weren't casual observers preparing to write tour guides.

On the opposite side of the Park, the north side, along Baltimore Street, there were about 15 street corners for casual loitering: Montford, Luzerne, Glover, Lakewood, Belnord, Kenwood and Streeper. The long steps in front of Saint Elizabeth of Hungary made an excellent launching pad as well, but some of the boys living close by would not want to be seen in such an obvious location. The non-local boys didn't care.

Some evenings, Billy could be found at the corner of Kenwood or Streeper. Streetlights made shadows form at the house corners and Billy would be there in the late evenings, for maybe one or two summers, mid-'70s. Always he was casual and friendly, with a large black comb at the ready, in his left front pocket. Oh! (as Rimbaud could so often begin a line of poetry), those hot, heavy, and so humid Baltimore evenings, each night having its own particular smell, its own particular fantasy, its own particular ecstasy, or danger. In those times the city seemed so labyrinthine, so compelling, so endless and resistant to change. And I, for one, really believed that it would all last forever and myself along with it, all of it so sanctioned by the ages. I was so much younger, so clueless and obsessed and I knew no tomorrow. Yet all of this did change and so quickly vanish from history. Faster than a heartbeat.

In memory of Cardinal Francesco Maria del Monte, Caravaggio's first very rich and very powerful first Patron, early 1500's.

Out of Hock, n.d.

Every year or so someone would get Dennis' jewelry out of hock. Who knows where he got the money for the "grillz!"

Keys, c. 1970

I was taking this guy back to his neighborhood one night none too sober and we were heading down Patterson Park Avenue which undeniably sloped downward toward "the Avenue" which was Eastern, and he says to let him out right here.

I say OK and stopped but just before he gets out, he grabs my car keys pretty fast, leaves the door open, runs in back of the car, across the street and into Patterson Park. I don't know if he did this to get back at a person of ambiguous and un-American sexual tendencies or that it was just something he had to do for diversion because nothing else is going on in his working-class life anyway or he somehow was planning to sell them back to me for a price at some future unspecified date which turned out to be sooner than later.

Instinctively, I put the car in neutral, an old VW, thought I'd pulled the emergency brake on and took off after him, just into the edge of the park when I noticed the car slowly drifting down the avenue headed for Eastern at the bottom of the hill. I started running, but there was no way I was going to catch it. So, the car continued drifting down I guess one block and just at the intersection of this neighborhood cross street it unbelievably makes this right turn and comes to rest against some parked cars on the left side of the street.

I found this out when I finally got there. Little to no damage, anywhere. Makes you wonder. But I'm not finished. So, I see this man sitting on the marble steps of the first row house on the block on Patterson and I tell him this kid stole my car keys and my car is sitting on the cross street, a dramatic event which he probably witnessed anyway. I make up some story as to how it happened but obviously this is one of the most famous, and I guess for too many others, the most notorious hustling areas in the city and I'm not sure he really believed me.

So, we're talking, I'm pretty confused and desperate and in a matter of about 10 minutes he notices this kid about six blocks down, basically on Eastern, waving in our direction. He suggested it was probably the same kid who took the car keys, so he agreed to walk down and see what he wanted. He comes back and says the kid will sell the keys for 25 dollars. So, I give him 25 dollars, he walks down and gets the keys back.

I talked to this man in a rapidly sobering state a while longer, thanking him many times, it was really a miracle, but my life was miraculously full of these Spielbergian happenings. He says no problem or the late '60s or early '70s equivalent meaning the same thing. It was all certainly more compelling, better than television. Then I got back in my car and drove back to my apartment at 18 "East Madison Street." I was done for the night.

Hour of the Wolf, 1972

The hour between night and dawn, where sleep is deepest.
When nightmares are most real.
It is the hour when the sleepless are haunted by their worst anguish.
When ghosts and demons are most powerful.
The night when most Phantoms and fears of the unknown grow.
 —Ingmar Bergman

A Tale of an Old Mattress, 1999

This dirty old mattress just leaning against the wall in a basement. With or without one, two or three of my models upon it. Why was it where it was when I found it? It smelled and had obviously been used inconsiderably for so many years. It held too many secrets. When I, a photographer, finally got to it, I didn't help matters at all.

① Endymion was an Aeolian shepherd prince, renowned for his exquisite beauty and loved by the Titan moon goddess, "Selene". Accounts differ slightly depending on which one of them you are reading or all of them. The Titan gods were created

② from "Chaos" and preceded "Zeus" and the "Olympians". Each night the Goddess watched over Endymion in her moonlight as he slept peacefully beside his herd of cattle at the foot of Mt. Latimos.

③ Endymion too was in love with the Goddess Selene and he wished to remain forever young and beautiful like the Goddess but his wish would be granted if he also chose a time to die —

④ and so he opted for "Eternal Slumber". Sleep was defined as a form of Ecstatic Death and likended to the joys of love. His wish was granted so each night the sleeping youth was visited by his "lunar lover" and bathed in pale moonlight they would consummate their love. ♉ 1972

Wood Ears, n.d.

"The fields have eyes, and the trees have ears," a sea with a thousand faces. A proverb in ancient Latin literature in the High Middle Ages. So, it's impossible to pass unnoticed with all the eyes and the ears working properly. We are under constant surveillance; you cannot speak without being heard. Sounds like a thriving Dictatorship to me. "Speech is silver, silence golden." So be silent and listen. There exists a large floppy blackish mushroom called "Wood Ears." I ate one once in a small Japanese restaurant in South Baltimore in the late '70s with my friend Keith. We were both drinking heavily and both of us laughing, ignorantly making fun of the little mushroom. "Wood Ears!! You gotta be kidding!" "Wood Ears! Just leave it to the Japanese!" But at least now I know where they came from and why they are called "Wood Ears."

Shower Series - The End, 1998

Shower Series
"The End"

Death of a Hustler as Seen From Heaven, 1993

One Saturday night Larry was bar dancing at Atlantis. His movements were stiff, uninspired, and awkward, and too obviously his heart wasn't in it. But he had his admirers, anyway. Some man must have brought him down to this place, not any place he would have even looked for or found on his own.

I knew Larry for almost 11 years. At first, he had no job and desperately needed money. He had a wife and 2 kids. Whenever he was with me, she'd call in the evenings, asking him where he was and when he'd be home, he'd say he was meeting a friend, maybe looking for a job or just busy. His father, Italian, with some Mafia connections, had much better things to do in his life than staying home with a wife and raising a kid. Larry watched too many times as his father verbally and physically abused his mother, an American Indian, a truly terrible and very frightening thing for a young boy his age to be watching! It would haunt him for the rest of his life and making him afraid of any close connections or close relationships with anybody. His father had probably sent him to a military school in Maryland, just to get rid of him.

For several years Larry really needed money with very few ways to make it. He seemed very willing to use his body with an older man to make it, but these relationships didn't last long, maybe one night or a week.

I quickly learned that as long as some form of "straight" pornography was available he had no trouble at all with some form of immediate sexual contact with a man. He always told me that he never connected with any other men, but the evidence was there that he did. But gradually, over the course of a few years, I was slowly learning that it was far more than just the money that Larry was looking for even although his need for "straight pornography" was "genuine." In a few more years he was finally beginning to get his life back together, this time seeking some form of steady employment like learning to be a plumber. But somehow our relationship continued. This went on for a few more years and I began wondering just what it was, all along, that I was offering him? I figured that maybe he just needed some kind of a relationship with an older male whom he trusted, somebody who was showing him some form of kind and genuine attention, a form of love by someone who, in some way, needed him, considering his very lonely, loveless and frighting childhood and the sexual part of this attention was specifically geared, unintentionally, to increase that.

At the end of our relationship, he was no longer expecting any cash payments from me whenever we got together. Which, at first, was significantly confusing but I said nothing to him about it. All along, without telling me, he had been working to obtain his real estate license. Once he was qualified, he left Baltimore and moved somewhere west, and I never saw or heard from him again. His mother adopted and raised his 2 kids as her own.

A MECCA FOR YOUNG HUSTLERS AND DADDIES:

By the late nineteenth century, cities across the United States constructed red-light districts—often called "tenderloins"—as zones of abandonment where the degradation and immorality associated with the poor, sexual and gender deviants, and racialized populations could be contained and cordoned off from respectable white families and homes. These seemingly abject, anti-domestic, transactional, and profane districts were at the same time incubators for rich kinship networks, syncretic religious practices, and oppositional politics. Street kids, sustaining themselves through prostitution and other criminalized economies, created a counterpublic complete with rituals for renaming new members, conventions for collective housing, and networks for pooling resources to increase the chances of mutual survival. Many migrated from tenderloin to tenderloin, often in sync with festival and seasonal patterns, creating a sprawling web of familiar places and kin.

By the mid-twentieth century, after reformers succeeded in shutting down red-light districts in most cities, street kids and hustlers were banished to a criminal urban underclass.[1] Hustlers and street queens gathered on "meat racks" or "meat markets"—phrases referencing the sex workers displaying themselves like products in a food market—and the assemblage of dive bars, hotels, theaters, and arcades in which they lived and socialized. The "traffic" in male prostitution, an early homophile organizer reported in 1964, took place "in the tenderloins, the Pershing Squares, and the Main Streets" across the country, in "the streets, theaters, gay bars, sailor hangouts, pinball palaces, hotdog stands, and the parks and street corners of the 'meat blocks' of some of the main thoroughfares."[2] Congregating in these spaces were immigrants, racialized populations, and tourists who—crossing moral and physical boundaries—slummed for sex and entertainment. Before the gay liberation movement of the 1970s, these spaces were the center of the best-known homosexual public cultures.

I show in my book *Kids on the Street* that the marginal position of street youth—the self-defined "hair fairies," "boys," "queens," and "undesirables"—was the basis for a moral economy of reciprocity and mutual aid. Tarnished as criminal and immoral, as undesirable blights on downtowns ripe for reinvestment, street kids developed a flexible and fraternal accumulation of obligations and reciprocities by which they could "watch each other's backs."[3] As early as the late nineteenth century, they were in turn "taken in" by an older, paternal community of survivors, intermediaries, and caregivers (for example, bartenders, bouncers, and johns) for whom the kids remained, after all, the principal draw for the formal vice economies. Moreover, runaway and "throwaway" youth traveled migratory circuits that connected far-flung districts and the people who traversed them, all the while fostering alternative socialities, cooperative economies, and novel forms of mutual aid.

The photographer Amos Badertscher was among the actors who animated this street-based economy in and around Baltimore's meat racks from the early 1960s through the early 2000s. Known as the "early-morning john" among Baltimore hustlers, Badertscher's photographic sessions—for which he paid subjects small sums of his own inherited money—were part of the accumulation of financial transactions that animated the meat rack scenes.[4] His photographs document the transactional, intergenerational relationships—the hustling way of life—that were among the most visible manifestations of homosexuality before the gay liberation movement.

The moral economy of reciprocity that people developed on meat racks across the United States during the twentieth century is essential to an understanding of Badertscher's work. His relationships with the boys—as documented in his photographs and writing—is a manifestation of this moral economy as it played out on Baltimore's many street corners, parks, and backroads.

While street kids' social worlds took historically and geographically specific forms, their ethic of reciprocity appears to have crossed the decades and geography, therefore indicating some continuity in the history of their moral economy. For this reason, we can begin to understand the kids' sense of justice and exploitation by examining the principle of reciprocity, a principle based on the simple idea that people should help those who have helped them. More specifically, according to James Scott, it means "that a gift or service received creates, for the recipient, a reciprocal obligation to return a gift or service of at least comparable value at some future date."[5] Anthropologists argue that the norm of reciprocity is steeped in morality: by giving, receiving, and returning gifts, a moral bond is created between people exchanging them. Reciprocity thus contributes to social cohesion.[6]

Hustlers and street queens were motivated to help one another because they themselves anticipated needing assistance at a later date. In their own interest, they cooperated to survive. The norm of reciprocity also applied to relationships between kids and those who animated the meat rack vice economies. For example, the management of meat rack businesses—bars, arcades, hotels, and theaters—often allowed sex workers to congregate because they would draw paying customers. The all-night coffee shops and diners that allowed street kids benefited from the patronage of hustlers and street queens, especially at night, when "respectable" people were asleep in their homes. Pornography studios were often located in or near meat rack districts, including those for publications such as *Athletic Model Guild*, *Physique Pictorial*, *Butch*, and *Tiger*.[7] As such, these actors developed a collective vision of the proper economic functions and performances of those who animated the downtown "vice" economies.

While these informal networks based on reciprocal exchange were vital strategies of survival, they were also critical components

1. M. L. Keire, *For Business and Pleasure: Red-Light Districts and the Regulation of Vice in the United States, 1890–1933* (Baltimore: Johns Hopkins University Press, 2010), 3; Ruth Rosen, *The Lost Sisterhood: Prostitution in America, 1900–1918* (Baltimore: Johns Hopkins University Press, 1982), xii.
2. Harry Benjamin, M.D. and R. E. L. Masters, *Prostitution and Morality* (New York: Julian Press, 1964), 316.
3. Joseph Plaster, *Kids on the Street: Queer Kinship and Religion in San Francisco's Tenderloin* (Chapel Hill, NC: Duke University Press, 2023).
4. Barry Reay and Branka Bogdan, "Queer Baltimore: The Photography of Amos Badertscher," *Sex in the Archives: Writing American Sexual Histories* (Manchester, UK: Manchester University Press, 2019).
5. James Scott, *The Moral Economy of the Peasant: Rebellion and Subsistence in Southeast Asia.* (New Haven: Yale University Press, 2006), 168.
6. On reciprocity, see Bronislaw Malinowski, *Crime and Custom in Savage Society* (London: Paul, Trench, Trubner, 1932), 30–50. See also Marcel Mauss, *The Gift: Forms and Functions of Exchange in Archaic Societies* (Glencoe, IL: Free Press, 1954); Cyril S. Belshaw, *Traditional Exchange and Modern Markets* (Englewood Cliffs, NJ: Prentice Hall, 1965).
7. See Thomas Painter's letter to Alfred Kinsey, March 10, 1966, Painter Collection, Kinsey Institute; David K. Johnson, *Buying Gay: How Physique Entrepreneurs Sparked a Movement* (New York: Columbia University Press, 2019), 25.

DOCUMENTING BALTIMORE'S MEAT RACKS Joseph Plaster

<u>A BRIGHT AND CHARISMATIC DEMON #1</u>, 1998

of a counter-discourse that enabled kids to critique the dominant culture and develop an alternative set of values against which the worth of individual lives could be measured. Because street kids and street queens existed towards the bottom of the moral and economic structure, they were in a position to see the discrepancies between the ideals of American culture and their actions—between respectable "fronts"—public personas—and the deviant and exploitative behavior that "front" sometimes covers over.[8] Many developed an irreverent attitude toward society's "morality" and rejected as hypocritical the "respectable" world that condemned them while simultaneously purchasing their sexual services. Many street kids insisted on the value of sociality and sexuality untethered from the nuclear family, reproduction, and the gender binary and dramatized their moral vision on downtown streets and boulevards in spectacular fashion.

Street kids often approached commercialized sex as one component of a street-based moral economy, one that operated according to different values than those enforced by the dominant culture, but which nonetheless served to shore up the self-worth of the marginalized. I conducted oral histories with more than eighty people for my book *Kids on the Street*, who often presented commercialized sex not as inevitably exploitative but as an oftendangerous means of survival that nonetheless shored up their value. Tamara Ching, for example, told me that sex work in San Francisco's Tenderloin enabled her to develop a self-worth. "Out of sex work I got esteem," she said. "I knew that people couldn't make fun of me because they couldn't afford me. Being one of the few Asian and Pacific Islander hookers back in the sixties and seventies, I was at a premium."[9] While outside observers often approach prostitution as exploitative, especially when there is a significant difference in age between client and sex worker, these were not widely held views among street kids.

While the street scene was animated by an ethics of reciprocity, there were as many exploitative dynamics operating within this migratory world as there were threatening it from without. As a general rule, the kids considered relationships to be exploitative when they violated the norm of reciprocity: the idea that a service received creates a reciprocal obligation to return a service of comparable value.[10] For example, the kids might consider a john to be exploitative if he refused to pay or did not honor the agreed-upon fee. Joel Roberts, who

8. For this formulation I am indebted to Esther Newton, *Mother Camp: Female Impersonators in America* (Chicago: University of Chicago Press, 1979).
9. Oral history by Joseph Plaster with Tamara Ching.
10. Scott, *The Moral Economy of the Peasant*, 170.
11. Oral history by Joseph Plaster with Joel Roberts.
12. George Henry and Alfred Gross, "Social Factors in the Case Histories of One Hundred Underprivileged Homosexuals," *Mental Hygiene* 22 (1938), 606; see also H.

hustled San Francisco's Tenderloin in the 1960s told me, "Today, what people think is exploitation is just having sex with somebody young. I don't think we felt exploited by the john unless he didn't pay you what he said he was gonna pay you."[11] Hustlers who were displeased with clients could also supplement their earnings by robbing, extorting, and blackmailing them. Because closeted homosexuals needed to conceal their nonconformity, large sums could be extorted from them without danger of arrest.[12] As such, relationships between street hustlers and clients could sometimes be exploitive and sometimes offer forms of mutual reciprocity.

Non-hustling homosexuals who congregated in meat rack districts often adopted street kids' moral vision as their own. A 1941 sociological study, for example, followed a Times Square john who "lessened the intensity" of his conflict with his homosexuality "by gravitation to the society of male prostitutes." In time, he began to "challenge polite society" by pointing to "their pretense and hypocrisy."[13] A homophile organizer in San Francisco's Tenderloin reported in 1966 that it was like "seeing behind the power structure when you watch a lovely big Cadillac drive up, pick up a boy and a businessman goes off and the boy's back an hour later with $20 in his possession. And this man may have been a judge or an important politician or a high placed lawyer."[14] For many homosexuals gathering on the meat rack, street kids made visible the dominant culture's sexual hypocrisy, opening possibilities for sexual dissidents to develop new models of morality, conviviality, and mutual aid.

Amos Badertscher was one of the many figures who enlivened Baltimore's meat racks: "locations that are legendary in Baltimore gay history," he wrote, that "today almost nobody even knows about, let alone remembers. City Hall Square, 3 "'White Coffee Pots,'" one at Howard and Franklin, one at B'way and Eastern (as in "The Avenue") and another at Baltimore and Holliday. The large "'Bickford's Cafeteria'" with its exotic collection of drag queens and young hustlers, perverts and "'daddies'" and ladies of the night and anybody else with at least two dollars for dinner."[15] The corner of Park and Madison was "a mecca for young hustlers and daddies and the most notorious corner on the Mt. Vernon meat rack."[16] On Eastern Avenue running along the south side of Patterson Park, "boys would be sitting on the white marble steps of so many row houses, hitchhiking in either direction as long as it took, or cryptically signaling with their eyes and a slight movement of the head, their availability."[17] Many men traveled to

BIG DADDY UNDER I-95 #1, 1995

CYNTHIA #1, 2004

Lawrence Ross, "The 'Hustler' in Chicago," *Journal of Student Research*, no. I (Fall 1959), 5.

13. George Henry, *Sex Variants: A Study of Homosexual Patterns With Sections Contributed by Specialists in Particular Fields* (New York: Hoeber, 1941), 383.
14. Meeting minutes, "Consultation on the Church and Homosexuality," February 1966, 31, Don Lucas papers, 9/17, GLBTHS.
15. *A Story of One City and Two Lifetimes*, (1989-2017), p. 208.
16. Ibid.
17. *Billy of Baltimore Street—"Faster Than a Heartbeat"* (c. 1975), p. 170.
18. Ibid.
19. *Death of a Hustler as Seen From Heaven* (1993), p. 182.
20. C. Seymour, 'A conversation with Amos Badertscher,' *The Archive: The Journal of the Leslie/Lohman Gay Art Foundation*, 38 (2011), 4-7.
21. Barry Reay, *New York Hustlers: Masculinity and Sex in Modern America* (Manchester: Manchester University Press, 2010), 16.
22. See U.S. Census records.
23. *The First Day* (2001), p. 70.
24. Ibid.
25. *The Abondoned Body Shop* (2003), p. 50.
26. *The Homeless Are Not Harmless* (2001-06), p. 86.
27. *Boys and the Streets of Baltimore* (1977-2017), p. 120.
28. *A Story of One City and Two Lifetimes* (1989-2017), p. 208.

Baltimore from other cities and other districts, he wrote, "to bear witness."[18]

Badertscher recalled that he picked up his first hustler in 1960, when he was twenty-four, on the Mount Vernon meat rack. It was his first sexual experience with a man.[19] He began photographing hustlers in the mid-1960s; a modest inheritance in 1975 enabled him to concentrate his energies full-time on photographing meat rack hustlers, trans women, drag queens, and bar denizens. From the 1970s to 1986, he lived in a top-floor apartment on Madison Street, a short walk from the Mount Vernon meat rack. After hiring hustlers, he would often invite them to stay overnight to photograph them in the morning. "I was photographing hustlers, boys that I would pick up on the street…. The predominant drive was sexual contact, sexual exploration. [The boys] had no clue what art photography was. They just wanted to make a few bucks."[20] Badertscher's photographs are material remains of the transactional, sexual relationships that animated the meat rack economies.

Badertscher's subjects were generally young men known as "trade": usually conventionally masculine adolescents from working-class backgrounds who engaged in homosexual acts without assuming the identity of a homosexual, so long as they maintained a masculine demeanor and limited themselves, at least in principle, to a penetrative role.[21] His subjects are usually white teenagers in a city that became majority black by 1980.[22] As such, he privileges white street kids but rarely documents the queer people of color—and black queer people in particular—who created their own dynamic sexual cultures. The photos are typically bordered by the artist's own handwritten text, which offers biographical notes on his subjects, often stories of familial and social abandonment. It is important to note that these are stories that hustlers told a client, and which were in turn interpreted and edited by Badertscher. The stories are not necessarily a reflection of empirical truth but of the narrative strategies hustlers devised to secure resources from clients and other actors, and thus to survive. As such, the stories tell us as much about the artist's desires as they do about the subjects depicted.

Badertscher's photographs and stories document his complex and contested relationships with street hustlers. In one piece, Badertscher photographs his own figure, reflected in a mirror, as a hustler named Brian perches on his lap. Both are completely nude aside from their black boots. According to Badertscher's writings that accompany the photograph, Brian was constantly committing petty robberies to pay for drugs, "even if those goods belonged to his girlfriend…or an unsuspecting 'john,' like me, for minimum amounts of cash." The first day he photographed Brian, "he attempted to steal my ancient cell phone by wrapping it up in his sweater." Badertscher appears unfazed: it was "the price of doing business!"[23] According to handwritten text around the photograph, "Brian said he'd been hustling from 12 or 13 years old, his parents just neglectful alcoholics. He began with drugs, lived with a girlfriend and fathered a son." Eventually, he found steady employment and "moved out of the city, away from the life, the chaos and all the old contacts."[24]

It was not until the late 1990s and early 2000s that Badertscher turned his attention to the disused and decaying areas of postindustrial Baltimore, places he called "the vast wastelands of west Baltimore, close to I-95, if not under. A place where the homeless survive or at least try to and some of them don't. A place where murders happen or at least they try to and where street prostitutes from Wilkens Avenue bring their 'johns' for a quickie."[25] This "no-man's-land" south of Wilkens Avenue and almost under I-95 Washington-Baltimore, he wrote, was populated by "all those people out there in the wilderness: sometimes the police, sometimes an aging ex-hustler or two, one of them I once knew and now looking like Charles Manson. The homeless criminals or at least those who at best can do criminal things, those who prey on the homeless, those who are just hiding out and those who will rob you or stab you for nothing hoping to get something."[26]

Throughout his life, Badertscher fetishized the intergenerational transactions and oppositional politics of Baltimore's meat racks; he appears to have resented the respectability politics popularized by an increasingly mainstream gay rights movement. Looking back on his life in 2017, Badertscher spun a narrative of decline and normalization rather than the more familiar story of gay progress. "It might be hard to believe for a 'Normal Citizen' but in those days [the 1970s] it was a simpler world. Street drugs and AIDS had not yet arrived to take lives and ravage the city. And as for the 'Gay Identities'? Well, fortunately they had not yet been invented as far as the streets of Baltimore were concerned."[27] In 2017, "every last trace of this world has vanished; and for me, an alien city!... And now, all the normalized faggots, finally assimilated, commodified, the status-quo of 'belonging.' Yes, my dear, 100% depressing! You'd better believe it!"[28] Against the backdrop of assimilation, Badertscher documented a sexual underground that has largely been lost to history.

IMAGES AND STORIES
PART TWO: NIGHTLIFE

Mid-night at Rumors on Lombard Street, 1994

Girls at the Hippo, 1993

Medusa was one of 3 gorgon sisters, all of them "chthonic" monsters." "Chthonic" of, or pertaining to the deities, spirits or other being dwelling under the Earth (i.e.) in other words, "the Underworld."

Of the 3 Gorgon Sisters, only 2 of them were immortal but Medusa was not, so she could be slain by Perseus. He slew her and cut off her head. He then placed that head on his shield as an "Aegis." Anyone who saw that terrifying face and the legendary gaze was instantly turned to stone.

So what is an Aegis—a shield on a breast plate traditionally worn by Zeus or Athena, bearing at its center the head of those terrifying snakes of the Gorgon Medusa. Perseus and Alexander the Great wore one and it offered stellar "protection." The best thing to wear into battle. That head and the writhing snakes were so terrifying they'd turn any enemy to stone.

Cavorting around lightly, a happy Sister, maybe, but don't be deceived. Even without the snakes and the "not being immortal" business, Medusa was still Medusa, a gorgon! Warehouse and whole cities even of children's toys will always represent adorable creatures. Santa Clauses, for example, "somebody" or "something" from Wonderland. Maybe a "grinch," a small Peter Rabbit, a woodpecker … a pink elephant, a "Barbie." However! If you really wanted to do it, by some unholy adjustments, a shifty shifting of improper elements, a whole warehouse of "laced" watermelons, a little bit of murderous magic in the right places, a little bribery of the most evil magicians, a "Mass" backwards and all kinds of disturbingly slinky methods known only to disfigured witches, chthonic Sisters and happily damned everywhere, you can make these very same appealing characters into ones very menacing, slightly off center. Schizoid. Disconnected. Improper. Unpredictable. Scary. Too many of one thing, or many things crawling around all over the place but by that time, for a once happy and innocent kid definitely, too late.

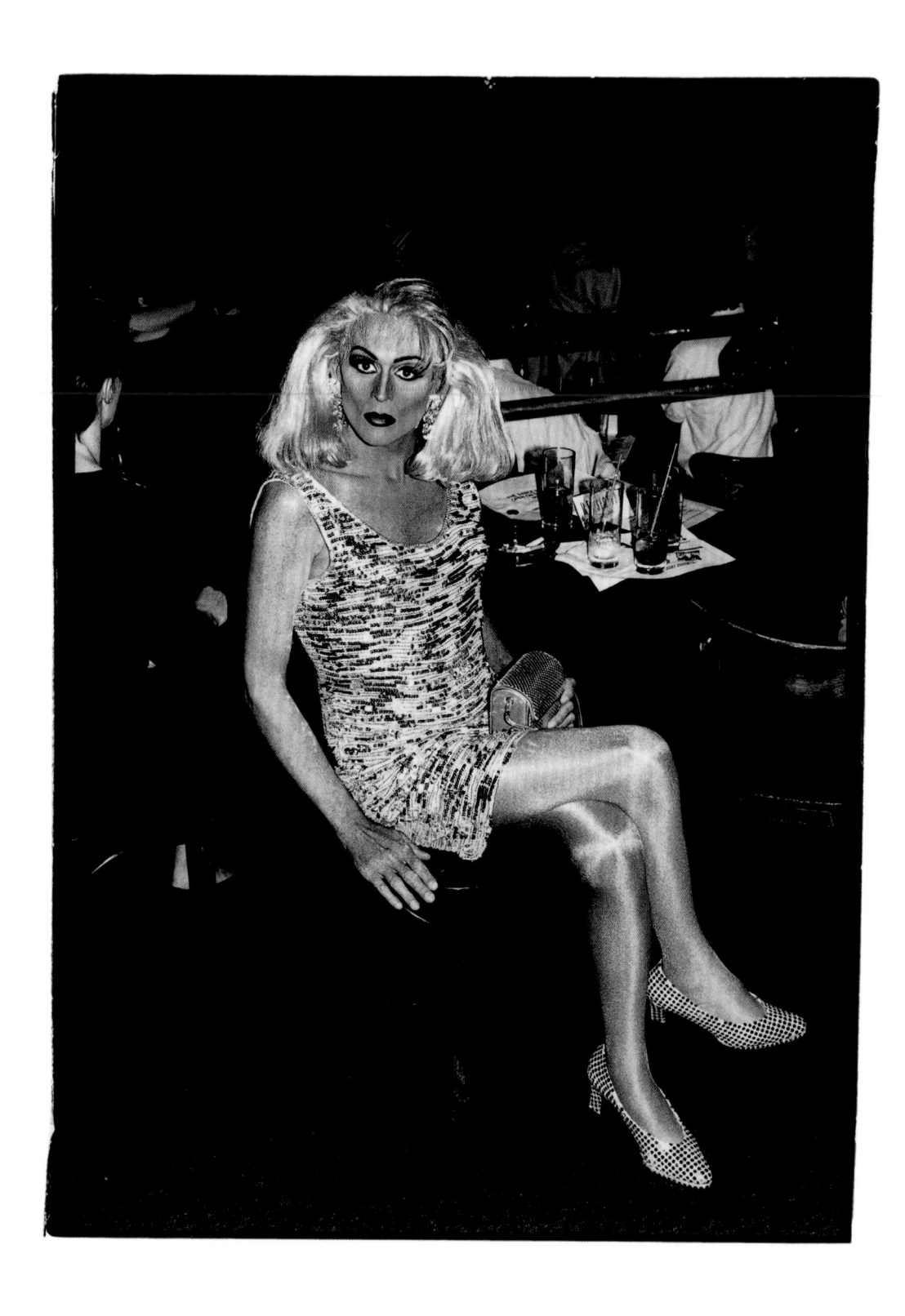

Meant to Explode in the Hands of Her Enemies, 1983–90

I first saw Jennings walking his pink poodle down Charles Street in 1982. That said, he was very far from a pansy.

You couldn't be in the same room with Jennings and not know it. He was a queer with a hundred faces, the bite just under the surface. She was meant to explode in the hands of her enemies.

It was at the usual dizzy and helpless Sunday "happy hour" at Mary's I heard a violent explosion behind me, sort of to my right, and then a quick hail of glass shrapnel. Jennings had just slammed a beer bottle on the edge of the bar, turned quickly and held the jagged business end just inches from some faggot's face.

He was a rare hair stylist with fantastic attitude. Though dying from AIDS in 1996, he faced off Death boldly.

There was a short black lady named, are you ready? "Aquanetta" who worked in the main Baltimore post office. She was someone you didn't mess around with. She worshipped the ground Jennings walked upon. When she discovered that I had photographed Jennings, I received much better service.

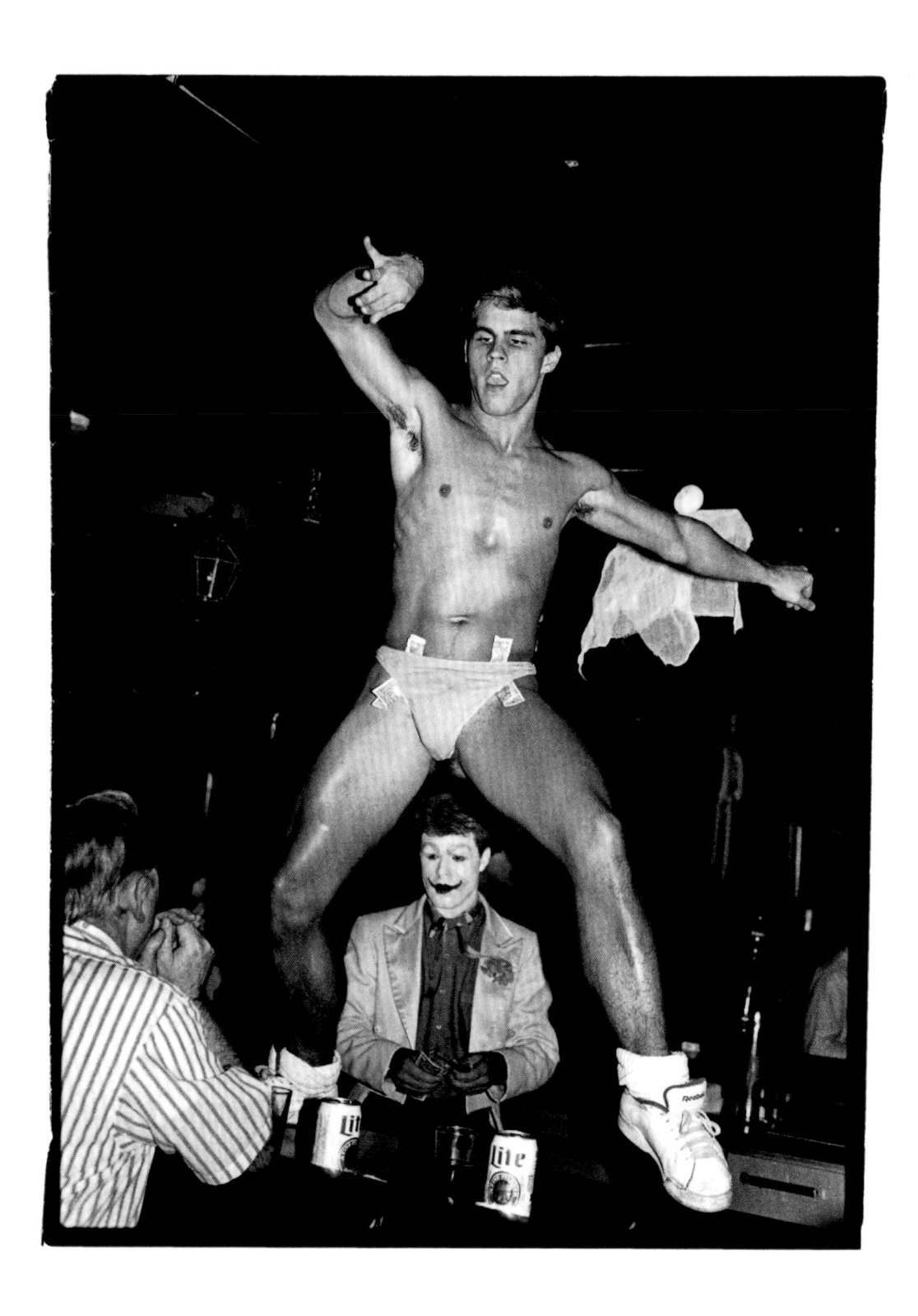

Bookin's, 1998

A Towson State University student and one of the two best dancers at Atlantis. It was the only dance bar in town and was located right across the street from the detention Center and every weekend the caged villains would shout and wave at the fags in the parking lot through their cell windows. They meant business. The dance bar was especially successful on Sunday nights because it allowed the last serious gasps of pleasure before Monday morning. But according to City codes full nudity was not legal until 2 years later as they had to protect the children and old ladies who just might wander in there. It was Halloween.

The Gay Gene, 1995

Around the mid '90s you might occasionally see and notice this large homeless gay man on the streets of Baltimore, gliding, dancing and waving, throwing kisses to passing vehicles, hitch-hiking and at times holding a bouquet of flowers. He told me his name was "Sophia" but he signed "Vincent" on the release.

Keith decided to name him "Terry Lee" and that settled it. And then, one night we saw him while coming out of Central Station on Eager Street. He was sitting on the long granite steps of the "Maryland Club," a conservative landmark, a bastion of privilege in the city. Terry had on a snug black cap, lipstick, a bouquet of plastic flowers and an earring on his right ear that looked like a very large and colorful out of control molecular construction. Maybe it was that "gay gene" that everybody's desperately looking for that doesn't exist.

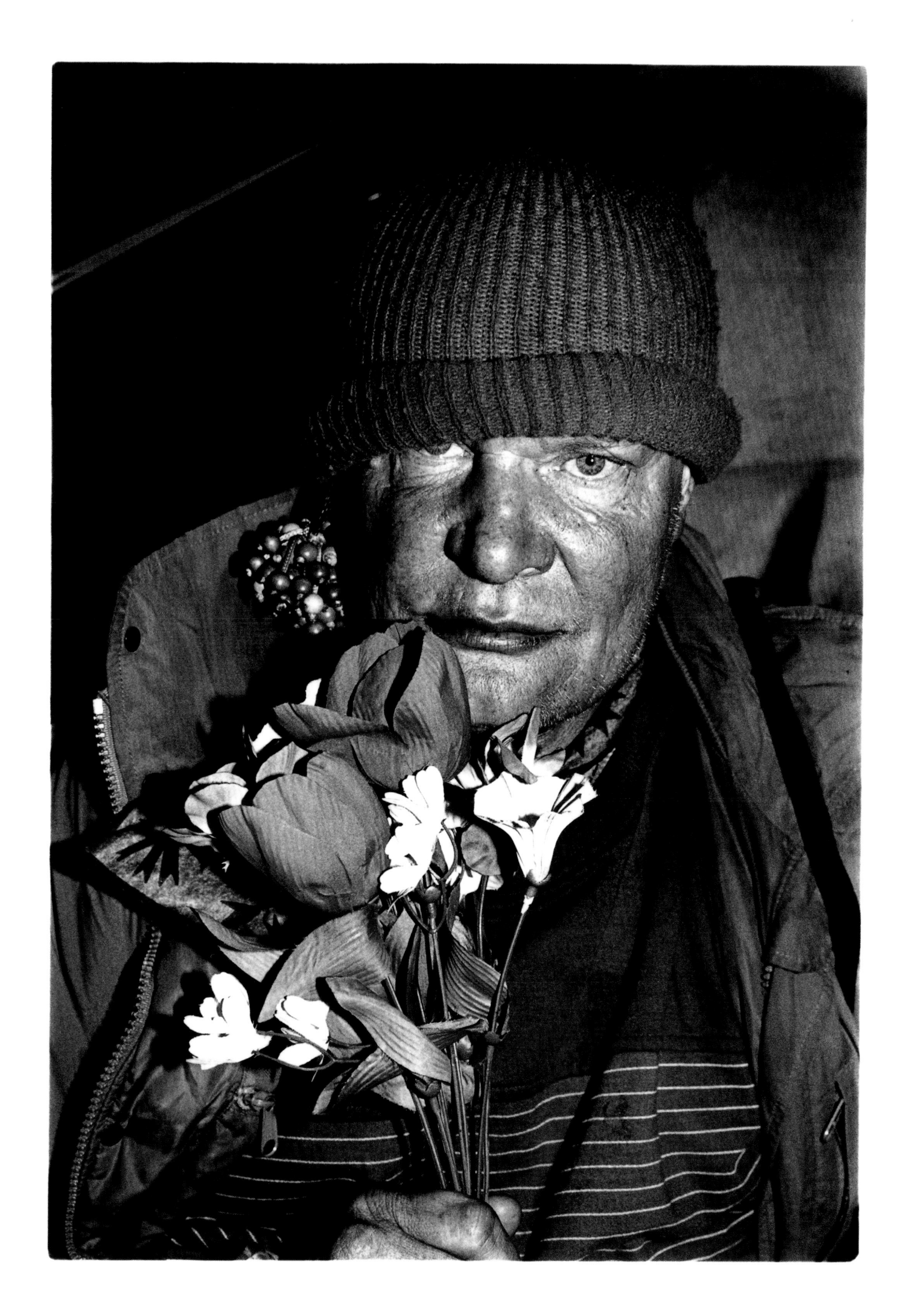

The Egg Lady, 1974-75

Waters discovered Edie as a bar maid in Pete's Hotel by Baltimore's harbor and its questionable waters. She became an international star. She had worked on "the block," knew Blaze Starr and was missing some teeth.

And Edie was a Muse, a consoler of stray children, a loving collector of the dispossessed and she had alarmed enough people even whole families out of the '50s, '60s, '70s, of course with a banana load of help by Waters and his truck loads of perverts.

Her apartment on Aliceanna Street was so cluttered with stuff it would have given a registered thrift store addict a coronary. There were slightly heavy undefinable odors, impossible scents, a jumble of strange gases a fragrance designer would refuse to recognize. Unemptied litter boxes could have been a little bit of it. For a time, she ran a store, "Edith's Shopping Bag" on B'way by "Bertha's Mussels." There, you could even touch the saint or give her a little hug.

One night at Leon's, 10 minutes away from the Hippo, she slammed her pocketbook into a policeman as he was planning to arrest Keith who was on his knees on the sidewalk pleading that he was "Old Stock" (just one of his favorite obsessions) meaning "Olde Baltimore Stock," a son of the historic ethnic neighborhoods and the gleaming marble steps and the mind that went with it whose fathers were always employed at the big steel mills and shipyards. The cop was supposed to respect this presumably being from Baltimore.

So, this all continued a while until last call at Leon's when the real work began outside on the sidewalk, the free prostitution that could continue indefinitely until the very last pits of desire had been extinguished. Keith was never arrested and probably ended up drunk and passed out in somebody's bed. But when Edie died in Los Angeles in 1984 and had drunkin' of Lethe's waters she didn't remember any of this.

The Denim and Pearls Ball, 1975

The Denim and Pearls Ball: so long ago, a landmark in gay Baltimore history if ever there was one. It all happened in the old Alcazar Ballroom, the large entrance on Cathedral Street on a Saturday night in December of 1975 and remembered by almost no one and even that number is dwindling. If it hadn't been for my friend, the Baron, I would have totally missed it. The ballroom, now part of an Art Institute, shared the block with the Mt. Vernon meat rack, a significant launching pad for generations of Baltimore hustlers.

The Ball was also the singing debut of Edith Massey, the John Waters' film star of "Pink Flamingos" and she was the "Egg Lady." The songs: "Rhinestone Cowgirl," "Big Girls Don't Cry" and "Punks Get Off the Grass," all three recorded by "Egg Spurt Productions" in 1982. She was always waiting for the "Egg Man" in white, but we are all waiting for the Egg Man in White, if you know what I'm say'n.

Music supplied by "Jan and the Roc-a-Jets," the first lesbian band in Baltimore to dress like men. The band played most weekends at the now legendary "Pepper Hill" gay bar on Gay Street between 1963 and 1968 when it closed. Also remembered by no one but it was the very first gay bar I ever went into. Its parking lot was right next to the Central Police parking lot so the Vice Squad didn't have far to travel in case of emergency. Today, over 5 decades later, the bar has been replaced by a huge concrete pylon supporting I-83.

Black Tony, 1975

The trans bars, for me, in the mid '70s were a little scary.

It was 1975 and I had decided one morning that I was really going to get serious about my photography. Fortunately, I had no art school training to stop me. So, I asked "Bubbles", who was just getting to know everybody gay in Baltimore, to find me a strange "character" to photograph. So, he gave me someone called, pretty convincingly, "Black Tony" and definitely not someone I was hanging out with. She was quite large & living in the same seedy first floor apartment for years on Maryland Avenue, between 25th and 26th Street. Maryland Avenue was a one way and headed in a downtown direction and would surprisingly and abruptly turn into Cathedral. The Cathedral was on your left side and the Enoch Pratt Free Library on the right. Hmmm.

One eye was disquieting as it seemed not to be there, and I never asked if she were a genuine sex change. Who her clients were and how she found them …

Black Tony's apartment was pretty small and most of it bed and the rest of it dark, dank, and fetid, intimidating. His door was at the end of a long hall poorly lit, damaged, and almost shredded linoleum covered the hallway floor in sickening colors of seriously faded rose and orange, that might have dated back to the '50s or even '30s! At least it went straight back from the entrance on the first floor and right to his doorway and apparently good enough for his mixed clientele.

At that time, I suspect that his bed was used for commercial purposes. There are always men out there who are turned on by another man dressed like a woman. They just don't have to 'go down there'. Big tits help a lot. A customer just rang a bell, was buzzed in, and walked down the dark corridor to the end and his room was right there. Twenty dollars would do it. Convenient.

Directly Outside the Entrance to the 14-Karat Cabaret, 1993

These kids on the pavement directly outside the front entrance of the 14-Karat Cabaret
on Saratoga Street. The club was mostly queer and for the time, unusual and for the time
pretty cutting edge for Baltimore.

A Story of One City and Two Lifetimes, 1989-2017
One Life Already in Heaven and the other About to Be

Kenny "Legs" as he was in 1989.

He hit the streets of Baltimore at 14, in 1964. He hustled almost every location that a young boy could hustle on the east side and uptown in the '60s and '70s; locations that are legendary in Baltimore gay history and today almost nobody even knows about, let alone remembers. City Hall Square for one, 3 "White Coffee Pots," one at Howard and Franklin, one at B'way and Eastern and another at Baltimore and Holliday. The large "Bickford's Cafeteria" with its exotic collection of drag queens and young hustlers, perverts and "daddies" and ladies of the night and anybody else with at least two dollars for dinner.

If you couldn't find it there after "Happy Hour," it didn't exist. It was the Baltimore version of "Playland" on 48th Street in NYC minus the game machines and the Puerto Rican kids well before Mayor Rudy Giuliani got his fucking "quality of Life" hands on it. "Playland" figured prominently in the collected autobiographical writings of Luis Miguel Fuentes's, "Diary of A Dirty Boy." At first the book was a cheap paperback, probably under a dollar but today a used copy sells for over 300 dollars, if you can even find one.

Kenny enjoyed the bars in Baltimore. He loved Eddies Bar at Light and Water Streets because in the '50s and '60s Baltimore had an active "live" theater scene and the very best hotels were just blocks away and a few famous Hollywood and television actors would visit Eddie's and never leave empty handed. He could name names and he did. There was always the corner at Park and Monument Streets, right at the front door of Grace and St. Peters High Episcopal Church, a mecca for young hustlers and daddies and the most notorious corner on the Mt. Vernon meat rack. And finally, the "Pepper Hill Club" right on Gay Street and the weekend home of "Jan and the 'Roc-a-Jets.'" The bar was basically in the lap of the Central Police parking lot so the vice squad didn't have too far to travel in an emergency.

So, when he was about 18 Kenny traveled west and worked for "Sugar Sweet," an enterprising hooker in Houston until they were all run out of town by the vice squad. Vice is everywhere man and not just in Baltimore.

He, Kenny, was a real sweetheart. Somewhere between Houston and Baltimore he acquired his working name, Kenny "Legs" from an ancient stripper, "May de Carla." But he did have long legs and was tall and skinny and now used both of them to get back to Baltimore, fast, from Texas. Legs, do your Stuff! and they did.

And now in his late '20s, he hitch-hiked east and lived with his mother somewhere in Highlandtown and Saturdays he always held court at "The Unicorn," on Boston Street, formally "Frankie and Ronnie's" and before that "Faye's Mistake." And by now nobody knew this. An unusual name for a bar. A fourth name, Quest, would soon follow just before it closed. Just one block away was Connie's "Masquerade" and I never figured out if the bartenders were man or woman and you sure didn't want to mess with Connie. A little further up in the opposite direction, was the "Sip N Bite," run by a few Greeks, the very last stop after last call for Boston Street patrons and a favorite place to eat on Sunday for the star of "Pink Flamingos," Edith Massey.

It was there that I met John, Kenny's last boyfriend, a nice boy and a nice poet and his poem "Misty the Unicorn" should be attached here somewhere if I can find room for it. Kenny was one of the best of the truly bad girls in a city so full of street angels and Baltimore was Heaven. If this city had existed around 1300 and was in Florence, it would have been dealt with properly, you guessed it, in Dante's "Inferno." Above all else, Kenny was a Survivor in the Grand Manner. He died of AIDS about 1998.

But now, in 2017, every last trace of this world has vanished; and for me, an alien city! Streets significantly widened and others squeezed and cluttered by new parking regulations and "free zones," former directions of streets, changed. Except for the Episcopal corner, all other structures replaced. It's difficult to tell where anything had been in the first place and where even the "White Coffee Pots" had been and good luck with Bickford's. A huge concrete pylon where the "Pepper Hill" had once stood and a street right next to it where I was pulled over at 2:22 A.M. by a cop who just knew a queer had to be driving drunk after "last call" at the "Hill" but saved by 2 respectable ladies running out of a parking garage in serious distress, right to my left. The cops who had sometimes given a hustler a ride for a favor.

The good Mayor of Baltimore in those days, William Donald Schaefer, and his hopeful slogans, "The Greatest City in America," "The City That Reads" and now "The Greatest City for Homicides, violence, drugs and addictions." The "Hippo," now a CVS store. Last week, 9-24-2017, a patron of "Central" was shot and killed on his way to his car. These were the same streets and alleys that I had navigated on foot at night all over the city for decades. Is this the same corner where that little "White Coffee pot" stood with all its "available" patrons who often were happy to spend the whole weekend if necessary and now across the street from a "Civic Center" and on a wide thoroughfare partially potholed? And now, all the normalized faggots, finally assimilated, commodified, the status-quo of "belonging." Yes, my dear, 100% depressing! You'd better believe it!

And yes, I've heard of Richard Prince, 1998-2000

The "Sportsman's Lounge" a rough Black bar on Park Avenue, in the late '80s. "Eric the Bouncer" was a large man. He insured that everybody was happy and enjoying themselves and not doing anything they shouldn't be doing in a gay bar. Sportsman's supplied drag performers for the Mardi Gras, formerly a working class white gay bar called Go-West owned by Jimmy Arnold. It burned to the ground some years later. The "Sportsman" had been replaced by a black asphalt parking lot and even that is coming apart.

Mardi Gras was one block up from Sportsman's, in a decaying district along Park Avenue, the scene for numerous Sunday evening Black drag shows around 2000. In between both bars was the China Doll where you got cheap but excellent food—a late '90s version of Mee Jun Low around the corner and across the street from Martick's Bar, a former "speak-easy," which supplied one or more characters for John Waters very early movies, by now pretty much unavailable. Mee Jun Low, with its one waitress, Irene, was a Baltimore institution—everybody went there.

At Randy's Sportsman's Bar, a black gay club, 412 Reels Avenue in 2001. The place has long been closed as is most of the block and probably slated for demolition.

HR 2001

A Dark Alley, 1993

After some costume party, maybe Halloween outside the Hippo. This is where every-body hung out after 2 A.M. for at least half an hour or before the cops came. Pick-ups happened. Dates set.

The best way to describe Bebe was intimidating. In a dark alley at mid-night!

Bebe was a highly talented and outrageous dresser during the later '70s. Not someone you would want to cross. She loved slim white boys.

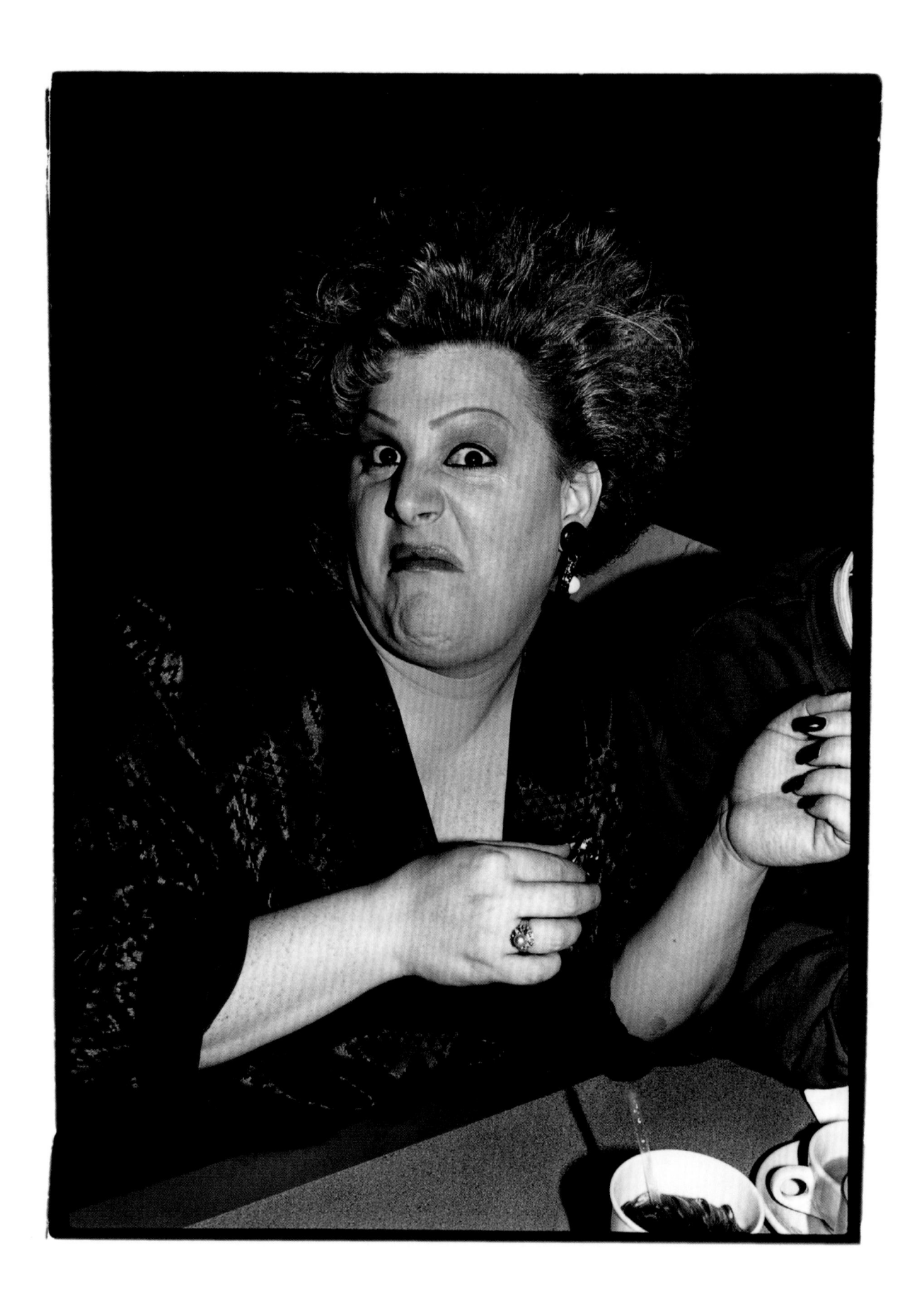

Inspired Drama, 1994

At the Sip N Bite on Boston Street. "Well. I will just go next door where I will be treated like a lady!"

The Lady in Question, 1994

Nobody knew anything about her. Some called her "Baby Jane." She visited Central
Station at night on an erratic schedule. She'd stand in the same place in the same clothes
right between the main doorway at Charles and Eager Streets and that cash or vending
machine on her right, holding a tall glass of beer. Sometimes she was quiet, sometimes
not, sometimes a little drunk. Patrons might buy her a beer and chat. I made her nervous.
It's obvious she likes very much to be with gay men.

Home in NYC

The immensely talented Allan Lozito, founder of the three-member performance group, "Saratoga," in the mid-'70s played the gay clubs in D.C., NYC., New J. , but mostly Baltimore. Home base was his mother's apartment at the corner of the eponymous Jane and Hudson Sts., in New York City. Allan's hypnotic stage persona masked a lonely, chaotic, and self-destructive personality unrelieved by his comic projection and drugs.

When in New York he daily went to the "Piers." Allan died of AIDS in 1986 in the same apartment in which he was born.

"Playland," 1999

The name of this place was "Playland." It opened one fall in Baltimore in 1999 under the cover of darkness and didn't last much longer than a year. Besides this "whipping chamber," just one of the "torture" scenarios, people having fun, there was an artful and certified Nursery with nippled bottles, really large undies, handy paddles, bright pink colored head gear, the requisite diapers, peach colored pacifiers and lollypops. Most of the "children" in the large triple- "X" diapers needed to be put on a "Slim Fast" diet and some needed a shave. There was a tall "old, rugged Cross," a cute lithe Savior with really nice buttocks, being tortured, I imagine, slowly to Death. There were genuine sinners kneeling at "His" feet and those who weren't "touching" were praying.

God!! You talk about a whole bunch of "bread and butter" straight, gay people and you gotta problem! A second time visit usually out of the question.

Sportsman's Lounge, 1998–2023
Club Mardi Gras
"Angie's List"

Angie was amused by anything: A green jackal,
A happy clam, "A State Inspector of Air waves,"
The wrong thorn in the lion's paw,
"The 5 Elbow Sisters," "The Sink of Virtues"
New World monkeys,
A piano tuner of earthquakes!
A pissed off "Mona Lisa"
An abused Ganymede ass Backwards
A one-hour Orgasm! Ending in Death!
"The Donald's" soiled Underwear!
A little blue turtle named "Quack!"
A blind prophet named "Cillyform"
"Slugger Anne"
A Thermometer Queen; too busy to chat
A Tooth in a Nail factory
Little Miss Wiggle Room
A Rattle Snake's Untrimmed Toenails
The "Bumhazel" Desperate Living Apartment Compound, Complex!
Tri-Crystal Underwear-"Hot Pants!"
A steamy Bird meeting!
An Enema dog.
The Spider Club.
A Slap-A-Donion Inch-Squeezer
A Jackal named "Bubbles"
A fat turtle named "Meat Rack"
An Electricity Queen! Birth date and voltage unknown.
The "Happy Chance" Madhouse!
An Oxygen Drama
The bleak history of a paralyzed Mobility Queen!
A weeping Clam, Once happy!
A red, white, and blue tarantula with too many things wrong with it!
A Polished Chromium or a clear plastic one, if necessary, Guaranteed "Peace
Eliminator!"
The Flexibility Queen who somehow got flushed down the toilet!
A Life-Ending "Pig Weed" Water pill.
A Chocolate "Crustabella," covering all bases.
An Equation to end all Equations, period!
The Masque of Mandates!
"Finnegan's Wake"
A Nuclear Toe Warmer
A Nail in a Tooth factory
"A Phala-Centric Mushroom, fifty-five times deadlier than a rattlesnake but lovely to
look at!"
Anybody named "Jiaqi."

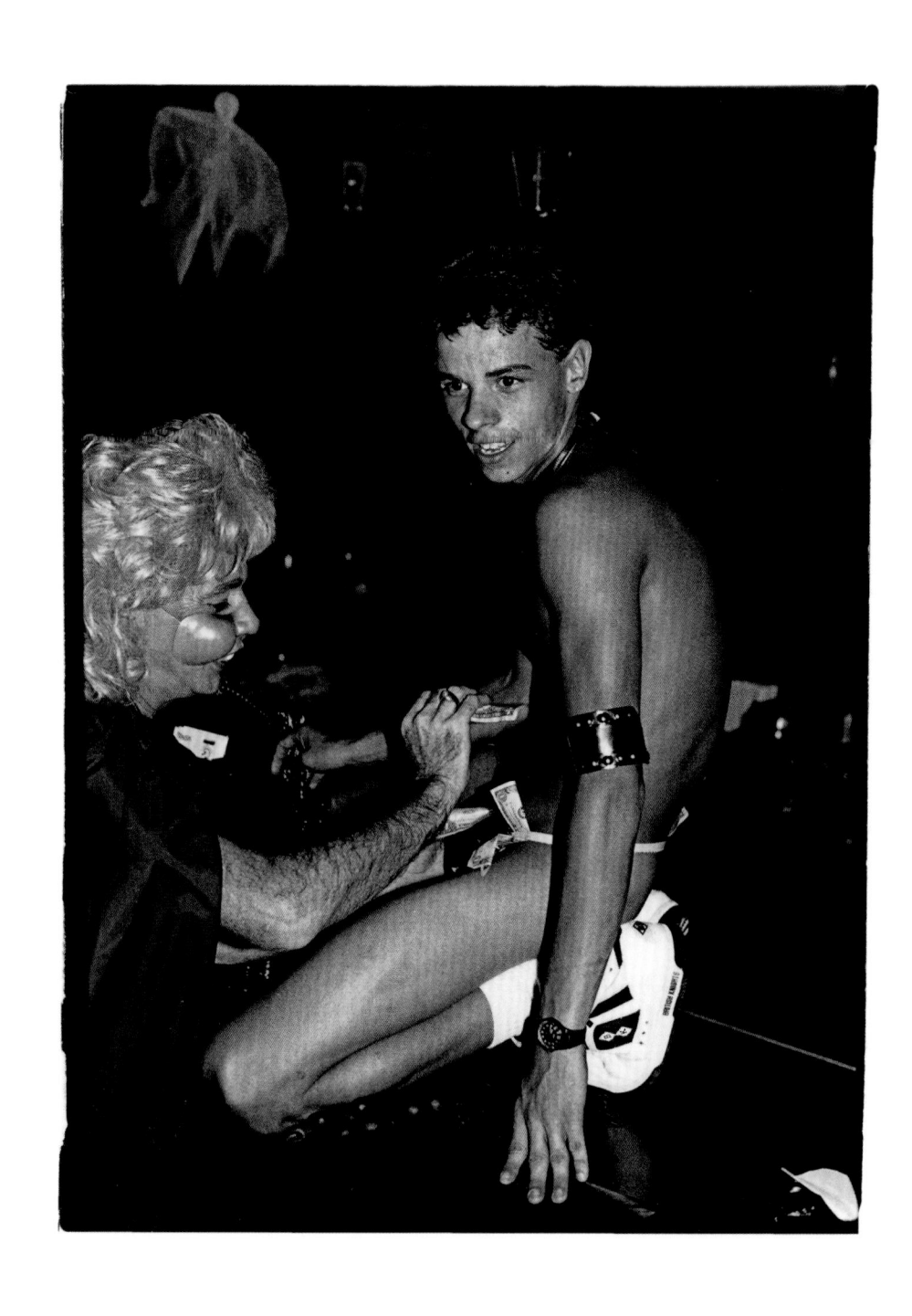

Atlantis Dancer, 1988

Sundays were especially good at the Atlantis. Although nude dancing was banned for many years to cover up the "merchandise," the city codes finally changed and the boys danced nude. This was a development I never witnessed. Atlantis, like the city, has long ago disappeared, replaced by its opposite, a female strip bar. The inmates across the parking lot don't have the fags to kick around anymore. Perchance to dream.

I developed a highly challenged relationship with one of the managers, not both, but one. I was banned and my name added to the liquor license as an undesirable alien.

Brian, a boy from the east side neighborhoods, had been entertaining men in one way or another since the age of 10. He was the best and most popular dancer at Atlantis. Brian, never having had a father, just lived for the attention of older men. His mother had no interest in raising her 2 sons. Even when his body began to show some early symptoms of AIDS, he still attended the yearly "Gay Pride Festival" in Wyman Park in 1992. He didn't want to let go. Even then he still wanted me to photograph him, even in a hospital bed. Unfortunately, I never did. He died in 1993.

The '70s Rocker, 1978

Following the rebellious '60s and now by the end of the seemingly liberated '70s (except for the polyester) with the easy availability of sex on the streets, in the parks and the gay bars, it was really possible to believe, and I definitely did, that a complete sexual revolution was finally attainable, and this miracle would be fully accomplished within the next decade. So much hitch-hiking would often lead to a sexual encounter of some kind, a guilt-free blow job, a pack of cigarettes, a little bit of money, a place to stay or even just a lift itself, was the going rate. Homosexual pornography sold in the light of day so fabulous that today it would earn you at least 3 years of brutal confinement and a public brand for eternity. Bi-sexual boys found the gay bars more desirable where they could freely express so many more aspects of their sexual personalities.

The decomposed corpse of Dr. Alfred Kinsey, so ignored and vanished for so many years could at last completely turn over in its grave, not for bad but for good. In fact, now no grave itself could possibly be able to contain him and as a parting gesture at last making mincemeat of our cherished and shop-worn conceptions of Death. Now, how could any American citizen in his right mind possibly want to go backwards? To fall once again into the jaws of sexual repression and erotic gibberish. It was all looking so good. In fact, it was all looking too good. So, beware.

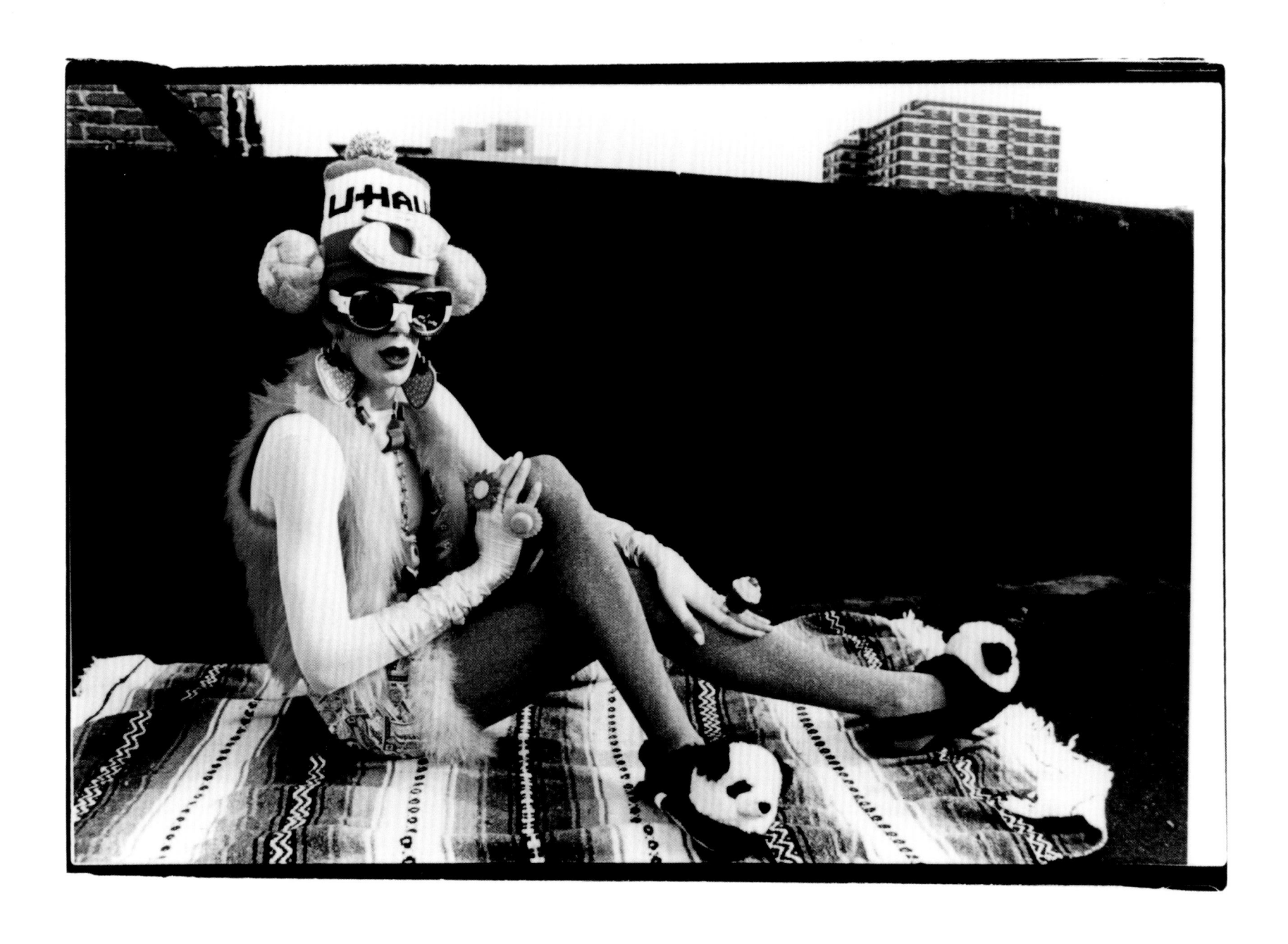

Names, 1993

If Alice had been paying attention to her magic mirror in "Wonderland" she wouldn't have missed Denne: Madenny Fielding Carlyle, Penelope Pit Stop! Sometimes Denne, sometimes David. Each visit, it's best to ask. This collection of names in one living being and all of the personalities and phobias and insanities that came with it and unfortunately there were others. She'd be right there next to the Slithy Toves and the Bandersnatch. Precarious Slidings of the elements, for sure.

Conceived under the sign of the trans-sexual whatever that is, so there were others.

Madenny Kennedy, a master of Retro-Syringe Art, Pop-Condom Art and also creator of gnome-like lover demons, modern succubi.

Put all of these names and personalities and creatives together into one lethal package and "whatever" emerged would bring a suburban shopping mall to a standstill and cardiac arrest to a construction site.

(Fred) Bea Merry, 1997

I met Fred one night in what turned out to be a very short-lived gay bar called Custom House on a small side street of the same name and run by a sizeable, unpredictable, and nasty drag queen named Amanda.

It was located not even half a block from the Gayety Burlesque Theater and just across the street from the famous Blaze Starr's 2 O'Clock Club. "The Baltimore Block" was just a large collection of strip clubs, barely dressed dancers, ample breasts, B-girls and prostitutes and bouncers, sex shops and peep shows, but nothing for free.

"Blaze" was a flesh bombshell and sex dynamo, loud and nationally known. She once said she had had a "quickie" with "Jack" in a closet and was just amazed at how quick he could be. Could matters possibly get worse and the answer was Yes!

Right at one of the corners of "The Block" was one of the ubiquitous "White Coffee Pots" with at night collection of young hustlers, each slowly nursing a coffee or soda and watching closely the moving cars through the large plate glass windows, all of them looking to "go out." All it took was eye contact and a slight movement of the head and you had a connection. If all else failed it was just a two-and-a-half-minute walk up to "Court House Square."

Fred was slim and old and very talkative. Weirdly, but not for me, I thought of Nestor, the "Pylian syre," once a renowned warrior and then the wise and ancient councilor of the "Iliad," reputed to have lived for three generations, in drag. He counseled almost anybody around who would listen but specialized in great Kings and even greater warriors like Achilles and one even greater King who unfortunately refused to listen and that's how we got the "Iliad."

During the day Fred lawyered and so in front of my camera he insisted on wearing a mask to ensure anonymity and I guess this is "Batman," his favorite maquillage. He had a large collection of black shoes with heels impossibly high on which he was wobbly.

A Tough Life—A Tough Woman, 1998

April, April de Marnay to be precise, squeezed out of the closet a little before 1984. Her first time in a gay bar scared her to death. In time she got over it and made three wonderful friends and the next time he went he dressed as a woman. Frank's not gay but he loves to dress like a woman and hang out at the gay bars. He found that a number of men have a sexual fascination with other men dressed like a woman but they will totally ignore the very same person out of drag. April was a tough girl but she had a tough life. At six years old she was regularly beaten by her redneck father and then by her redneck stepfather and constantly enduring a typical redneck alcoholic mother—pretty intense. So, when she got old enough and big enough, she knocked the guy out cold and left and went out on her own. Within time the redneck father and stepfather and redneck alcoholic mother became Born Again Christians. Pretty intense.

In the late '80s she met a truck driver from Seattle at the Hippo, both went to a few after-hours spots and then to his hotel room in the old Brexton. When the guy asked April to tie him to a chair, April obliged, but then got pissed at all his sexual suggestions, and sexual innuendoes so she gave him the back of her hand, thrice, walked out and left him there in that condition. For two weeks she desperately checked the newspapers and the police blotters really afraid she might have killed him. But April was a good woman: incorrigible, harmless, and wonderful.

Millinery on Parade, 1976

Joseph was one of the regular patrons at Leon's. He was always a quiet and subdued presence and with an unusual talent for designing these outrageous, colorful, and sizeable head pieces like an Apache or a Halston on acid. And he always managed to maneuver these inspired creations with such finesse, weaving his way slowly, this way and that, through the overcrowded interior usually on Friday or Saturday nights, without poking an eye or a crotch or a pocketbook. These head pieces usually took him about a month to design and were never repeated. Obviously, his creations did all of the screaming for him, creating all of the drama around him.

232

Dauphin, 1992

Frankie was a Grand Imperial, Legitimate Dauphin—from France—where else!
The Dauphin graced the lens of the Court Photographer with his presence.

Urban Abduction, 2002

How to ensure a triple-XXX rating and trigger a public outcry. I've never heard one, but Americans are always crying out in public about something. They are always disturbed and the most disturbing thing about being always disturbed about something is disturbing.

Allegro opened on the site of an older gay bar, Mary's.

Around 2001, Allegro hired "Luna" to incite a cutting-edge ambience similar to that found at Nation and the earlier Tracks in Washington D.C. In short time Allegro unpredictably became the hottest gay spot in Baltimore, the only spark of salvation after the closing of Connie's Masquerade on Boston Street in the mid-'90s. Nothing in city gay life ever redeemed Allegro's closing other than a small bunch of gay "theme" bars specializing in corporate, mainstream cloning.

This Woman Makes You Wonder, 1993

Gregory was a too well-known hair stylist and "Jennings'" best friend, both popular in a creative, original, dangerous, and endearing way. Inside the Hippo, it was impossible to miss them. When we were finished with the camera, Gregory, still nude but for the stockings and shoes, black motorcycle cap and gloves, threw the whole thing and himself down on a bed that just happened to be there, legs raised high and happily spread in the air and said, "What about this one?!!! I wasn't sure whether this was an invitation for me or my camera.

The French Connection, 1981

It was 1981 and Karey (Punk Toni) was serious. It was too early in the morning, and I was just as serious about sleeping and battling the excessive dimensions of a hangover, the price you just have to pay for daily Paradise and some of it just around the corner or less than a block away. He was banging on the door and so viciously ringing the bell that I thought I'd turned off because I had promised him a photo session and he was a glutton for attention. Most of his existences were borderline and he needed cash. "My God!" That mad Frenchman, actor and theater critic, Artaud, had come back again to haunt me because I was refusing to read his stuff, and this was hardly the first time. With a sinking and ailing heart, I was suddenly remembering the existences of some of the other tenants in the building. I was already on their shit list. Oh My!! The sun was not yet in the correct position, and I really needed to use the bathroom. But, at least, for now, I didn't have to read or promise Antonine anything.

Been Around, 1992

I met Ben at the "Sleaze Ball," a rave, at Club Paradox in 1992, a relatively significant gay and punk party for Baltimore, organized by "Punk Toni" and friends.

At this time Ben was trying to support a young son and a wife in Annapolis, Maryland and had traveled a lot for his 20 years. At the Ball he was afraid nobody would notice him, as if you could possibly miss him. This led to a description of his life in tunnels, in cellars of abandoned houses and warehouses. Living out of dumpsters—the economics of living on virtually nothing, and drugs. Just one of his many stories he told me involved the fate of one of his best friends, Ian, a late-night overdose, whose body had to be thrown into a dumpster to avoid detection.

Haile Selassie's Deputy Prime Minister, 1993

Ramsey with the relentless ego and a driven deputy prime minister: a former Jehovah's Witness after witnessing Jehovah did acting and drag. In 1993 in Baltimore, he attended and performed at the "Hippo" first and then "Central Station," both bars at the corners of Charles Street and Eager Street. By the turn of the century, he had expanded and polished his repertoire as both a performer and Woman and taken it all to "Nation" or "Velvet Nation," the newest, hottest, cavernous gay club in Washington.

The Boy Next Door, 1982

It was at Connie's "Masquerade" on Boston Street where there was a doorman and you weren't sure if the sizeable blond bartenders were man or woman but either way it was obvious they could take care of themselves and especially Connie, you didn't want to mess with the Bull Dyke Connie. One night, Keith pointed out this very cute boy dancing I should photograph, so I asked him. He was friendly and agreeable, and he looked pretty harmless. I was just not prepared for all the dangerously exotic and pseudo-violent stuff this seemingly harmless boy got into.

Just the beginning … Adam, 1990

A slim patron from the Hippo, whose middle name was "Sunshine" (his parents were hippies) in 1990, as Adam just after the Expulsion. God had already created the Garden of Eden on the 5th or 6th day and put Adam in it. But Adam needed a woman so it was Eve, a tall pulchritudinous strawberry blond bombshell who was put in there with him because God wanted to make doubly sure that His Handiwork would be fruitful and multiply and who knows what kind of stuff Adam could get into if left to his own devices. Now everybody was in place except the Serpent and it was just a matter of time, according to Scripture, before all the Troubles began happening: Terminal Environmental Destruction, TED, casually disguised as GW "Global Warming," Overpopulation and low minimum wage were just three of them. Now Eve, although so juicy and beautiful was never too bright but Adam was an idiot. This was just one of the unfortunate legacies that, later on, all the children had to learn to deal with but never successfully. A whole lot of them would end up in jail or on disability. OK. So, in that time the Garden still contained a countless number of shiny and miraculous objects and just one of them was this large and innocent looking sacred Portfolio sort of hidden under a rock but still in plain view very carefully detailing all of the frightening and torturous concepts of Family Values. And even that contained an even larger but unprintable footnote on Gay Marriage and Gender Accessible Bathrooms, GAB; in English. Not anything a small child could afford to listen to. Whoever did this didn't waste any time doing it but things moved too fast in those days just after Creation because Time wasn't even invented until after the Expulsion and that was only going to happening after the 7th day Sunday: Time moved so fast sometimes that whatever it was you could be thinking of doing would be finished before you could even think of doing it so you'd just have to begin at the end and work backwards to the beginning in order to know exactly what it was you had wanted to do in the first place. All in a day's work Mary but what's a day? And what else could you expect in a world where Seraphim outrank Cherubim?
 Sunshine! Really slim! Fine, sharp, chiseled features. Photogenic! "Ganymede" had more curves but was ready to roll. Next to impossible to take a bad photograph.

Dancer from Nation, 1999

A charismatic and photogenic entertainer at Nation in Washington in 1999: Aubrey
who just wanted to be a woman and not a man.

Bar-back Antonio, 1996

Antonio was a young bar back at Splash in 1996, the most popular gay bar in New York's Chelsea neighborhood on 17th Street. It had 2 floors, 5 or 6 bars, 2 or 3 coat check rooms and a porn video room. The bar tenders were big, real nice if you liked big men and real showers on stage and stiff drinks were sure to encourage the proper behavior. Antonio came from Howard Beach, a borough of Queens and his boyfriend worked in one of the coat check rooms. It had been love at first sight. Ultimately Splash closed after 22 years of service.

"Queen of Comedy," 1997

It's Shawnna Alexander, Queen of Comedy. One of the 2 best gay entertainers in Baltimore. She performed at a few gay bars, the monthly drag shows at Club Mardi Gras on Park Avenue and at the yearly Gay Block Party at the intersection of Charles Street and Eager just outside the Hippo. A talented and outrageous comic performer.

Originally named "Shawn," she offers a little bit of this and a little bit of that! Off stage it's a real city street hustle, a little bit of this and a little bit of that, most of "it" legal. The persona of Shawnna came out strangely about 25 years ago ... She has been known over the years as doing some outrageous performances.

He is sort of like the Whoopi Goldberg of Baltimore. Shawna doesn't see himself as gay, lesbian, transgender or transsexual but more like a "box" containing a little bit of everything. Like a brilliant actor he totally assumes his projected identity on stage and this performance is a coveted therapy that allows him to escape the horrors of "normalcy."

Guy & Company, 1989

Guy really wanted the attention of men, one way or another. Well, there were so many ways to do that! Just one of them, hustling. Maybe the Navy. Another way was nude or almost nude dancing on a bar but as of 1989 he hadn't yet tried that.

So, during one Sunday Afternoon he and a group of friends made their way to Atlantis. The customers were loud and happier than usual. Guy and his friends sat at one end of the bar watching the young dancers.

At some point a few of his friends began cheering and noisily pushing him onto the dance bar, as if he needed coaxing. After that he became a regular dancer each Sunday night during "Happy Hour."

Four months later, Guy and his best friend traveled to some place on the west coast and became "Porn stars" where he got a lot more than the attention of men.

Nude Dancer, 1993

One night in 1993 Steve was dancing in Baltimore and somebody who knew I was a photographer, brought him over and said that he needed some money to get to Washington and would I pay him enough for a photo session? "Sure!"

Once in Washington, Steve headed for one of the hottest dance bars in the S.E. section in the City where all dancers were nude and definitely available; "touching" optional. The bar was called Wet, and Steve quickly became very successful and one of most popular dancers.

The New Deal at the Hippo, 1976

Thank God it was "Queers," "Homos," "Faggots" before it was "gay." The only waiters inside the Hippo were Kenny and "Chicken." The owner, Kenny Albert, was in the basement. Cute underage queens in white shorts passed out on the benches. Oh! And pornography on the tables. You had to be least 16 to get in. Some pretty convincing girls paraded across the street after happy hour and the customers came. You could always find a genuine street hustler or two in the woodwork. These were the old days in Baltimore City. Everybody was pretty much on their own. There was no sexual trauma or counseling and decades of therapy. If you were "violated," count your blessings. Rather, it was how much can I make and when can we do it again. It was sex, drama, danger all the way and it would never get any better than this!

Gary with his fabulous hair had just won the "Mr. Hippo" contest and now his memory would be enshrined within the annals of a bar that was expected to last forever. Both Gary and his best friend, Vernon, always sat in the same location in the Hippo and held court with their privileged admirers and could ask anyone to do anything and it was done.

So, it was one of his friends who came over to me one night in the Hippo out of nowhere and said "Gary wants to talk to you!" Was I hearing this right or was I dreaming? A god had spoken! But he really did want to talk to me because he knew that I was a photographer and he wanted to be photographed in the next few days because the day after I did this, he was having all his hair cut off and he needed a visual record of his previous persona for posterity. Cut off all that beautiful hair! But obviously there was something inside him that I had been missing and he was little more than just an attractive American working-class gay boy who just wanted to move upwards on the social ladder, that's all. You might see him at times dining with a friend and both of them wearing the "preppie" sweater that you could tie the arms around your waist when it was too warm to wear them. But in one sense he was a prophet, innocently anticipating what would become in just a few more years, the "Normalization of Fagdom!"

The Boy on Eager Street, 1976

After "last call" at the Hippo, on the weekends, the young queens paraded across
the street, like Sirens, arms, and hands all over the place, waiting for their "regulars"
or looking for new ones. Daniel liked only blonds.

Flare, 1986

One very popular film in the late '90s, "Office Space," made the name "Flare" famous.
"Flare" were these little or large print-on buttons of all colors and sizes attached by
a safety pin to your front clothing. The writings on them were usually little advertise-
ments of one thing or another or wicked or funny observations on the Universe.

 He called himself "Tyme" and was this very friendly "check-out" guy in a "Fresh
Fields" market in Mt. Washington in 1986. "Tyme" had a little less than 30 pieces of
flare attached to his black leather jacket. Just one of them read, "I drink to make other
people interesting." And right below it another one read, "If it's humanly possible."

253

Mistress Q, 1994

She does indeed look frightful! Possibly a "Bad Hair Day," or a "Bad Hair Weekend!"
Maybe a peptic disorder, bowel disfunctions or a good "Sting of the Furies!" But the
Furies are everywhere, Man!! Not just in Baltimore. But actually, she was a sweetheart.
Every weekend she worked at the "Baltimore Zoo" teaching children all about the ani-
mals, how to love them and understand them and not to tease or frighten them or try to
hurt them.

Mistress Q was also a "skin donor." Not that she actually gave her living flesh
away to just anybody, instead, in the evenings, she allowed her skin to be appropriated,
temporally, as a white living canvas for fledgling tattoo artists. In return, she got all
those horrible monsters, ship sails and frightening symbols and cryptic writings and
all the Devil's nightmares! For free.

"Mistress Q" at the "Hippo" one Saturday night. She was a sweet Heart.

I'm return she got all the monsters, frightening / frightening cryptic symbols, free!

amor
Baldwin Shaw
1994

She was also a skin donor. NoT that she actually gave her living flesh away to just anybody but allowed it to be approbated, temporally by as a living canvas for fledgling tattoo artists

"No Nammie," 1993

John's night life might have begun at Tracks in Washington during the '80s before he moved on the Nation. He looked like a cross between an oriental concubine and a dramatic 1920's movie star, perpetually ready for her "close up!" You couldn't miss her. He had a subdued personal presence but his maquillage and costume were inventive and extraordinary. Like a true actor, he inhabited an ever-changing personality.

Miss Charisma Aviance, 1999

The "it" of "it" is best defined by the brilliant critic and collector, Vince Aletti. "Queer" is transgressive … audacious …unsafe…unapologetic and often subversive. "It" doesn't have a look, a size, a sex. "Queer" resists boundaries and refuse to be narrowly defined. And "Tracks" defined "It." Just take a "Lozenge" and you were ready to roll.

"His Holimess the Paws," 1999
James Joyce "Finnegan's Wake"

At Tracks in the late '90s in Washington there were usually a few customers who just needed to come out of the woodwork. Exquisitely scary, raw, and intimidating and I was afraid to approach them.

"Sista Face" was the sizeable "Hostess" of Tracks reclining as a grand odalisque on the bleachers by the volleyball courts and she held the keys to the V.I.P. room and "Miss Charisma Aviance" was her trusted confidant.

She played pool and then lounged in the pool room, with thick hairy legs in torn black fishnet stockings, spider-like shoes, and underwear. I was afraid her tongue might lash out like lightning and letting her digestive juices doing the rest, looking like she'd just eaten a toad fish.

At Nation, again, "Sista'" was the Hostess with the keys to the V.I.P. room and "Charisma," "Charisma Aviance," once again, her trusted confidant, the "I" as in indigo.

At times Sista Face looked like a Nightmare. Not quite Medusa quality and minus the snakes and hatchet. A couple of times "Sista" had to remind me the name was "Sista," not "Sister."

"Sista" had been the "Hostess" at "Tracks" in Washington until it closed in 1999 & now the "Hostess" at "Nation".

"Sista' Face" or just "Sista" with her "Charisma". With her trusted confidante,

1999

A Ride, 1994

Early on Jef-Rey pulled open the emergency door of Life and jumped in. Anything to shock this broad is not of Human design. One of the most talented, outrageous, and persistent performers, as "Hermaphroditee," in the gay bars and clubs in Baltimore during the '90s. He founded the performance group "Frau Live" which would often include "Meduza" and "Piss." One night when the group was going to perform at the 14-Karat Cabaret at Saratoga and Fleet, just one of the perks offered on the flyer was "free blow jobs!"

This was just too good of an offer for the Baltimore Vice squad to miss, it was right up their alley, and they rushed right over and shut the place down and all the girls went to jail. He also performed at the Stud, a brand-new bar, just opened on Charles Street just a little ways up from Club Charles. You would see people in there you almost never saw on the usual club circuit. A few members of the John Waters crew showed up frequently. It was owned and run by this wild woman. During all of Jef-Rey's performance years she never appeared as the same woman twice and not even one free blow job ever materialized.

As for Jef-Rey, each brilliant performance required him to propel himself into other dimensions by any means necessary too many times. Over the years the "dimensions" got deeper and stronger and finally threatening to consume him completely like a "Black Hole." He finally realized he needed desperately to get his life back together again and "get clean." He did! Afterwards he would never perform on stage again and became a recluse.

A Picture of Innocence, 1976

Sandy was this very sweet person and every Saturday night she showed up at Leon's, the only bar she went to.

Sometimes "Divine," the star in "Female Trouble" and "Pink Flamingos" would hang out there, out of drag and nearly unrecognizable, leaning against the cigarette machine between the 2 doorways. Take the bar back, Jim Joiner, a growler, the bouncer and a painter, a bearded loveable holdover from the "Beat Generation." So many times at night you'd see him descending from the ceiling in an unstable, creaky, makeshift tiny primitive elevator, an unenclosed platform actually, with the goodies. It reminded me of Katherine Hepburn descending from Heaven grandly and slowly in her elegant cage elevator, a "deus ex machina" if ever there was one in "Suddenly Last Summer."

As for Sandy, almost everybody in the bar knew her and loved her. Sandy loved "immaculate": frilly and white and tight dresses, the picture of Innocence, an image of a girl somewhat younger than she was with large breasts. She still lived with her mother. Sometimes I wondered if "She" was a "He." I heard that silicone injections led to severe epidermal dysfunction and cancer. She died sometime in the late '70s. She could always be seen at the bar on Saturday nights almost 'til the very end.

Beauty Engineer XXX-Traordinaire, 1993

Her mother made the marriage of the century and left her bags of uncut diamonds. At 16 she had tons of blond hair and was sent all over the world because people were in love with her. At one time she did the Fall and Spring line for Givenchy, Paris. The remains of the jewels, art and original furniture not found in her apartment on the thirteenth floor of "Hopkins House" are safely displayed in her other houses.

"3 Ravers" 1999

Basically they pursued "Raves".

3 "Club Kids" showed up at a "Gay Pride Festival" in 1999 at the corner of Charles St. next + Eager.

Club Kids, 1999

Three ravers show up one summer in 1999 at a "Gay Pride" block party at the corner of Charles Street and Eager. It was right alongside the Hippo and Central Station. Liquor hardly lacking and a lot of performance: Shawnna Alexander, "Queer of Comedy!" Right off the street and neighborhoods of the east side. For her a real city hustle, a little bit of this and a little bit of that. Most of it legal.

These 3 ravers naturally pursued raves both in and out of state. They were all eager to be photographed as we were not on Eager Street. Their true sexuality was a good question. I didn't bother to ask. I just wanted new people to photograph.

A Fairy Tale, 1978

Before the Hippo opened, the most popular of the neighborhood bars was the "Pepper Hill" on Gay Street.

As Hippo's popularity grew, it drew a large collection of gay customers dressed as a woman and including one young waiter named "Chicken." Lena and her best friend Natalie were just two of the very early patrons. In time Natalie became an actual sex change. After "last call" at 2 A.M., a lot of the queens would gather across the street making joyful noises, arms and hands flying all over the place, either looking for a loose trick for the evening or becoming bait for the older paying customers driving by. Good God! Gay life in this city in the '60s, '70s and '80s. was a "Miracle." It couldn't get any better than this! But "this" is what I had always been made for!

Leonard, when he finally got older, retired "Miss Lena" and by some twist of Fate I found him again, this time working in a bleak Baltimore City diner, this time dressed as a man! A fairy tale ended.

Searching for a Lost Adolescence, 1994

I first met Eric in the Spring of 1977 at Mary's bar that was on the corner of Cathedral and W. Chase Sts. The bar was owned and managed by Cal, whose liver had more lives than the true Cross. It was one of the hot spots for some celebrities and those on the gay circuit. Cal sold the bar in the late '70s and it was replaced by a straight strip bar. Eric was young at this time and was therefore brought by an older chaperone. He lived on Elm St. in Hampden, a working-class suburb, and was impatient to taste the gay scene in Baltimore City.

When I saw Eric bar dancing years later at Club Atlantis, (where older men were looking for a good time and their lost adolescence) he told me I had photographed him in the late '70s. I was drunk and wasn't listening well and it took me three years to make the connection.

across the street of the parking lot was the Baltimore "Intake Center" and the villains were always at their cell windows, whistling

Sunday afternoon it was gay "Happy Hour" all over the city and "Cell", Atlantis" was, after all, the "lost city" as well as the only gay dance bar in town. Right

and screaming at arriving gay customers, making fun of them but everybody knew they needed "help" badly. There was at this time a city ordinance against complete nudity in all gay bars and dancers had

to wear at least a g-string, i guess, to protect the children in case any of them showed up there. Finally, in the mid-90's this code was rescinded and now nothing was left to the imagination. Unfortunately, by that time, i had managed to get myself "barred" and i never saw it.

"Always on Sunday."

90's Amos Badertscher

Talents, 1992

Phillip was a patron at Tracks, a bar that had something for everyone: hard-core drugs, dance floors, pool tables, and a large sand covered courtyard for sports, conversations, pick-ups, and general posturing. Was this all for real or was it just in the mind of the beholder? And this could spark a long conversation about Plato and Aristotle about what is "reality" and so forth. Remember, Aristotle was the tutor of the war "criminal," Alexander the Great. You might wonder what the Hell he had been teaching him.

The P-Poem: A pretty short history of Sexual Intelligence and Exhaustion, 2010-22

No penis is the same Instrument twice.
If a penis could talk, what would it say?
Would it say thank you for a little attention?
Would it say I'm hot or I'm having a bad day?
I'm sorry?
If the penis said "sorry" I'd have to ask it how sorry was it.

Does a Martian have a penis?
And what would it look like?
Would we even recognize it as a penis?
Does he or it need one?
You can sometimes tell from what position in the Universe the person attached to the penis comes from.
You can tell a Russian Romanian Siberian penis from one in Michigan.
Some penises are ridiculously large and others insanely small.
Just what does it do for your resume if you have a small one?
Would you commit suicide?
Would you move to Afghanistan or Florida?
But there are people who are turned on by a small penis.
I'm not one of them.
From a small penis I'd imagine you have nothing to fear.
If you have a very big penis probably too much of your intelligence has somehow migrated in that direction.
If you're a teenager, it can prove embarrassing.
I saw this video once
Where this kid was lying on a beach chair in the sun
And you could see something large and wonderful, dangerous, and ungovernable crawling around in his black swimming trunks.
At first, I couldn't believe what I was seeing.
At the same time, he was trying unsuccessfully to hide it or to beat it into submission.
And this was failing because the thing
had a mind of its own.
The video predictably found its way onto the internet and
Once on the internet, like the penis, it was completely out of control.
A penis just behaving like a penis
And the whole thing was quite extraordinary.
I wonder if the kid made any money doing this.
Was it staged or was it just the right person coming along at the right time with a camera?
Did a "heterosexual" couple with two kids see this happening? Would it totally fascinate, excite, or scar the kids for a lifetime?
Would they need therapy and counseling?
And who would pay for it?
And would it end there?
Would somebody get sued?
Or put on the "sex offender list"?
Would the kid in the video go to jail?
But it's not something a concerned parent would find amusing.
With an excited penis you just have to know how to manage it.
A penis is repetitive always doing the same thing. But each time you see one working properly you quickly forget about the Martians, the iterated algorithms
And the Heisenberg equations.
For some people the whole thing can be disruptive and disturbing. They might wonder what in Hell God was thinking about in His Infinite wisdom.
Could people who feel this way about the penis have had a bad childhood?
Could they have seen the kid in the video?
But I too had had a bad childhood and I never found the penis to be disruptive or disturbing.
Is there such a thing as Infinity?
Or does it all possibly end somewhere?
Can I trust Einstein?
Is there any kind of penis we don't know about?
Like in another dimension?
Are other dimensions worth thinking about or is it just a matter of getting down to business.
For me the first time was so frightening I had to stop doing it.
The next day I told all this to my neighbor next door who I thought was a "normal" American boy.
Well, he seemed "normal."

But what's "normal?"
He said I had nothing to worry about. He showed me how to do it properly and convinced me to try it again.
I did try it again and never regretted it.
In conclusion, the penis is inscrutable,
It doesn't vote.
It eschews ideology.
It doesn't take drugs or commit suicide.
It's a work of God.
It speaks every language.
It doesn't need any help getting to where it's going.

It never takes "no" for an answer.
It never goes on vacation.
It wants all the attention.
It shows no pity.
It never has to be encouraged. It hasn't a brain.
It can ruin careers and or result in death.
This is not encouraging but
Nobody seems to worry about it.
When dysfunction finally slams into the penis like an asteroid, of course you never expected it, but you know right away you're in trouble.
Your penis is talking telling you that your life in its most fundamental dimension is finished.
Hello!
This is your penis talking. I'm finally shutting down! I just wanted to give you a heads up.
Oh, thanks a lot!
No problem.
You might as well take up table tennis or move in with your parents in Florida.
I look at this all philosophically whatever that means. But what could possibly replace a flawlessly working mindless penis. Am I missing something?

Bowels of Perversion, 1976

Frank was born in 1955, (the year I graduated from High School) and died of AIDS in 1992 at 37. He lived for years with his mother on S. Decker Street and had his first sexual experience with an older man at an age I won't mention, in Patterson Park on a hot summer's night in Baltimore and "loved every minute of it."

Due to alcohol and drug abuse and an absent father who deserted him when he was 10 or 11, he frequently ran away from home and school and when he was older, he often attended "Leadbetters," the most popular and accelerated mixed bar in Fells Point at that time and one night he just managed to fall through the skylight in a kind of drug blackout in 1974.

His career as a hair stylist began when he "passed out cold" in the "Sip N Bite" on Boston Street, a place where all the fabulously deranged fags and fagesses, drag queens and movie stars congregated after 2 A.M. and right there, in the bowels of perversion, he was rescued shortly after 2:38 A.M. by a kind and sympathetic patron who got him into hair school in NYC and on the road to recovery.

The recovery would take a long time and tuition and living expenses were somehow met with a little help from the patron as well as "stripping" in gay dance bars and a lot of hustling on the weekends. One night he was kidnapped by a deranged admirer and held in the guy's apartment for 3 days. This was not the first hustler this had happened to. There were 2 others in Baltimore.

For years Frank was a very popular and successful hair stylist in Baltimore, a frequent visitor at the Hippo. Back then, in those early days, patrons put a lot of inventive effort into designing their maquillage and the persona that went with it; another Universe, never to return. That night he was smiling and ecstatic: "I'm going home with this wonderful man who's going to do all kinds of good things to me."

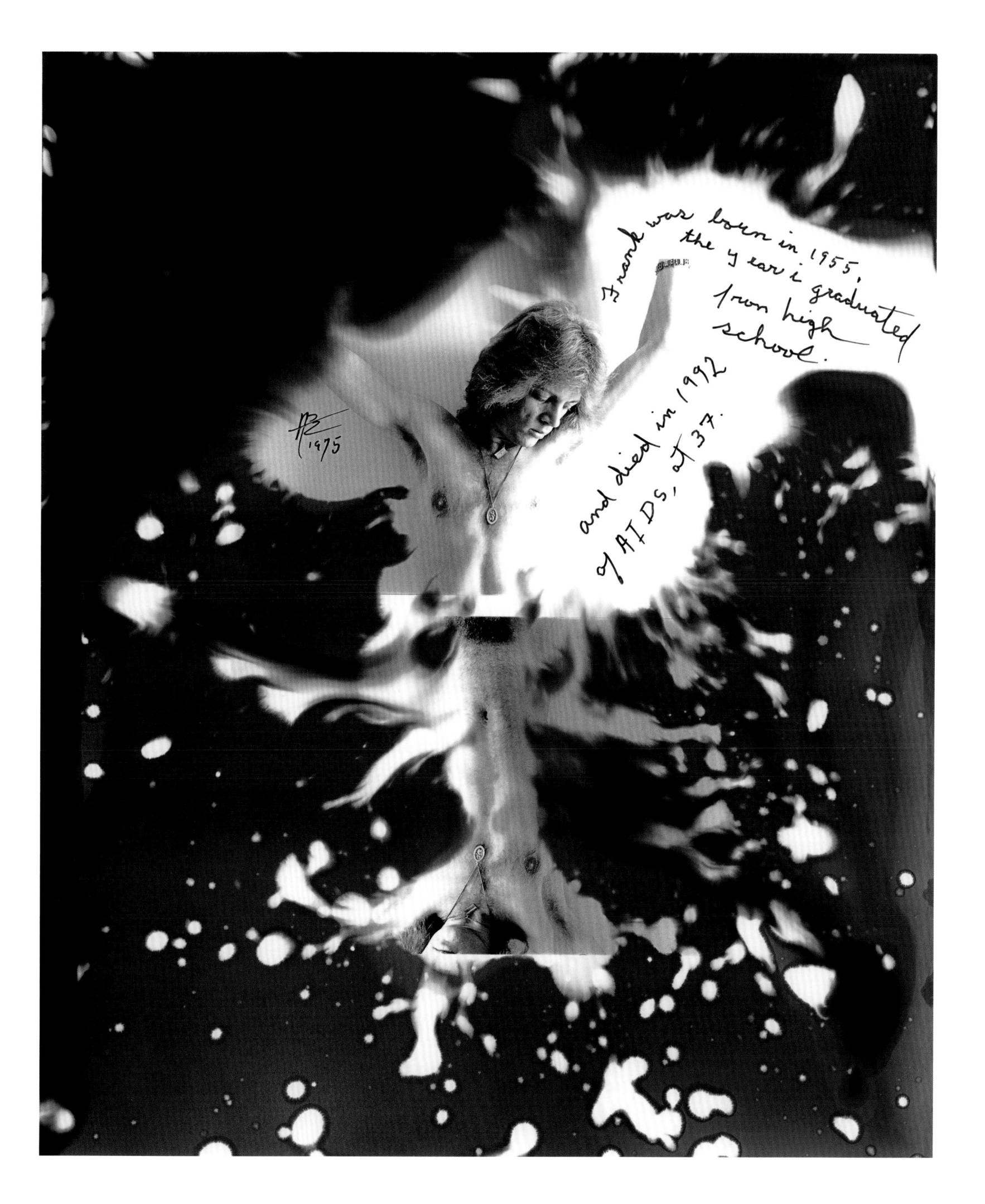

PHOTOGRAPHY AGAINST THE "NORMALIZATION OF FAGDOM":

In the early 2000s, shortly before Amos Badertscher gave up photography, the street boy Dennis became one of his most popular models. Dennis frequently appears outside, posing with and blowing fellow hustler David (2004), in a nude photoshoot in a homeless man's den under the concrete pylons of the I-95—the Baltimore–D.C. Interstate—or in staged scenes shooting up heroin in Patterson Park.

Dennis also features in much of Badertscher's domestic studio work, the setting in which the photographer first mastered the medium in the 1960s. In *Art Disrupters #2* (2002, p. 153), the hustler and a female prostitute provocatively pose together against a bleached brick wall, swapping a studded collar and leash between them, he sometimes standing over her, his erect penis bobbing near her face. Dennis wears the collar again in *Luna and Dennis #1* (2002, p. 235), standing in the embrace of a Divine-esque drag queen. Badertscher scribbles on the borders of these pictures that Dennis was a "natural actor," who could "instantly and convincingly" take up any role given him, because "another role, another identity, at least gave him something, temporarily, to latch onto."[1]

Badertscher trains his camera singularly on Dennis in the studio work of the *Giacometti* series (2003), ghostly figure studies of the hustler undressing, and the *Male Studies - Bare Bones* series (2003), in which he anatomically fragments Dennis's contorted body, the camera burrowing, for instance, into Dennis's asshole as he drapes himself across Badertscher's legs. The frame reminds one of Dennis Cooper's depiction in *The Sluts* (published in 2004, at the same historical moment), of the extremity and variety of the explicit sexual fantasies that older men harbor for younger hustlers.

Dennis's sexual malleability, and skills as an actor, clearly reflect the transactional condition governing his appearance before Badertscher's lens. Like many of his models, Dennis was paid to be there, an exchange that marks the exploitative edge of Badertscher's

project, given the artist's own freedom to enjoy his inherited wealth. For Joseph Henry, writing in *Artforum*, his depiction of hustler sexuality thus "obeys pre-established scripts and configurations of power."[2]

Yet Badertscher's work also explores hustling as a mode of sociability, in which the hustler and john are both implicated. The contingency of sexual identity is exposed. As he explains, "I have images of girls blowing their hustler boyfriends under the interstate, gay boys blowing each other, straight boys blowing each other for money. I want to show, in the most graphic terms, what hustling is all about, what sex for sale is all about. This is a way to understand that lifestyle."[3] Badertscher's presence in the *Bare Bones* series—as in much of his studio work, cradling a model between his legs before a mirror—indicates that, like Cooper, his subject is as much the problematics of the desire of the john as it is hustler "lifestyle," and how the two figures are presented together through his photography.

Through Badertscher's work, Sigmund Freud's foundational assertion that the sexual object and drive are but soldered together is given renewed meaning in postindustrial Baltimore.[4] The artist shows the relation of sexual behavior to conditions of economic decline; the hustlers he photographs have been abandoned by capital and are also fulfilling its logical extension. For Michel Foucault, speaking in 1982, practices of homosexual consummation are all "products of an interdiction," of "very concrete and practical considerations" that say "nothing about the intrinsic nature of homosexuality."[5] Badertscher repeatedly delights in showing how formations of identity, as manifested through sexual acts, are weak and fungible. He is especially critical of "the normalization of fagdom" since the 1980s, which he associates with the long march of the political Right in the United States, rather than any fantasy of emancipation.[6]

How, then, to understand Badertscher's contribution to the history of photography, in

particular to those photographers, also working out of the dying embers of modernism, who took a similarly ambivalent position about the emergence of urbane gay identities across the same period? His amassed archive provides an intimate, elaborately constructed picture of sexual commerce in postwar America, stretching from the civil rights movement, sexual revolution and Vietnam War era, through the HIV/AIDS epidemic and rise of the New Right, up to the reascendancy of imperialism in the War on Terror post-9/11, all filtered through the economic decline and later gentrification of his port city home.

Badertscher's annotation of prints recalls the image-text constructions of Duane Michals and Hal Fischer, artists juxtaposing language with staged street photography to create surreal and structural depictions of gay desire. His exploration of the camera as productive of pleasure, especially in his studio practice, similarly dialogues with Sunil Gupta's use of the camera as an instrument of cruising, and with the wide array of photo documentation of public sex in the 1970s, notably on the derelict New York piers, including work by Peter Hujar, Alvin Baltrop and Leonard Fink. Finally, Badertscher's subject matter—the exchange between photographer and sitter, and questions of power and subjection therein, as well as the lived reality of heroin, hustling, and sex-for-sale in contemporary America—have been variously taken up by artists as diverse as Robert Mapplethorpe, Larry Clark, Philip-Lorca diCorcia, and Leon Mostovoy.

Taken together, these photographers index a story of the fitful and uneven entry of photography into contemporary art, and the emergence of a field of gay photo work. (For example, training in photography at the New School in New York in 1976, Gupta cast around for precedent in the depiction of sexuality in the medium, finding inspiration in Michals, Mapplethorpe, Hujar, and Arthur Tress.)[7] Badertscher's work—as a self-referential, vernacular practice, not directed at an art world

1. *Luna and Dennis #1* (2002), p. 235.
2. Joseph Henry, "Amos Badertscher at Schwules Museum," *Artforum International*, June 17, 2020.
3. Craig Seymour, "A Conversation with Amos Badertscher," *The Archive: The News Publication of the Leslie-Lohman Gay Art Foundation* 38 (2011), 6.
4. Sigmund Freud, Three Essays on the Theory of Sexuality (1905), in Standard Edition, Vol.7, ed. James Strachey (London: Vintage, 2001), 148

5. Michel Foucault, "Sexual Choice, Sexual Act" (1982), in *Foucault, Ethics: Subjectivity and Truth*, ed. Paul Rabinow (New York: The New Press, 1997), p. 150.
6. *A New Deal at the Hippo*, p. 251.
7. Sunil Gupta, "Queer Migrations" in *We Were Here— Sexuality, Photography, and Cultural Difference: Selected Writings by Sunil Gupta* (New York: Aperture, 2022), 135.
8. See the introduction in my recent book, cowritten with Flora Dunster, *Photography: A Queer History* (London:

Octopus/Ilex, 2024), for more on the problematics of the term "queer photography," which can easily humiliate the diversity of practices, politics, and effects held under its name. See also Laura Guy, "Queer in Practice," *Source* 79 (Summer 2014); the introduction to "Queering Photography" by Elspeth Brown, Bruno Cechel & Sara Davidmann, *Photography & Culture* 7:3 (November 2014), 235–38; Vince Aletti, Richard Meyer and Catherine Opie, "Queer Photography?," *Aperture*

AMOS BADERTSCHER IN CONTEXT Theo Gordon

WEST SIDE, SO QUIET, 1978

context of reception, at least until his first exhibition at Duke University in 1995—offers welcome challenges to current efforts toward the formation of a gay canon of photography, indeed to the very question of "queer photography" itself, and its attendant cultural politics.[8]

At present, the cultural politics of sexuality are caught in the reactionary Right's attempts to treat categories of gender and sexual orientation as fixed, self-evident, and immutable, nowhere more evident than in the attempted bans on drag queens interacting with children (and on drag more broadly), the policing of single-sex spaces, and the general anxiety surrounding the transgender child. All these phenomena take their root in earlier moments within gay liberation in which assimilative aspects of the movement attempted to jettison its more radical street fighters, including homeless queers and trans people.[9] As Mack Friedman notes, the movement "would leave its most valiant instigators—street queens and teenage hustlers—at the side of the curb."[10] Badertscher's focus on hustler culture, and vehement rejection of identity, take on renewed significance in this context. In 1991, Simon Watney described a division, still active now, between "those who think of the politics of sexuality as a matter of securing minority rights, and those who are contesting the overall validity and authenticity of the epistemology of sexuality itself."[11] Badertscher's work, for all its "thorny ethics," certainly contributes to the latter project.[12] His photography of hustling provides an historical archive of sexuality "as a site of definition, regulation, and resistance" in the recent past of Baltimore, resonating with the instability of identity, and of the photograph-as-document, as explored by many of his contemporaries.[13]

In Badertscher's early photographs of the 1960s and 1970s (in his words, "the best and the last decade for Baltimore"), models from the gay bars and meat racks appear in relatively good health.[14] His annotations, written in the wake of the ravages of subsequent decades, both eviscerate identity politics and gleefully declare his violation of the conventions of documentary; in "Queer Studies—When Ignorance Is Bliss" Badertscher laments that "just a little after 'Stonewall' the shit really hit the fan in America. The new words were 'fruit,' 'faggot,' 'homo,' just up America's alley. A Puritan culture always needs fuel, something new to get hysterical about."[15]

For Duane Michals, who first wrote on his prints for his exhibition *Stories* at MoMA in

218 (Spring 2015); and Marquis Bey et. al., "Trans Visibility and Viability: A Roundtable," *Journal of Visual Culture* 21:2 (August 2022), 297-320, for other and recent perspectives.

9. See Scott Branson, "Gay Liberation Failed," for a recent view on the recurrence of cross-generational and transgender anxiety in gay assimilation, The Baffler, February 21, 2023, https://thebaffler.com/latest/gay-liberation-failed-branson. Accessed 6 July 2023.

10. Mack Friedman, *Strapped for Cash: A History of American Hustler Culture* (Los Angeles: Alyson Books, 2003), 132.

11. Simon Watney, "Queer Epistemology: Activism, "'Outing,'" and the Politics of Sexual Identities" (1991), in *Imagine Hope: AIDS and Gay Identity* (London and New York: Routledge, 2000), 55.

12. Henry, "Amos Badertscher."

13. Jeffrey Weeks, *Sexuality and Its Discontents: Meanings, Myths and Modern Sexualities* (London and Boston: Routledge & Kegan Paul, 1985), 10.

14. *Jackie, A Life, My Oxygen #1*, (1975), p. 157.

15. "Queer Studies—When Ignorance is Bliss," (n.d.), p. 30.

16. Sarah Hermanson Meiser (ed.), *Arbus, Friedlander, Winogrand: New Documents*, 1967 (New York: Museum of Modern Art, 1967).

17. Michals is explicit in the book that "the photographs and captions are not illustrative of Cavafy's poetry. They are separate and sympathetic." Duane Michals, *Homage to Cavafy* (Danbury, NH: Addison House, 1978).

18. See David Getsy, "Catherine Opie, Portraiture, and the Decoy of the Iconographic" in *Confronting the Abject* (Chicago: School of the Art Institute of Chicago, 2015), 15-37; Julia Bryan-Wilson, "Gay Semiotics, Revisited," *Aperture* 218 (Spring 2015), 33-39; and Gordon and Dunster, "Hal Fischer" in *Photography: A Queer History*, 34-35.

1970, annotation was a way to disabuse what he saw as the limitations of the isolated modernist print, as recently reinvigorated by John Szarkowski's *New Documents*.[16] Several of Michals's early *Sequences* dwell on the beauty of the nude masculine figure, yet it was not until *Homage to Cavafy* (1978) that he would explicitly celebrate "a man who loved other men," who had made "public these private passions," by publishing staged interior photographs of male sociability juxtaposed to Constantine Cavafy's poems.[17] At this same moment, Sunil Gupta was inspired by Michals's use of image-text to create his *Gay Sequences* (1977–79), four photo series of men cruising the streets of Montreal, accompanied by poems with an ambiguous relation to the images, telling of the ambivalence of coupling and separation. Both Michals and Gupta share with Badertscher a desire to use image-text to observe a poetics of the epic in the minutiae of lived experience. (In his annotations, Badertscher frequently cites sources as grand as Heraclitus, Ovid, Homer, William Shakespeare, and James Joyce.) Michals, Gupta, and Badertscher also share the aim to destabilize the transparency of the documentary form; it is not possible simply to "read off" identity from any of these practices. Even in a work like Hal Fischer's *Gay Semiotics* (1977), which thematizes the urban codes of the newly public gay population in San Francisco, the self-evidence of documentary is satirized in the wry dryness of many of Fischer's labels.[18] Badertscher's seemingly banal anti-identarian scribblings, often registering facts of destitute lives in a disengaged tone, tap into a vein of ambivalence traceable in even the most seemingly transparent gay practices of the moment.

Badertscher's refinement of his studio practice, notably introducing the use of mirrors, extended his rumination on desire and the documentary form. With the rise of neoliberalism in the 1980s, "stepped-up law enforcement and declining social services," in tandem with the crack cocaine and HIV/AIDS epidemics, "made the streets more of a living hell than ever before."[19] Alongside increasingly waxen and waiflike hustlers, as in the *Always Searching Out Your Weak Points* series (2003, p. 95). Badertscher appears with his camera in the frame, caught in the surface of the studio mirror to foreground the thrust of his desire.

In his celebrated recent studio work, Paul Mpagi Sepuya uses the mirror to create a circuit of image production between the reflective surface and the camera, a space

A BRIGHT AND CHARISMATIC VILLAIN, 1998

19. Friedman, Strapped for Cash, 219.
20. Flora Dunster, "Do You Have Place? A Conversation with Sunil Gupta," *Third Text* 35:1 (2021), 92.
21. *Always Searching Out Your Weak Points* series (2003).
22. Leo Bersani, "Sociability and Cruising (2000)," in *Is The Rectum a Grave? And Other Essays* (Chicago: University of Chicago Press, 2009), 47.
23. Vince Aletti, "First Break: Larry Clark," *Artforum International* 40:9 (May 2002). 47.
24. As José Estaban Muñoz has argued, a homophobic homosociality between men plays out also in these images. Muñoz, "Rough Trade/Queer Desire: Straight Identity in the Photography of Larry Clark" in Deborah Bright (ed.), *The Passionate Camera: Photography and Bodies of Desire* (London and New York: Routledge, 1998), 167–77.
25. Philip-Lorca diCorcia, *Hustlers* (Göttingen: Steidl, 2013).
26. Michel Foucault, quoted in Judith Butler, *The Psychic Life of Power: Theories in Subjection* (Stanford: Stanford University Press, 1997), 101; Bersani, "Sociability and Cruising," 60.

of appearance. Sepuya and his sitters appear within this space, playing with the camera to suggest the possibility of controlling and manipulating representation, and so gesturing toward the collaborative fashioning of a whole new regime of vision. In Badertscher's work, the mirror is much more about reproduction, emphasizing how his camera creates the conditions of appearance. Badertscher's open legs literally frame and cradle his subjects, while the mottled surface of the mirror mimics the battered bodies and spirits of his subjects. Photography of cruising has repeatedly insisted on the camera as a desiring machine, as in Gupta's *Christopher Street* (1976). In this important work of street documentary, the lens became "an extension of his libidinal gaze" in the liberated West Village, "a way of 'having them all.'"[20] Alvin Baltrop's New York City pier photography (1974–86) and also that of Leonard Fink (1967–92), frequently delights in providing clandestine views on sex acts in the ruins, the photographs posing the voyeuristic dynamic of a peep show. Badertscher's work participates in this tradition of photographic desire, yet by foregrounding the camera's presence through its mirror reflections, his desire becomes almost too obvious, too insistent. The penetrating presence of the camera in his *Always Searching Out Your Weak Points* series matches the apparent mystery and darkness of the sitter: he had "the face and manner of an intelligent charmer, masking the destruction and total confusion within."[21] Part of the appeal of cruising photography is its play with surface alone, with a mode of the social in which subjects become "less than what we really are" through acts of looking.[22] Badertscher's studio photography plays between surface and depth, offering both mere mirror reflections and a penetrating camera lens that shows his desire as the lynchpin of the scene.

Badertscher's expanded studio work paralleled his increasing awareness of his relation to other photographers, such as Robert Mapplethorpe and Larry Clark, even as he rejected their courting of the art world through the representation of subculture. Clark's landmark series *Tulsa* (1971) and *Teenage Lust* (1983), were formed by his desire to pioneer the photography of a "hidden" realm: "I knew I had this secret life in Tulsa that no one photographed, so I went back and started photographing my friends."[23] Tulsa was aimed at the New York art world, and as such Clark is a dramatic storyteller in his tight choice of exposures, which, as in the picture of a youthful semi-erect cock, incite interest in the implied subsequent action of the scene.[24] By making his own staging of images, including drug taking, so apparent, Badertscher reveals the theatricality that underpins Clark's supposed naturalism, and shows the sexual scene as comprised of roles sometimes reluctantly taken up, rather than simply fueled by outright, or "authentic," desire.

Badertscher's subject, as I suggested at the outset, is the transactional aspect of sexuality, its resistance to identity formation, and hence its capacity to bend and break under the strains of capital. As such, his pictures with scribbled annotations have closest affinity to the work of those artists who similarly foreground the relations of exchange that enmesh photography, sexuality, and cash. In 1990, at the height of the culture wars, Philip-Lorca diCorcia used the money from his National Endowment for the Arts grant to pay for hustlers in Los Angeles to pose for his series of filmic Cibachrome prints, *Hustlers* (1992). As diCorcia writes, "photography is an exchange. The original title for the project was *Trade*: as in the street word for prostitutes, as the exchange of services for money, as the role reversal which voyeurs indulge and photography provides, as the desire to be anybody but you."[25] By stating the transactional fee for the picture as part of the work, diCorcia exposes the flows of cash that ordinarily run secretly through the entire economy, including the art world, toward the supposed "margins" of the social body. His intervention recalls one of Leon Mostovoy's photographs from *Market Street Cinema* (1987), in which one of the lesbian sex workers in San Francisco wears a T-shirt printed with a picture of Margaret Thatcher, captioned "We Are All Prostitutes."

The unequal exchange of power in Badertscher's work reminds us that, of course, we are not all literally sex workers; the abject suffering endured by his hustlers, in contrast to his own economic security, is clear to see. His photography does, though, generously keep open an aperture onto the mobility of sexuality against sexual acts and identities, especially assimilative individualism. Foucault once proposed that "we have to promote new forms of subjectivity through the refusal of this kind of individuality which has been imposed on us for several centuries," while Leo Bersani has asked if practices of cruising, as a form of sexual sociability, could "help us to at least glimpse the possibility of dismissing moral worthiness itself, of constructing human subjects whom such moral categories would fail to 'cover'?"[26] Badertscher's photography can hardly be said to provide an answer, but it does invite us to dwell in, and rethink, the bind.

IMAGES AND STORIES
PART THREE: MIRRORS

Mirrors are a wonderfully evocative complication in photography. Usually, when we see a subject, the familiar binary of viewed/viewer is reinforced, establishing us as the central audience and reason for being of any photo. But introduce a mirror, and that whole dynamic goes sideways. Depending on the angle, we sometimes can't see the subject at all, but only the reflection. Other times, mirrored subjects might suggest that they're posing for one another and our presence is secondary, if it registers at all.

Amos Badertscher's photography makes liberal use of mirrors for a different reason. He uses them to capture his own reflection in the act of taking the photo. This simple fact recasts his power and authority as an artist. By making himself now both artist and subject, he opens himself up to the viewer's gaze, both allowing us to peer behind the curtain of the photographic process and leveling the power dynamic between him as a more established, older man and his subjects, who were often young, addicted, and leading tenuous, unstable lives. The fact that these mirrors are scarred and damaged declares their presence, underscoring that what we're seeing isn't a transparent window on the real, but something manifestly staged.

In the large number of images in which he mirrors himself, his aging, naked flesh stands in pointed contrast to his lithe, young models. He willfully exposes himself as a voyeur and as socially marginal, performing and subverting the dirty old man persona. Despite his ostensibly more secure station in life, he is almost as vulnerable as his subjects, and way more naked.

Jonathan D. Katz

Out on the Baltimore Streets at 17 #1, 1996

A Self Portrait, late '90s

Action Pants
A self-portrait, me, just passing the time, probably waiting for a model to show up.
1. "It's not about giving the sighted world what it wants to see" —Chris Colin, NYTimes, November 29, 2009
2. "Nudity allows us to sneak into human weaknesses and the most secret parts" "Situations" —Antoine d'Agata 2007
3. "Lechers are the only hope of the twenty-first century!" —Nobuyoshi Araki
4. "If it doesn't have ambiguity don't bother to take it." —Sally Mann

The "truth" does not follow a Moral Compass !

A wise fellow Goddess.
↑ Put that in your pipe
and smoke it !

chill out !, chill Out !
My little ones, chill Out !.

Mid-90's

"The "Lost" have only this one
deliverance ::: To hope for none".
Aeneid - Book II

Just "me" way back then, still happily stuck
in the 20 ith Century ! Don't worry, those are
just pressure socks, not to worry! Offerings
to the Devil !

Stephen's Cousin, 1995

Sonny was born in 1974, the same year his parents split up. His father taught him boxing to help him survive in his grim west side neighborhood. But that was in the '80s and since then the neighborhoods are astronomically worse. His father himself was involved in a street brawl that left him in a coma for 7 years and he died in 1994.

Sonny taught his cousins Stephen and John, how to hustle "fruits" along Wilkens Avenue. This was to pay for heroin and otherwise supplement an income which was basically nonexistent. They would track junkies and rob them too. Sonny still lived with his mother in a very small row house on Wilkens. He could neither read nor write nor work.

That Summer, 2001

Bonzo was a marvelous liar and a trip. He lived with his grandmother on Pratt Street in one of those east side working class neighborhoods that at one time had seen much better days and hardly 2 blocks from Patterson Park.

His mother had fled to Ohio with her younger son Carl because she had to get away from all the drugs in the city or die. Bonzo desperately needed, but had never had, a man's attention, a presence hopefully providing some discipline and some masculine direction. He was just out there on the streets alone but at least he always had someplace to live in. He was always the performer craving attention and I was certainly supplying that.

He was also a neighborhood bully, a gossip, and a thief. One summer he stole my framed 20-dollar bill with Mary Boone's signature on it. How did her writing get on the currency? I'll tell you: One winter, just before Christmas, Bill B. and I were in NYC and in one of NYC's large and very expensive uptown galleries. She was short and I spotted her coming out of one door in the white wall and headed for another door, apparently her office and Bill, followed her right in there and asked her to please sign this 20-dollar bill because it was the only thing we could manufacture in the way of a surface at that moment. She said: "Well, I'm not going to get in any kind of trouble doing this, am I?" "Oh no! of course not" Bill assured her, and she never did.

Once back in Baltimore, the bill was framed and placed on top of a marble surface which was the new top of an old radiator and to the left of my favorite reading chair named Cy. But the signature would never be looked at by anybody anyway except by Bonzo. He could smell money in a small patch of skunk weeds and alligators. The currency was detected, disrespected, violated, lifted, and spent and all too quickly consigned to "the dustbin of history." Marx or Trotsky? Maybe?

A Conversation, 2000

Stay outta the drugs, Bonzo.
Shit I didn't know you had drugs. What kinda drugs you got here?
Well, morphine for one, so you really gotta stay out of that one, Bonzo.
Morphine! A., you shittin' me! Morphine ?!
Yeah, it's for the pain in my neck. I got arthritis. I need it. So stay out of that one, OK.
Just look at how small they are. Oh, come on, A., just gimme 3 little ones, OK?
I'm not giving you 3 little ones of anything so forget it, Bonzo.
Oh, come on man it's just 3 little pills. I could really use 'em. Especially tonight.
Forget it.
A. Look, next time I promise, I'll do it for free!
Next time! Why not this time, Bonzo?
Man, I really need the money this time because it's my grandmother's birthday. I swear, I'll go out free next time and I'll do anything you want…well… except…
Bonzo. Just forget it, OK! Just suppose you get caught on the street with 3 little morphine pills in a pocket. Then what are you gonna say? This man gave them to me. And then what man, exactly.

A.! I'm not gonna get caught on the street with 3 pills for Christ's sake. How stupid is that! You don't have to worry about 3 little pills. But I'm just sayin' I found 'em on the street or somethin'.
Gimme a break, Bonzo!
(So! Exactly 43 minutes later. Anywhere on the streets in Baltimore City. Probably in a drug zone. and 2 police: Chuck and Barry, I'm pretty sure.)
Hey! Hey! Just look who it is Chuck. Just look who it is. Didn't we tell you last time to stay outta this area, Bonz! Your brain on vacation, Bonzo? What was it, 2 weeks ago? What was it, Barry? Was it 2 weeks, or not!
It was 2 weeks!
Ya' hear that! 2 weeks! It was 2 weeks! Right?
Look. I'm not doin' nothing. I forgot. I'm going to my grandmother's. It's her birthday.
This isn't about your grandmother, Bonzo. We told you last time to stay out of this area.
Didn't we tell you that!
I'm not doing anything! Somebody just gave me a ride and they just let me off here— just a minute ago. I swear!
Oh! You hear that, Chuck? A man just left him off here a minute ago.
I swear!
What man? You seein' a man now, Bonzo? You still seein' men? What are you seein' him for? Does your grandmother know about you seein' men? A hell of a birthday present, I'd say.

Quiet, Shy Dude, 1998-2000

He lived in a small south Baltimore working class community, Brooklyn, which was on the way to the Dept. of Motor Vehicles and then farther down the road was Annapolis. Between these two destinations exists a large cemetery where both my grandmother and her brother, Clarence and his wife Margaret lie buried and all of them survivors of the Great Depression. "Monk," their stray gray cat died in an alley before they did. J.R. spent a lot of his time all the way across the city with his girlfriend because he didn't go to school and his parents locked him out of the house while they were working.

His real name was Glen, but he was called, "JR". A shy quiet dude. He was distant from his parents and from the world around him. Neither one of them knew how to raise a son. Missing too many days at school, one day he gave up on it entirely quit in the 7th grade. But even that was tepid. So, he decided to try hustling but only if his best friend, Sean, would make the contacts for him.

Check forgers are not easy to find in Baltimore City, esp. on the West side along "Wilkins Avenue". Check forging takes a little talent + imagination.

Sean had a genius for hooking up with exactly the wrong kinds of people, like the pimp and drug & dealer and check forger on the West side of Baltimore City.

In about 3 more years, his best friend Sean, was now in jail. Sean had managed to hook up with a drug dealer, a pimp and a check forger.

D. , 2002–04

David was born in March 1981. He was raised completely by his mother, a lesbian who married to have children in Baltimore County. She separated from his father, an alcoholic, when he was three. D. was aware he was gay from about 14 and sometimes worked as a "Call Boy" following graduation, acquiring some addictions to prescription drugs.

Sometimes the Vice Squad, 2000

Jamie was born in 1981. Her father hung himself when she was 3 and her beloved grand-
mother died soon thereafter. She wanted a strong male figure in her life and when this
didn't happen, she quit school and basically did just whatever she wanted to do. She had
a daughter born in 1998 when she was 17. She works on the west side and at the time
was doing heroin.

 Most late afternoons Jamie could be found sitting on the same white marble steps at
the end of a line of row houses all with white marble steps running along Wilkens Avenue,
the hustling Mecca on the west side of Baltimore City. She worked alone and had her reg-
ulars. Sometimes a carload of local older boys driving down Wilkens Avenue. Sometimes
the vice squad would move her off her corner.

A Dark Alley in Baltimore So You Didn't Have to Be in It!, 1998
Intelligent Demon

He was born Jan. 1976 and his parents broke up when he was 12. He and his older brother John learned how to survive on the streets early. Their mother left their father when they were 4 years old because of constant abusive alcoholism and all the accompanying violence. Stephen also learned how to hustle from his tough little cousin, Sonny.

Intelligent, well-meaning, and creative, Stephen had an unfortunate on and off battle with heroin. He drifted from family to buddies to male friends for shelter and support.

He married his girlfriend in 1994, at 18 and had a son 3 months later. The boy was named Myson, (my son): a nice name; just another cosmic adventure. But Stephen was as ill-suited for marriage as he was for employment – always on the streets, always with men.

In 1997, just before a brief jail sentence his wife learned he "went out" with a lot of older men and they never had any money because most of it went for drugs and sometimes when he didn't have any place else to stay, he was kept by an older woman. So naturally they fought constantly, and he was often arrested for domestic violence.

The resulting court summonses were ignored, and he was arrested for that too. He no longer saw his wife and readily admitted his bi-sexuality. He did another six months relating to domestic violence.

After his release, at times he was living on the streets and in abandoned houses. His weight varied and one time he looked like a victim just released from a Nazi death camp.

One of his later girlfriends, Julia, was a "roller" and another brought her own young son as well into the equation, such as it was. He was excessively tough even although he had quit school in the 10th grade. I'm surprised he even got that far. Despite all this he was intuitive, witty, charismatic, and wily.

One day, out of nowhere, and I was really surprised, his father came up to me and said: "You knew Stephen, didn't you?" Unfortunately, Stephen's constant use of drugs and opioids finally destroyed him. He was killed by a truck while crossing "Eastern Avenue" in July 2020 at 44 years. I was really surprised. Of anyone, he would have been the guy to get himself back together again.

Dress-up, 1996

I really liked Corey. He wasn't queer ("He kissed me there in the dark as we were leaving. I felt so angry I wanted to hit him, but I was so scared. I was 16 then.") but he loved female clothing and liked to watch his girlfriends dress.

Corey delivered plants and young trees from a large commercial greenhouse in another county—so that's how we met him in 1996. We were beginning a garden in the back of the house that had once been a parking space. We decided on an enclosed garden with a commercial steel door. Why?! Well, for one thing, we live in Baltimore.

Corey: "We spent 50 dollars on crack and smoked it all in about 10 minutes. I'm glad I didn't need to go back again to decide it was a waste of time. For my graduation present I got to spend 3 days in jail and 2 years on probation for smoking pot."

And then another thing. One day I was standing at the back window, and I saw 2 men just loading up with all the unopened bags of mulch and fresh soil for the garden we had stacked there. Another 2 minutes and I would have missed them. I ran out to ask, "what you are doing?" and they said "Oh, we thought it was trash and we are hauling it off." Fortunately, the bags were too heavy to run with, so they dropped it and ran. Next day I called "Overhead Doors."

I was raised in this suburb in the '40s and '50s and my parents never locked the doors at night. News boys stashed their papers on a corner and people left their change on top. The cat lived in the garage and was free to wander anywhere at night. Also, in there were some caged white mice, a lizard and two turtles. Sometimes, the cat was allowed inside but he had to stay in the kitchen. One day he had this big hole on this neck behind his whiskers when the black maids came to the house to do the laundry, they had to eat on these "special" plates which were stacked in a cupboard, and nobody was allowed to use them.

Sometimes I would just stare at those plates and wonder what the matter with them was. I was told it was an old Southern tradition. Like not using the living room, except for guests.

But as a kid, I was no stranger to "dress-up" myself. As a very skinny and skittish kid I would often dress up like Roy Rogers because he was my best friend and absolute hero. I'd talk to myself before I went to sleep at night about these amazing and impossible adventures Roy and I would have together, and we had this impervious underground train that we used to go quickly to anywhere in America if necessary. Just the two of us. Each night another adventure. Like the movie serials.

So, I was wondering where in the "sex pro" I went wrong. Years later I was thinking about all those star-spangled outfits and saddles, the 800-dollar boots, the shiny guitars at about 500 dollars and the talking, dancing horses. It was "cowboy drag". Thanks to the big movie moguls a lot of Americans never grew out of it. Even today some men out west still walk around in 800-dollar boots and those weird hats and the guns.

Stories, 2000

John, always known as JJ, lived in Dundalk, east of Baltimore City and all of it a formidably mixed bag of humanity – a working class neighborhood where a lot of the people weren't necessarily working. John was Marty's cousin although you'd never suspect it, even with the same last names. His mother had died of cancer, and he lived in one of the units of subsidized housing alone with his father, a man on various disabilities.

John hustled men periodically. When he would call in the early morning when I would be recovering from my daily hangover, he would begin to describe in excruciating detail the color and shape of every item he was wearing, the type and color of shoes, his exact location on Dundalk Avenue, the names of the streets he would be passing, some drab significant landmarks and in which direction he was headed and the precise time he would be doing this. All of this for my ravenous pain ravaged curiosity so I just couldn't miss him. As if this was humanly possible. When I met him, he would invariably begin telling me one of his labyrinthine, either slightly harmless or unsettling stories about himself or his father or a particularly dysfunctional neighbor and sometimes the details would change each time he told it. Really, his life was in another dimension. If John was on a particular mission in life, either now or in the not-too-distant future, I'm pretty sure he didn't know what it was.

Never Again – A Photographer's Statement, n.d.

It looks to me like a reverse Balthus and the next question is who's Balthus and how reverse. If you are planning to make a legitimate living, eschew hangovers, are not comfortable contemplating losing various parts of your body as well as your life (lots of alcohol helps), and wish to find yourself in the Modern or located somewhere in the Chelsea Circuit, easily accessible on a Saturday afternoon art Pilgrimage and offering a product that doesn't have the slightest smell of an MFA and not surprisingly reeks of Sulphur, well, forget it.

 More likely an ancient reptile sort of in the spirit of Michelangelo. The sexual truth in Art, maybe. The best way to go into an unknown territory is to go in ignorant, as ignorant as possible, Dorothea Lange, and yes, with your eyes wide open and leaving all of your personal and religious ideologies in the large black buckets at the door. Look! Look! Look! Die knowing something! You are not here long, Walker Evans. You are not going to change anything. Now, any other questions please see my assistant should I have one.

Vita Opulence, 1999

"Vita" started out in full drag in Pittsburgh in 1992, just out of his teens and then came to Washington where he performed, organized, and hosted drag performances at Ziegfeld's and Remington's. He said he has long been intrigued by all the men who pursued him dressed as a woman but ignored him completely dressed as a man. He calls these men "trani-chasers." But he dressed only to be a performance artist and not to be a woman.

The Hot Looking Crocodile, 1996

Chucky was usually high for his photographs. He lived on the west side of Baltimore City and hardly one block from Wilkens Avenue and from a large family seemingly subsisting on drugs and prostitution. One day he took me to the largest cemetery in Baltimore City and showed me the graves of his 6-month-old son and his 15-year-old brother who had died of a cocaine overdose. He had done time for many parole violations and using and selling, prostitution and probably more. The police were always looking out for Chucky. Not just looking out, "looking out," but looking out as a police would be looking out for a habitual adult criminal. But things probably had gotten too hot for Chucky in his old west side neighborhood around Wilkens Avenue and so the next time he called me he was now living all the way across the city on the east side of Baltimore, probably with someone else, in a small slightly newer neighborhood right across the highway from the "East Point Shopping Mall."

And it was right here in this new neighborhood and right on the street in the front of the house where he was staying, surely with someone, and right on the front seat of my car that it all ended between Chucky and me. We were talking when he suddenly took out from someplace on his body this sizeable and very serious looking loaded weapon, big black and heavy and seemingly brand new and with a slight smile placed it on his lap like a boy showing his father an "A"- triple plus paper on a final mathematics examination which now meant that he would be going to college and probably on full scholarship. Was he trying to tell me something or what? Why was he doing this? To impress me, showing me how big and bad and dangerous he was? But I knew that already. Was he planning to liquidate one of the few benefactors he still had left on the planet or was I shortly to be relieved of my car and the little bit of money I had brought along with me? Was he trying to scare me, showing me who's boss?! Or had he established, in the meantime, a new identity as a legitimate and slightly dangerous criminal not yet gang affiliated, it was about time. I was pretty sure he wouldn't kill me; I was always worth more to my subjects alive than dead! But I wasn't waiting around to find out. It's remarkable how fear and the imminent threat of "Death" makes you think "fast!" You do something crazy!—Something totally unexpected by you as well as the client.

An evil turn in our relationship, for sure. But with a street associate even the most profitable connections never last long and as far as I was concerned and, in this instance, it had definitely lasted long enough. I am only surprised that such an event hadn't happened sooner. But not to worry. These little things had happened before. Even Atropos knew I had a lot longer to live.

A Botticelli "Venus" (and her brothers), 1998

Malisa, Chucky's sister, was one of the most popular girls on Wilkens Avenue. She would usually sit on the same white marble steps, the last house in a row of houses, right on the corner. Two blocks from where she and all her brothers lived. Both she and all her brothers came from a large family of beautiful children on the west side seemingly existing on drugs and prostitution. If the "johns" were a little nervous about picking her up along Wilkens they could always turn right at the corner and meet her again, usually maybe 2 blocks away. The cops were much more serious about the girls than the male hustlers because it was easier to get a conviction for a girl.

She was as beautiful as a Botticelli. As the months went by, her habit got worse. She was now injecting into her hands, already so swollen and needle marks, very red all over her legs. If you look closely, you can see the track marks of the needles on her arms, fingers, and legs. She had been arrested a few times for prostitution. Another year and she disappeared completely from "the Avenue" and Chucky had already moved across town.

Unlike Chucky, at least her brother Paul learned too many terrible lessons and never became addicted.

at various times the police were trying to trick
unsuspecting "johns" into picking up a female member
of the vice squad on the corners. But these girls always
looked like professional dancers or B-girls. They looked
like a small piece of heaven in a pile of shit. If you
got caught in this charade you deserved it.

②

Paris is Burning!, 1997

One afternoon I was cruising by the house Stacey was supposed to be living in to find her when a police officer pulled me over, checked my credentials and asked me why I was driving around this block and I told him to meet Stacey because I was a photographer and he said just what do you mean photographer!

Of course, he had no idea what I was talking about, but he did know about pornography and just far too much about sexual connections. He didn't look happy and then told me that a murder had just happened there the previous night behind the house and if he ever saw me again in the neighborhood, well you can imagine. This was one of my prime cruising areas. In the meantime, I could pull over to the curb and not move. As I was sitting there in my car by the curb wondering if the policeman was still in his vehicle writing possibly my death sentence I was surprised how many boys, probably all hustlers, started coming out of the woodwork to watch the entertainment, even talking to the police and asking the usual questions and voicing mindless opinions, like they all had been buddies from the dawn of Creation. Obviously, this was a neighborhood rite and the modest pinnacle in their day. But—"You know how the children are." "Paris is burning!"

North Carolina Mike, 2003

He was called "North Carolina Mike" because that's where he came from, North Carolina. He had been living with an uncle for 13 years. His real father had been a prostitute as a boy, put on the streets by his own mother to fuel her heroin addictions and had finally gone to jail for sexual abuse when Mike was 4. Now he had come to Baltimore and living in the cheap, run down "Projects" in Essex, Md. way east of the city. Now living with his girlfriend and his son. Mike had his own issues with heroin addiction. A friend took him to Atlantis one night, the only dance bar in town.

Mike would hang out at Atlantis on Saturday and Sunday nights, play pool, and talk with the customers. Eventually he did bar dancing for about 2 months. He'd also hang out at Quest on Sunday afternoons, play pool and video games, the last of the good gay bars on the east side of Baltimore, just 2 blocks away from Eastern Avenue.

A Chill Roller, 1999

Julia was one of Stephen's temporary girlfriends, at least one of them. The woman liked her men rough, single, or together: dope white boys who could barely read or write. On weekends she hung out at the "Purple Goose" on Washington Blvd, not the safest place to be on a Saturday night!

During the day she worked in the Baltimore Circuit Court.

R. and His Friend Tony, 1998

In the summer of 1998, Ross and Tony were close friends. They shared the same needs
and lived in and utilized the same areas of the city. Both Tony's parents had been alco-
holics and they had separated when he was 7. But he continued to live with his mother
and managed to attend school up to the 8th grade. But she remained an alcoholic and he
really wanted to live anywhere else but home. He wandered the streets, sometimes living
with friends, occasionally hustling, and seeking some form of older male companionship.
Slowly he began to get addicted to heroin. His slim and beautiful blond petite girlfriend
named Michelle, lived with her mother and grandmother at the end of "Curley Street"
about one block from the east end of Patterson Park. So, her younger brother, Brian,
now lived with some older man in the neighborhood. By now both of them were addicted
to heroin and often in the late afternoon they would hustle on the sidewalks surround-
ing Patterson Park along Baltimore Street.

An Afternoon Story, 2002

He lived on Pratt Street around Patterson Park—sometimes with his grandmother, sometimes with one of his brothers, the oldest in jail. Various offensives: but nothing like murder or anything. I asked if he remembered his father and he had begun hustling at 15 at the suggestion of a 12-year-old neighbor. At 16 he fathered a child. I noticed, one afternoon, about 3:30 P.M. that he was moving a little wobbly on Pratt Street. I asked him and he told me he had just gotten up about an hour before and there was this bottle of whiskey, almost empty, by his mattress on the floor, so he finished it.

Gay Theory: The small portrait on the wall to the right of my nude body, is critical. It's also a lesbian dressed like a man. The even smaller picture just over my head is Michelangelo's "Pieta." It all sounds like "gay theory" to me.

Kayla, 2001

Kayla and her friends, often high could be found on the corner at South Patterson Park
Avenue and Eastern sometimes beginning at mid-afternoon.
 In 2004–2005, the area was gentrified and like the lobotomy applied to 42nd Street
in NYC, an era vanished.

Mike, 2000

Bonzo's buddy born in July 1997 in Baltimore City and has remained in the same neighborhood around Pratt and Ann Street all his life. This is the east side of the city. His father died of cancer when he was 14 and he lives with his mother, a victim of lung cancer. Mike's education and work history is limited and erratic, has done some hustling since 14, done jail time for assault and it is unlikely he could function easily outside the drug and crack neighborhood he inhabits.

Random, 1999

Randy, one year younger than his brother Ross and like Ross has been on his own since about 18 yrs. Old with very little schooling, roaming the streets, being introduced to heroin by an older brother, Eddie. Also, like all the brothers, (4), he hustled men. In Fall 1999, Randy had already spent significant time in detention centers, living frequently in abandoned houses in Baltimore City and so heavily into heroin that he could barely remain vertical for the camera. Randy is sometimes supported by random men and girl-friends and admits on occasion that he is possibly gay—otherwise contributing frequent-ly to the delinquency of an adult. He did six months on drug charges or trespassing or failing to appear in court or any two of these, or all of the above.

"The "Universal Eye sees everything". The Tales if could tell you."!!

2001

"Academy Award Nominee" !!

2001

"It's Not Me I Swear" !!

BALTIMORE'S "OUTSIDER WITHIN": RACE AND QUEERNESS IN THE PHOTOGRAPHY

The city of Baltimore has been a racially segregated urban center for quite some time, an observation reinforced by the 2003 U.S. Census Bureau, which noted that "Baltimore city is predominately African American" and "neighborhoods in the city are divided along racial lines."[1] As in the rest of Maryland, a distinctly Southern state steeped in racist attitudes, Baltimore's legacy is one of acute racial segregation bolstered by social and political "tools that were developed to enforce it over such a long period of time."[2] That history continues and positions it as one of many such cities in the adverse racial history of the United States.

The photographs of Amos Badertscher (1936–2023) reflect and contribute to this history as they document, through handwritten notations scrawled directly on the prints that recount the lives of his subjects, Baltimore's marginalized street culture of drag queens, performance artists, transgender persons, hustlers, and drug addicts dating from the mid-1960s to 2005. With these accompanying texts, matters of race, gender, sexuality, and class undergird "the stories that tell the pictures."[3] His imagery also shines a light on the gay places and spaces of late twentieth-century Baltimore, where the intersections of race, class, and gender are rendered visible, become meaningful, and yet are fraught by the divisions within them.

From the 1950s to the mid-1970s, Baltimore was a city characterized as "a gritty, working-class homosexual utopia" containing a "variety and down-to-earthiness of bars, clubs,

and restaurants" scattered in primarily working-class neighborhoods, many of which were "crowded with a wide range of queers, from hustlers to outrageous drag queens" from different racial and class backgrounds.[4] Badertscher's photographs are, in essence, a sociological chronicle of the numerous gay bars and nightclubs in Baltimore that have come and gone over the last quarter of the twentieth century. Although the mingling of races was, at times, tolerated in these and other spaces of the city, both racism and classism constituted a palpable reality and concern to both the African American and LGBTQ+ communities.

Badertscher's photography has been referred to as "a form of visual ethnography,"[5] but not in the anthropological sense. His approach is specific in that it charts primarily the poor white population of Baltimore. It is perhaps not coincidental that during the period in which Badertscher was producing his visual imagery of sexual and racial marginals, the Baltimore-based filmmaker John Waters began making his films about the "illegality and deviance … [of a] fanciful world steeped in its own morality at direct odds with the popular culture and mores of the time."[6] Badertscher mentions Waters by name in a couple of his photographic annotations, mostly in reference to gay establishments that both he and the filmmaker frequented in the past. Unlike Waters, who used an array of "sexual deviants" including "transvestites and fetishists" to engage onscreen in outrageous "sexual and criminal behavior,"

Badertscher never sensationalizes or fetishizes those considered part of these groups.[7] The photographer and filmmaker are similar, however, in that both of them are subversive in their use of "people marginalized by and excluded from conventional white America." Waters has often referred to these individuals as "white trash," an idiom that legal scholar Taunya Lovell Banks writes was used as "a pejorative directed at poor whites and attributed to blacks, with whom poor whites often were in economic competition."[8]

Whiteness, like blackness, is an unmoored and unstable social construction.[9] As Badertscher's photographs and Waters's films attest, both categories are typically operational "in conjunction with other social categories, issues, and powers."[10] The difference is that Waters aggrandizes his "white trash" subjects as "counterculture heroes" and cloaks his critique of white trash culture in tongue-in-cheek humor, whereas Badertscher displays no such attempted heroics. However, like Waters, Badertscher does showcase the "white trash" body as "a surrogate for talk about race and sexuality," but without ever explicitly using the term, which seems to automatically invoke its opposite, Black.[11] Indeed, inherent in the idiom is a tension between race and class, with "white" serving as "an ethno-racial signifier, and trash, a signifier of abject class status."[12] According to the sociologist Matt Wray, the assignation of the label "conjures images of poor, ignorant, racist whites." He adds that it is "hard to care about such people. It's even harder to take them seriously."[13] Badertscher does seem to care and take this group seriously, even though he himself was not of this class. In interviews, the photographer has expressed his bewilderment at what he perceived as the "convenient blindness" of society to the white working-class milieu that he frequented, documented, and made visible.[14]

As an "outsider within," Badertscher "participates in the culture that he represents without really being of it."[15] He strikes a precarious balance between voyeurism and participation in a way that recalls the path taken by the nineteenth-century French artist Henri de Toulouse-Lautrec, who appeared comfortable on the streets of bohemian Paris and in the company of Parisian prostitutes. Both men felt out of place in "normal" society but were completely at home amidst those on society's edge.

Black Tony (1975, p. 205) is one of the earliest photographs in which Badertscher explicitly identifies his subject by race. As evidenced

1. See Jonathan David Jackson, "The Closing of Atlantis," *Journal of Homosexuality*, Vol. 53, Nos. 1-2 (2007), 158.
2. Matt Crenson, "Race in Baltimore," *The Metropole: The Official Blog of the Urban History Association*, themetropole.blog/2018/11/08/race-in-baltimore/. Accessed on April 28, 2023.
3. Barry Reay and Branka Bogdan, "Queer Baltimore: The Photography of Amos Badertscher," *Sex in the Archives: Writing American Sexual Histories* (Manchester, UK: Manchester University Press, 2019), 194.
4. Frank Laterreur, "Baltimore Revisited—You Can't Go Home Again," *The Guide* (January 2007), Vol. 14, 13–19.
5. Reay and Bogdan, *Queer Baltimore*, 181.
6. Taunya Lovell Banks, "Troubled Waters: Mid-Twentieth Century American Society on Trial in the Films of John Waters," *Stetson Law Review*, Vol. 39, No. 1 (Fall 2009): 153–82; 154.
7. Banks, *Troubled Waters*, 160; on tracing the roots of the term "white trash," see also Matt Wray, *Not Quite White: White Trash and the Boundaries of Whiteness* (Chapel Hill, NC: Duke University Press, 2006). According to Wray (p. 43), "[m]iddle-class and elite whites quickly adopted the term to 'ascribe … a deeply ambiguous, liminal status' to white servants who labored in a slave-holding society."
8. Ibid.
9. Walter Jacobs, "The Tide of Second-Wave Whiteness,"

symploké, Vol. 5, Nos. 1-2 (1997): 232; 232–35.
10. Ibid.
11. Banks, *Troubled Waters*, 154.
12. Ibid., 161.
13. Reay and Bogdan, op. cit.
14. Gary Scharfman, "Illegal to See: A Portrait of Hustler Culture by Photographer Amos Badertscher," *The Archive*, No. 15 (Winter 2005). Accessed on June 5, 2023.
15. Reay and Bogdan, *Queer Baltimore*, 203. I borrow the term and concept "outsider within" from the African American sociologist Patricia Hill Collins, who uses it in the context of Black feminism. Generally speaking, "outsider within" refers to the "creative use" of one's marginality in society. In the context of the present essay, I employ the term to suggest Badertscher's photographic entanglements as artist and participant-observer with racial, class, and queer marginalities in Baltimore. See Patricia Hill Collins, "Learning from the Outsider Within: The Sociological Significance of Black Feminist Thought," *Social Problems*, Vol. 33, No. 6 (October–December 1996): S14–S32.
16. See Jonathan David Jackson, "The Closing of Atlantis," *Journal of Homosexuality*, Vol. 53, Nos. 1-2 (2007), 170.
17. Ibid.
18. Ibid.
19. Ibid.
20. Ibid.

OF AMOS BADERTSCHER
James Smalls

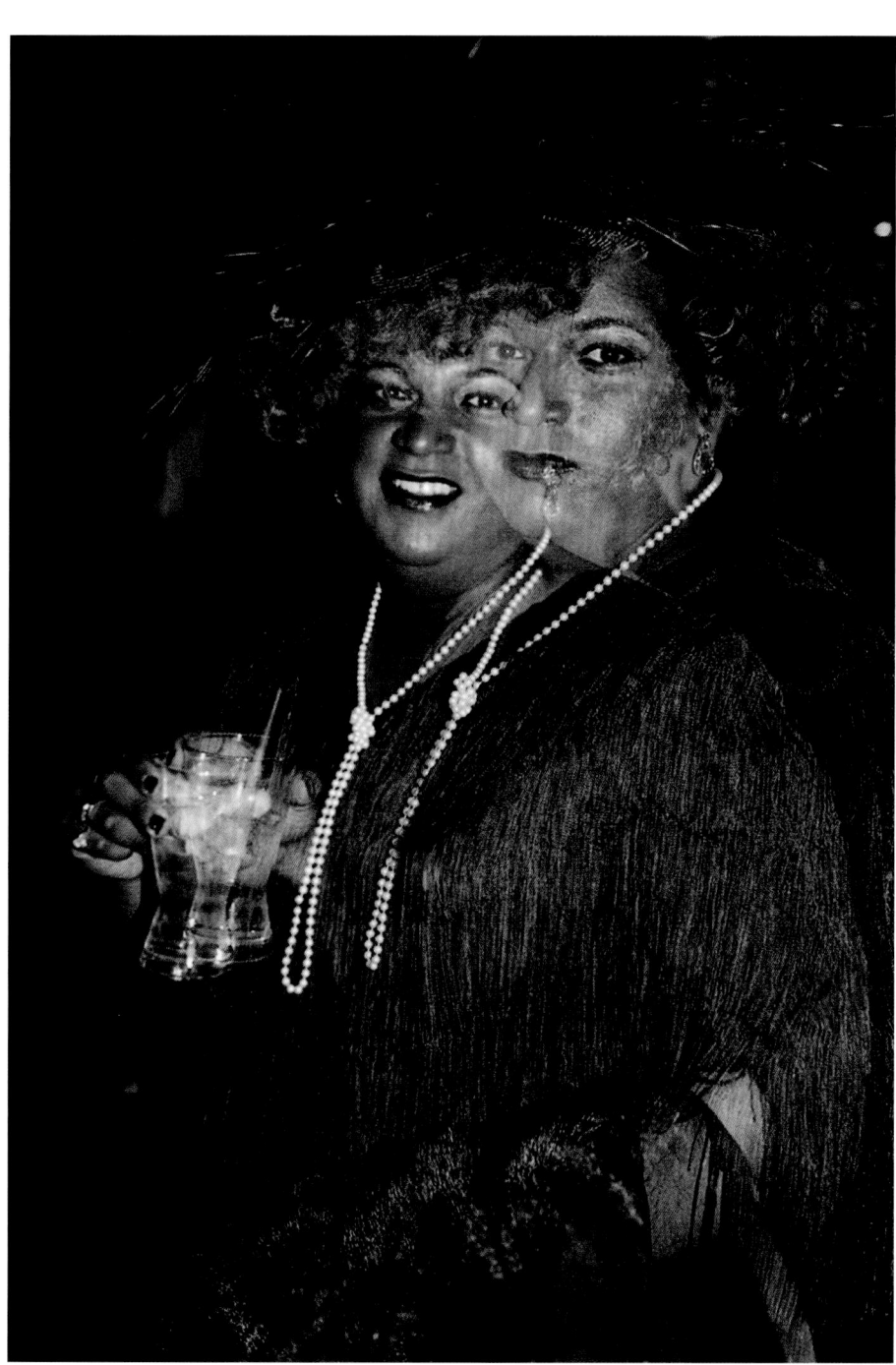

CHURCH LADY AFTER TOO MUCH KNOTTY HEAD, 1989

in many of the handwritten texts accompanying the photographs of Black Tony, the photographer does not seem to be especially fascinated with Tony's race; rather, he was focused, to the point of obsession, on where he lived and on his occupation as a transgender sex worker.

On a print of Tony seated on a bed (p. 205), Badertscher expresses further fascination with Tony's occupation as a transgender sex worker.

As already mentioned, Badertscher's photographs chronicle the gay geography of Baltimore, while also speaking to its ethno-racial history and dynamics. For example, the racial politics of Club Atlantis mirrored and perpetuated longstanding racial, social, and class divisions, and has been referenced as a "lost world divided along racial lines in the nightlife of the city."[16] The significance of *Church Lady After Too Much Knotty Head* (1989) rests not so much with the Black individual represented, but with the establishment patronized. Club Atlantis was a mostly white, working-class nightclub in Baltimore known for its all-nude male dancers. It closed in September 2004 and has been described as "one of the most legendary gay male hustler bars in the middle Northeastern states."[17] As observed by one patron, it was also notorious for its "overt unwelcome treatment of Black Americans or dark-skinned would-be strippers."[18]

Indeed, the history and geography of Club Atlantis made it vulnerable to race, class, and social divisions. It was not located in the gay commercial district of Baltimore City; rather, it was situated between the Central Booking building of the Baltimore City Police Department on Madison Street and two places of incarceration—one being the Maryland Penitentiary on 401 East Madison Street, whose inmates were mostly Black men and several of whom were on death row. Despite its location, many white working-class patrons described it as welcoming and having the feel of a (white) neighborhood bar.[19] The club's location played a significant role in determining the racial makeup of its patrons and its erotic dancers. While Blacks were not excluded from entering Club Atlantis as patrons—such as indicated by the presence of the Church Lady in Badertscher's photograph—the club refused to hire Black performers and discouraged the solicitation of Black patrons by these performers, underscoring the fact that segregation and racial politics were not fringe issues in either Baltimore's gay community or in sex work, but core concerns.[20]

The Hippo was a popular gay dance club,

first opened in the early 1970s and located at the corner of North Charles and Eager Streets in the Mount Vernon neighborhood. Although the Hippo's motto was "everybody is welcome," it catered primarily to the mostly mainstream white gay community. During the 1980s, the venue hosted performances by Broadway stars and conducted fundraising events in support of the fight against HIV/AIDS.[21] It permanently closed in October 2015.

In *Outside the Hippo* (1993, p. 213), Badertscher makes explicit reference to interracial fraternizing in one Baltimore gay club through the following text jotted around the photograph's borders: "After some costume party, maybe Halloween outside the Hippo. This is where everybody hung out after 2am for at least half an hour or before the cops came. Pick-ups happened. Dates set. ... Bebe was a highly talented and outrageous dresser during the later '70s. Not someone you would want to cross. She loved slim white boys."

Although Baltimore was racially segregated, interracial sex among gays and lesbians did occur frequently, albeit oftentimes clandestinely. In fact, "queers in Baltimore delighted in opposites ... black with white, drag queens with leather, poor with rich, younger with older, Poles or Russians with Wasps or Negroes."[22] The mixing crossed the gender divide as well, with "diesel dykes and others of the myriad lesbian subgroups hobnobbing with the whole range of gay-male types—from swish to macho." Things changed in the 1980s with the onslaught of the HIV/AIDS epidemic, when the political climate became hostile to queers, and when homophobia increased. With the onslaught of HIV/AIDS in the 1980s, when the political climate became hostile to queers, after which his mixing decreased significantly.[23] Mount Vernon was and continues to be a popular majority-white "gayborhood" of Baltimore and has a rich queer heritage that also includes a history of racism and classism. The neighborhood was considered as a safe space for the (white) LGBTQ+ community in Baltimore since as least the 1950s, when it became associated with a pioneering moment in history that predated the 1969 Stonewall Riots. "The 1955 Pepper Hill Club raid by police," was "considered the largest raid ever in Baltimore, in which 162 men and women [were] arrested on charges of 'disorderly conduct' or sexually deviant norms."[24]

In *Outside the Hippo* (p. 213), Badertscher appears to simply document his encounter without any personal or shared intimate connection with Bebe, who is shown at a Halloween

A PRINCESS, C. 1995

326

21. Francesca Cohen, "Club Hippo," Explore Baltimore Heritage. https://explore.baltimoreheritage.org/items/show. Accessed May 3, 2023.

22. Aliya L. Moye, "Queer Liberation, Race & Ethnicity, Society & Culture, Black Liberation," February 16, 2020.

23. Ibid.

24. Frank Laterreur, "Baltimore Revisited—You Can't Go Home Again," *The Guide* (January 2007), 15.

25. Joseph Henry, "Critic's Pick: Amos Badertscher: Schwules Museum March 6–July 27, 2020, *Artforum*, https://www.artforum.com/picks/amos-badertscher-83236.

party sporting exaggerated makeup with half her hair (or wig) dyed blonde. She wears a dark dress and is clearly taking delight in posing for the camera. The work is a prime example of Badertscher's fascination with drag queens and transgender folks who wear exaggerated clothes, wigs, and makeup.

Another example of this can be seen in an image the photographer titled *A Princess* (c. 1995–2001) (opposite) which shows a drag queen who had posed for the camera outside The Hippo years earlier. The handwritten script reads: "She doesn't look it, but a happy woman so abrasive, outside the 'Hippo' on 'Gay Pride Day,' at the corner of Eager and Charles. There were some patrons left in this uptown gay bar who were still putting a little bit of effort into their maquillage, reminding me, thankfully of 'The Good Old Days' in the Baltimore bars."

The Sportsman's Lounge, a Baltimore gay bar situated in West Baltimore, was the location of a photographic series Badertscher produced in the late 1980s and early 1990s. The establishment catered expressly to Black drag queens, transgender performers, and a gay African American clientele. One image in the series shows a smiling Black drag queen named "Angie" with the appended inscription: "The 'Sportsman's Lounge' a rough Black bar on Park Avenue, in the late '80s….The 'Sportsman' had been replaced by a black asphalt parking lot and even that is coming apart."In another photograph from same series, two Black drag queens (Angie and Koolah) pose with smiles for the camera. The handwritten text provides a wealth of information about the venue, its clientele, and Badertscher's relationship to them. It reads in part: "'Eric the Bouncer' was a large man. He insured [sic] that everybody was happy and enjoying themselves and not doing anything they shouldn't be doing in a gay bar. Sportsman's supplied drag performers for the Mardi Gras, formerly a working class white gay bar called Go-West owned by Jimmy Arnold. It burned to the ground some years later."

In 1993, Badertscher produced another photographic series called *Directly Outside the Entrance to the 14-Karat Cabaret* that spoke to the racial and class dynamics within Baltimore's LGBTQ+ community. One photograph (see p. 206) from this series shows a young black male dressed in hip-hop clothing and standing in front of a parked car. He grabs his crotch while giving the middle finger to the photographer/viewer. In another image (see p. 207) from the series, Badertscher shows a group of young Black males in loose-fitting street attire,

wearing baseball caps, and giving various lewd hand gestures and gang signals. Badertscher documents these images with the following handwritten inscriptions: "These kids on the pavement directly outside the front entrance of the 14-Karat Cabaret on Saratoga Street. The club was mostly queer and for the time pretty cutting edge for Baltimore." These kids, Badertscher tells us had been watching a performance artist, Madenny Kennedy, who the Baltimore vice squad had shut down because of an invitation offering "free blow jobs."

Interestingly, with this photograph and others in the series, Badertscher makes no mention of the fact that the "kids" he photographs are all Black males. Although the appended handwritten texts on Badertscher's imagery are intended to memorialize his subjects, there tends to be no sentimentality, but rather, a sense of estrangement present in the relationship between himself and the Black model, what Joseph Henry has referred to as a "tonal coldness" which, unlike with his images of white hustlers, is not coupled with any inkling of "outward eroticism."[25] The *14-Karat Cabaret* images seem to differ from Badertscher's photographic series of white subjects in that they reflect a spontaneous street photography in which there is a sense of separation or distance between photographer and subjects despite the photographer's interest in paying tribute to this Black and gay world as an "outsider within."

Based on the visual and textual information Badertscher provides in the 14-Karat Cabaret series, it is suggested that young heterosexual African American men had no problems with socializing with those associated with the LGBTQ+ community in Baltimore. Indeed, the series alludes to the social occurrence of Black bisexual and gay men operating "on the down low"—that is, men who identify as heterosexual, but who also have sex with men, a phenomenon that Badertscher's photographs and their taglines of white hustlers also make evident.

From the 1970s to 1990s Badertscher lived in a top-floor apartment on Madison Street in Mount Vernon, only a short walk from the Hippo and the Mount Vernon meat rack, a cruising and hangout area located around Read Street and Park Avenue, "where young men waited for a trick." Over the course of these decades, Badertscher's techniques and photographic processes changed, perhaps partly due to his relationship to the subjects depicted. These

modifications can best be seen in a photographic series created in 1998 that focused on activities in the Club Mardi Gras, formerly known as Go West, and located at 228 Park Avenue. The series consists of photographs with handwritten narratives about the club where many Black drag queens gathered and performed in the late 1990s and early 2000s. According to the photographer's handwritten text on one photograph, the drag performances at Club Mardi Gras "usually happened at least once a month!" Many of these images are grainy, out of focus, and are given such racially descriptive titles as Black Drag Show or Black Drag Ball along with the performer's colorful stage name, such as Francesca, Ella Backwards: The Lady in White, Ella!, Ma Rainie, Dianna II, and Marsella. With this series, Badertscher seems to be more of a spectator than a participant with his camera, objectively documenting the presence and performance of these Black drag queens. Other photographs in the series concentrate on the social exchanges between performers and audience members.

Appended to one photograph from the *Club Mardi Gras* series, Badertscher reminisces about the venue and acknowledges the reality of racial segregation in such gay spaces in Baltimore: "Like a shrine, the stage at Mardi Gras, a gay bar in a decaying district along Park Avenue, was the stage for numerous Sunday evening black drag shows around 2:00am owned by Jimmy Arnold. It burned to the ground some years later. The drag performers were mostly supplied by a much rougher black gay bar one block up, the 'Sportsman [sic] Lounge.'"

In the narratives and titles of some of these images from the *Club Mardi Gras* series, Badertscher makes explicit references to classical Greek or medieval literary sources. For example, in one such image double-titled *The Song* and *Nightingale*, Badertscher pens the following; "How could a swallow sing against the swan Lucretius." Yet another image, titled *Charon*, shows a Black male bartender serving drinks to patrons. The photograph's handwritten text reads: "Drag Show: Club Mardi Gras, 1998.'Hell' is just as far from anywhere! The weight of your soul determined by the weight of your shot glass! The last barrier to paradise!" Here, as in other photographic depictions in his oeuvre, Badertscher makes explicit references to Greco-Roman classicism, linking the name "Charon" with the ferryman of Hades, the Greek underworld. He also gives names such as "Homer" and "Iliad" in reference to specific drag performers. On one print from the series,

26. Reay and Bogdan, 175; see also "Icon Enrique Allure
 St. Laurent interviewed at the George Peabody Library
 by Joseph Plaster," March 12, 2019, Johns Hopkins
 University Oral History Collection, transcript, 1–43;
 14–15 for meat rack reference.

27. Joseph Henry, op. cit.
28. Ibid.

Badertscher penned the following: "Hades is just as far from anywhere! "Ferryman-Hades-Nightraven." In yet other prints of the Black drag queen "Marsella" performing, the following titles are given: *Marsella/Persephone 1998* and *Marsella, Into the Black Kingdom 1998. Wife of Hades. Iliad Book XIII.* It is quite possible that Badertscher's use of classical references was designed to bestow a combined sense of cultural legitimacy onto these Black marginals in a segregated space within a segregated city and society as a reflection his own sublime outsider experience.

One photograph from the series, *Kulah*, speaks volumes about the racial and sexual insulation of places like Club Mardi Gras. The image depicts a Black drag queen seated at a table and interrupted by the photographer, who has caught her in the middle of enjoying a large alcoholic beverage. The image is annotated with a revealing observation: "A small world but it was all hers." Again, depictions of Black drag performers from the *Mardi Gras* series tend to be blurred and grainy; clearly, Badertscher has chosen to employ a different photographic style. Although the series dates to 1998, the images evoke a synthesis of nostalgia and contemporaneousness, of past and present colliding as they chart a local gay history of racial segregation and class division. The unfocused and granular quality of these images suggest perhaps a more fleeting or impressionistic relationship with this segregated Black world in which Badertscher participates as an outsider. Clearly, the performers themselves do not seem to mind the photographer's presence and appear quite eager to have their pictures taken.

Another Black drag performer, Shawnna Alexander, became the subject of many of Badertscher photographs documenting Black drag culture in Baltimore during the 1990s. In one 1997 image of the performer, the photographer relays: "It's Shawnna Alexander, Queen of Comedy. One of the 2 best gay entertainers in Baltimore. She performed at a few gay bars, the monthly drag shows at Club Mardi Gras on Park Avenue and at the yearly Gay Block Party at the intersection of Charles Street and Eager just outside the Hippo. She doesn't define herself as gay or anything else: a little bit of this and a little bit of that! Off stage it's a real city street hustle, a little bit of this and a little bit of that, most of 'it' legal."

On another photograph, we read: "Born in Baltimore, Shawnna Alexander, 'Queen of Comedy,' was originally named 'Shawn.' The persona of Shawnna came out strangely about 25 years ago…. She has been known over the years as doing some outrageous performances. Like a brilliant actor he totally assumes his projected identity on stage and this performance is a coveted therapy that allows him to escape the horrors of 'normalcy.'"

Although Badertscher stopped photographing the Black drag world when he quit photography altogether in 2005, it is worth noting that Shawnna Alexander is still alive and well and performing as part of Baltimore's LGBTQ+ community, where she continues to be revered as Baltimore's Queen of Comedy within the drag world. In a recent interview, Shawnna recalled that her fellow performers "were like a family and she was given the title Ms. Nymph and was made part of the court." She would later assume several titles, including "Ms. Go West," "Ms. Mardi Gras," and Ms. Hippo," and has performed in other cities in Virginia, West Virginia, and the District of Columbia.[26]

African Americans were not the only racial subjects, nor was Baltimore the only geographical venue that attracted Badertscher and his camera. Aubrey, for example, was the name of an Asian drag performer who was photographed numerous times by Badertscher in 1999 at the Velvet Nation, a gay nightclub in Washington, D.C., as well as at his home studio. A scribbled handwritten narrative on one photograph provides some added information on the model and the venue: "Aubrey is one of the steller [sic] night queers at the gay dance club Velvet Nation in Washington D.C. to intrigue and entertain the more conservative yuppi much less" Badertscher also said of Aubrey: "A charismatic, and photogenic entertainer at Nation in Washington in 1999: Aubrey who just wanted to be a woman, not a man."

Beginning in the mid-1970s, when he had taken up photography full-time, Badertscher employed "the self-reflexive use of the mirror" as a photographic formula used in his images of white hustlers.[27] He shot such photographs in his apartment studio in Baltimore. It has been noted that through this photographic device, the photographer created scenarios that were born out of pornography. Badertscher seldom photographed himself with Black or Latino models in this fashion, even though Baltimore was home to Black and Latino hustlers, though he did produce a few photographs with himself and Aubrey in this manner. In them, photographer and model pose together in intimate physical positions. A mirror is used to split the image, with a glimpse of the photographer taking the photograph, thus suggesting a sexual encounter that "obeys preestablished (pornographic) scripts and configurations of power."[28]

Although Badertscher and his visual imagery reveal and acknowledge the existence of racial and class differences through his social and historical chronicling of specific individuals, hustler culture, and queer establishments in Baltimore from the mid-1970s to the early 2000s, he does not seem to pass any critical judgement in these photographs. Rather, as a white middle-class male, or "outsider within," he is more focused on chronicling or creating a visual and textual archive of his own estranged relationship with marginalized racial and classed communities in Baltimore.

EPILOGUE

O! miserable handwriting of old age and arthritis and all the misspellings and duplicated words and phrases and all those not duplicated gone missing.

Words followed too closely by other words and scooting off the highway and painfully collected and pitifully mended and then tossed back into sentences that were never paying attention and creating enigmas and curious mysteries not always worthy and jeered at by uncomprehending assholes but far too much for the Universe to bear or even acknowledge.

Words flying upwards and downwards but always to the left like Dante and Virgil due to too rapidly changing weather conditions or to which idiot agenda some local politician was pushing. Words getting lost or imprisoned and then lost again gasping for breath in a toxic environment or drowning in a Charybdis of apps and text messages enough to sink a million Titanics.

God will there ever be an answer or an ending? Will I end up in the Metropolitan or the dust bin, remember to take all my medications or finally survive the Inferno unleashed by putting transgender inside heartland American bathrooms?

Well, at least I can still see what I'm doing and, in a pinch, will it be cyanide or Revelation!

2023

"But i see that my spirit is asleep. If it managed to stay awake from now on we'd soon be at the truth, that may even now surround us with its angels weeping, if it had always been wide awake i'd be sailing by now on the open sea of Wisdom."

"A Season in Hell

"To whom shall i hire myself out? What beast should i adore? What holy image is attacked? What hearts shall i break? In what blood tread?"

"A Season in Hell"

"A spurting child, full of sadness, releases a boat as frail as a May butterfly."
"The Drunken Boat"

Arthur Rimbaud 1854-1891

"I came to find my minds disorder sacred."
"The Drunken Boat"

"Now is the time of the Assassins"

Rafael Alvarez was born in Baltimore's old St. Agnes Hospital the year Chuck Berry topped the charts and was educated in local Catholic schools. His parents called him Ralph. He learned to write in the newsroom of the Baltimore Sun as a teenager, leaving the City Desk in 2000 to work on merchant ships. He is the author of more than a dozen books, both fiction and nonfiction and is best known for the *Orlo & Leini* stories. His next book is about the Rosary.

Theo Gordon is Leverhulme Early Career Fellow at the University of York (UK), working on a book on art and HIV/AIDS in Britain. He has taught at the University of Sussex, Birkbeck College, UCL, and the Courtauld Institute of Art, where he gained his PhD in 2018. He has published widely in art historical journals, edited a selection of essays by Sunil Gupta (Aperture, 2022) and is the coauthor of *Photography: A Queer History* (Octopus/Ilex, 2024).

Jonathan D. Katz is an art historian, curator, and queer activist. Professor of Practice in Art History and Gender, Sexuality and Women's Studies at the University of Pennsylvania, Katz is a pioneering figure in the development of queer art history, and author of numerous books and articles, most recently *About Face: Stonewall, Revolt, and New Queer Art* (Monacelli, 2024). He has curated many exhibitions, nationally and internationally, including the first major museum queer exhibition in the U.S., *Hide/Seek: Difference and Desire in American Portraiture* at the Smithsonian National Portrait Gallery, which won several national and international best exhibition and book awards. The first full-time American academic to be tenured in what was then called Lesbian and Gay Studies, at City College of San Francisco, Katz was also the founding Director of Yale University's lesbian and gay studies program, the first in the Ivy League.

Hunter O'Hanian has a long career in supporting visual arts and LGBTQ+ studies. He is the past executive director of the Stonewall National Museum and Archive; the College Art Association was the founding director of the Leslie-Lohman Museum of Gay and Lesbian Art. Prior to joining Leslie-Lohman, he was director of the Foundation for Massachusetts College of Art and Design, president of Anderson Ranch Arts Center and executive director of the Fine Arts Work Center in Provincetown. He has served as a visiting lecturer, juror, and panelist on hundreds of occasions. In addition to curating exhibitions of work by others, his own work has been widely seen. He graduated from Boston College and received his law degree from Suffolk University. You can find more information at hunterohanian.com

Joseph Plaster is a lecturer and curator in public humanities at Johns Hopkins University. An interdisciplinary scholar trained in queer studies and public humanities, his teaching and research fields are at the intersections of U.S. twentieth century urban history, performance studies, public history, LGBTQ studies of religion, and oral history. His book *Kids on the Street: Queer Kinship and Religion in San Francisco's Tenderloin* (Duke University Press, 2023) explores the informal support networks that enabled abandoned and runaway "street kids" to survive in central city tenderloin districts across the United States, and San Francisco's Tenderloin in particular, over the past century.

Beth Saunders is Curator and Head of Special Collections and Gallery at the Albin O. Kuhn Library and Gallery, University of Maryland, Baltimore County. A specialist in the history of photography, she received a PhD in Art History from the CUNY Graduate Center with a dissertation on nineteenth-century Italian photography. She previously held positions at The Metropolitan Museum of Art and Sotheby's. She curated the exhibition *Lost Boys: Amos Badertscher's Baltimore* for UMBC's AOK Gallery.

James Smalls is professor and chair of the Department of Visual Arts at the University of Maryland, Baltimore County. His research and publications focus on the intersections of race, gender, and queer sexualities in the art and visual culture of modern Europe, the United States, and the art and visual culture of the Black Diaspora. He is the author of *Homosexuality in Art* (Parkstone Press, 2002) and *The Homoerotic Photography of Carl Van Vechten* (Temple University Press, 2006).

Acknowledgments

To complete a book like this it takes many individuals who care about the thoughtful preservation and presentation of an artist's work.

Many thanks to Bill Badertscher and his husband, Stuart Caplan, for their unyielding support of this project and many delightful dinners in Baltimore. We are indebted to the University of Maryland, Baltimore County; Maryland State Arts Council; and the Alphawood Foundation Chicago for their financial support.

Deepest gratitude to Beth Saunders at the University of Maryland, Baltimore County, and Jonathan D. Katz at the University of Pennsylvania for their immense contributions to this project. They are each wonderful, professional colleagues. Thank you, Jonathan, for editing the academic essays.

Amos's printer Julien S. Davis was a huge contributor as he provided more than half of the digital files selected for the book. Thank you.

Many thanks to the essay writers who offered their thoughtful insight and analysis: Rafael Alvarez, Theo Gordon, Jonathan D. Katz, Joseph Plaster, Beth Saunders, and James Smalls.

There were a number of individuals at the collecting institutions who were immensely helpful in securing prints of images used in this project: Bryce Zeffert and Lexi Johnson at the ONE Archives at the USC Libraries; Jonathan Marulanda, Stamatina Gregory, and Judy Giera at the Leslie Lohman Museum; and Emily H. Cullen, and Sean McNutt and Susan Graham at UMBC. Thanks also to Emily Cullen, Jared Christensen, and Vincent Carney for their assistance with the presentation of Amos's work at the AOK Gallery.

Many thanks to the professional team at Phaidon/Monacelli for their professionalism and generosity which led to the design, distribution, and presentation of this book, especially Alan Rapp, Michael Vagnetti, and designer Damien Saatdjian.

I also want to extend my sincere gratitude to Mischa Gawronski, Andy Johnson, and Matthew Leifheit, who were generous with their time as the project developed. Many thanks to my handsome husband, Jeffry George Cismoski, who supported me in this project every step of the way.

Many thanks to Brian Clamp at CLAMP in New York who has helped present Amos's work to the public.

Finally, I thank Amos. He was not only an artist, writer, and historian, he was also a student of art, icons, language, history, and a lover of books. He knew books' revelatory value in presenting and preserving history and presenting images and ideas. It was through books that Amos received much of his formidable knowledge of art history.

Amos and I spent countless hours reviewing early drafts of this book, both in person and on the phone. During some periods, we would talk every day. We discussed every aspect of the project. I learned a lot from Amos and he came to be a close, important life friend. I'm only sorry he did not live long enough to see the final version.

Hunter O'Hanian, December 2024

Captions and Credits

Unless otherwise noted, all images are gelatin silver prints.

Courtesy of Amos Badertscher Studio

Page 43
The Hippie, 1972.

Page 47
The Two Mikes #2, 1995.

Page 50
The Abandoned Body Shop #1, 2000.

Page 52
The Heart Necklace #1, 1976.

Page 63
Too Close to Wilkins Avenue, 1996.

Page 64
The Haunted, 1996.

Page 65
Almost Under I-95, 2001.

Page 80
Robbie and Bonzo Under I-95, 2001.

Page 85
In Patterson Park #1, 2001.

Page 91
Remington Boy #1, 1993.

Page 99
The Cute Sailor at Mary's, 1989.

Page 105
An Early Patron at the Hippo, 1975.

Page 106
A Rare and Beautiful Name, 1981.

Page 110
Sean of Club Charles #1, 1984.

Page 114
Miss Natalie - Coldfinger #1, 1975.

Page 119
She Was a Wild Woman, 1977.

Page 140
The Social Secretary, 1977.

Page 141
A Very Sweet Person, 1978.

Page 147
Preppy #1, 1989.

Page 167
David, the Boy in Collage with Flowers #1, 1974.

Page 169
Eddie in the Mirrors #1, 1998.

Page 177
The Mattress #1, 1999.

Page 178
A Hippy #3, 1972.

Page 179
A Hippy #4, 1972.

Page 181
Shower Series - The End, 1998.

Page 215
The Lady in Question, 1994.

Page 235
Luna and Dennis #1, 2002.

Page 241
Norman, "The Boy Next Door," 1980.

Page 244
Aubrey: Performer. Velvet Nation, 1999.

Page 248
Guy and Company #1, 1989.

Page 253
Flare, 1981.

Page 255
A Gay Tattoo Skin Donor, 1994.

Page 261
The Fiercest Performer #2, 1993.

Page 282
Out on the Baltimore Streets at 17 #1, 1996.

Page 285
Self Portrait #3, c. 1995.

Page 293
Portrait with JR #1, c. 1999.

Page 301
Sean and Mirror, c. 1996.

Page 304 left
Mike Was So Proud of His Body, 1999.

Page 304 right
Self Portrait: The White Room, 1998.

Page 309
Chucky: Self-Portrait #1, 1999.

Page 310 left
Portrait with Paul, 1999.

Page 310 right
As Beautiful as a Botticelli #1, 1999.

Page 319
The Corner, 2001.

Page 323
"It's Not Me, I Swear!", 1999.

Courtesy of the Estate of Amos Badertscher

Page 9
Hippy Festival, c. 1969.

Page 10
The Last Photographs #2, 2002.

Page 19
A Shocking Case of Trans-Lateral Positioning #1, 1988.

Page 24
Self Portrait Directly in Front of You-Know-What, 1996.

Page 27
Self Portrait at 38, 1974.

Page 29
Hey Lost Boy, c. 2001.

Page 30 left
Pat, 1963. Vintage Polaroid print with oil paint. 2.4 × 3.9 in.

Page 30 right
Craig - Hitch-Hiker, 1963. Vintage Polaroid print. 2.4 × 3.9 in.

Page 31
My Nookie, 1964. Vintage Polaroid print with oil paint. 2.4 × 3.9 in.

Page 32 left
Identical Twins #1, c. 1975.

Page 32 right
Identical Twins #2, c. 1975.

Page 33
I Met This Slight Boy in Mary's #1, 1977.

Page 35
Luis of Fleet Street #1, 1967. Vintage Polaroid print. 2.4 × 3.9 in.

Page 36
A Nice Arrangement, c. 1988.

Page 37
The Odalisque #1, 2003.

Page 39
Glasses Carl #2, 2001.

Page 41
Toddles, 1975.

Page 45
An Unfortunate Success Story #1, 2002.

Page 49
Great Bird Man, c. 1978.

Page 53
The Philosopher, 1976.

Page 55
Ken - The First Boyfriend, 1976.

Page 56
This Guitar Was His Only Friend, 1976.

Page 57
Kevi and the Baron, 1982.

Page 59
Mark, the Slim Punk Kid, 1978.

Page 60
He Was Junior #1, 1973.

Page 61
The Graffiti Wall #1, 1999.

Page 64
Sex Overload and Little Humor #1, 2001.

Page 67
By the Wall #1, 2003.

Page 68
D.L. On the West Side, 2001.

Page 69
Into the City #1, 1996.

Page 71
Confrontation: gegenüberstellen, 2001.

Page 72
Under the Remington Bridge #1, 1993.

Page 73
Jesus Christ Will Save You From Hell!, 1996.

Page 74
Male Studies - Body Parts, 2003.

Page 75
Captain America #1, 1994.

Page 77
A Warm Night for Trespass #1, 2001.

Page 79
R.I.P. Dear Jeremy, 2001.

Page 81
Insider Art Outside #1, 1998.

Page 83
The Last Photographs #2, 2002.

Page 84
Tough Little M.F.'s, 1997.

Page 87
Under I-95 #3, 2001.

Page 88
Sharp Knife, 2002.

Page 89 top
Homeless Man's Living Room #1, 2003.

Page 89 bottom
No Man's Land #1, 2004.

Page 92
Best Friends #1, 1998.

Page 93
Two Boys #1, 1996.

Page 94
He Was So Proud of His Body #1, 1999.

Page 95
Always Searching Out Your Weak Points, 2003.

Page 97
"I Can't Talk Now, I'm Being Photographed!", 1995.

Page 100
They Called Him Brother #2, 1979.

Page 101
Joseph, The White Portraits, 1974.

Page 103
The Architectural Secrets, 1979.

Page 107
Michael and the White Coffee Pot #1, 1976.

Page 109
His Holiness the Paws, 1991.

Page 111
A Self-Implicated Twink, 1977.

Page 113
A Lost Boy From Remington, 1983.

Page 115
The Mother's Son, 1984.

Page 118
Some Like it Hot - The Reincarnation, 1985.

Page 121
The Small Street Economies #1, 1977.

Page 122
First Year MICA Student #1, 1983.

Page 123
The Boy Across the Street, 1998.

Page 126
New Boys on Mt. Vernon #1, 1976.

Page 128
Stoney, 1982.

Page 129
Surprise!, 1981.

Page 130
Bruce on the West Side #1, 1997.

Page 131
A Mennonite Farm Boy, 2001.

Page 133
The Mild Prostitute, 1979.

Page 134
M.H., c. 2000.

Page 135
A Dollar a Minute Girl #1, 2002.

Page 136
A Poet, 1984.

Page 139
A Letter From Jail #1, 1979.

Page 142
The Portrait of Someone Else, c. 1973.

Page 143
A Midsummer Night's Dream, 1975.

Page 144
A Punk Boy #1, 1984.

Page 145
A Punk Boy #3, 1984.

Page 149
The Jet Pilot, 1982.

Page 154
Billy Under I-95, 2002.

Page 155
One of the Stories He Had to Tell Me #1, 2001.

Page 157
Jackie, A Life, My Oxygen #1, 1975.

Page 158
Sometimes I Feel Like a Rat in a Cage, 2001.

Page 159
The Visuals and Person Mismatched, 1976.

Page 161
Rough Trade #1, c. 1993.

Page 162
The Model - 22 yrs., 1982.

Page 163
Pompeiian Fragments, 1982.

Page 165
Portrait of a Hustler #1, 1974.

Page 166
A Little Bit of Money, c. 1975.

Page 171
Faster than a Heartbeat!, c. 1978.

Page 172
Out of Hock, 2004.

Page 175
On the Chesapeake #1, 1979.

All stories and images copyright © 2025
the Amos Badertscher Studio and William
Badertscher. All rights reserved.

Preface copyright © 2025 Beth Saunders

Introduction copyright © 2025 Hunter O'Hanian

"Lost Boys—And All the Rest of Us" copyright
© 2025 Rafael Alvarez

"Amos Badertscher Wasn't Gay" copyright
© 2025 Jonathan D. Katz

"A Mecca for Young Hustlers and Daddies:
Documenting Baltimore's Meat Racks"
copyright © 2025 Joseph Plaster

"Photography Against the 'Normalization
of Fagdom': Amos Badertscher in Context"
copyright © 2025 Theo Gordon

"Baltimore's 'Outsider Within': Race and
Queerness in the Photography of Amos
Badertscher" copyright © 2025 James Smalls

See AmosBadertscher.com for more information
about Badertscher's work.

Page 7
Installation view photo: Melissa Penley Cormier,
Manager of Research Graphics, University of
Maryland, Baltimore County.

Writing by others than Amos Badertscher are
reproduced under the Doctrine of Fair Use.
Individuals depicted herein have given their
complete and willful consent.

This book is generously supported by the
Maryland State Arts Council (msac.org),
Alphawood Foundation, University of Maryland
Baltimore County, and William Badertscher and
Stuart Caplan.

No part of this book may be reproduced, stored
in a retrieval system, or transmitted in any man-
ner for, by any means, including mechanical,
electronic, photocopying, recording or other-
wise, without the prior written permission of
the publisher, University of Maryland, Baltimore
County, Amos Badertscher Studio or William
Badertscher.

Library of Congress Control Number: 2024951359

ISBN 978-1-58093-647-7

10 9 8 7 6 5 4 3 2 1

Printed in China

Design by Damien Saatdjian

Monacelli
A Phaidon Company
111 Broadway
New York, New York 10006
www.monacellipress.com